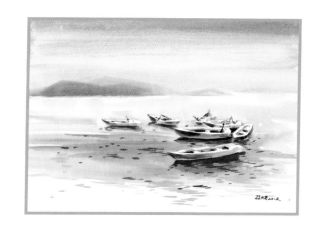

水之湄

日月潭水彩畫記

Searching For Beauty

Sun Moon Lake Watercolor Painting Journal

作者 / 孫少英

出版 / 盧安藝術文化有限公司

我看我賞《水之湄》

夏威夷大學榮休藝術教授 趙澤修

《水之湄》的出版和發行在台灣提升了人文精神和藝術影響，盧安藝術文化公司以文創產業提升了台灣旅遊產業的素質，這種有高度、廣度及深度的遠見對台灣的文化、經濟、社會、教育都有極大的影響。

這本珍貴的畫集使觀者在俗迷中得到清澈，在紛繁中得到寧靜。

到了日月潭只見群山環抱這一面明鏡，山光湖影，幽美澄闊，面對如此勝景，只覺一片寧靜淡遠，現實與夢境交織，期盼與希望綻放一起。心明神悟，原來水之湄就是這裡！不知曾經多少文人騷客、藝人畫家都來這裡留連，來過多次每次感受不同。水，在中國人的生活哲學上有太多的重要意義，帶有水旁的字在字典有就能找到四百三十七個之多。

好山好水要通過畫家的彩筆才能留下不朽的永恆生命，這瞬間的一揮可能為美術史留下一頁難忘的片斷！

少英住在水邊近處，四季晨昏，隨時可來寫生，這樣才能得其天時地利。他的水彩和素描功力可以把握和發揮這些美景的晨昏情調，把觀者帶進回歸自然的感受。湖潭景色處處都可入畫，他把這些鄉土氣息和地方情懷，深情和癡情的融於筆下，躍然紙上。

他以概括簡練的筆法，或渲染或平塗，適當的留白將整體美感，主觀感受，經過取捨組合，虛實得宜的處理了畫面的基本要素，簡潔靈秀，浪漫而有文學氣息，給觀者以從容的空間，自去審美尋繹。

我與少英相識五十多年，兩人終生都是從事藝術工作，又同是山東青島人，現在又都年過八十，所幸年高身健，老當益壯，又都愛好水彩寫生，登山涉水，集工作與嗜好於一身，所交朋友和學生們也都是樂此不疲的同道雅士。

我們相識於1957年，我由師大畢業，徵服預備軍官役，從幹校三個月結訓後，調赴金門防衛司令部任少尉美工官，當時結識了幾位軍中精英青年畫家，如李奇茂、舒曾祉、孫少英等。退役後，1959年留學日本，1961年回國擔任日月潭教師會館第一任館長，同時少英也已退役，正好邀請他來館擔任美術及攝影工作，他有書法基礎、素描、水彩均佳。

我們在日月潭工作兩年有半，暇時便划著一條單槳老獨木舟，泛遊湖上。有一次是八月節的晚餐後，我倆便一時興起，小酒一壺，月下行舟，趨向德化社，希望能夜訪毛王爺和一見白牡丹，湖色和山影在明月照耀下，如同仙境，令人陶醉。

1963年，我赴美國迪斯尼動畫製片廠受訓，兩年後回台與少英及幾位青年畫家同進台北光啓社工作，創立了動畫部，並製作了幾部短片，如《石頭伯的信》等。

我家住敦化大廈，周末常有很多畫友，前來相聚，如馬白水老師、劉其偉、王藍、席德進、羅慧明、鄧國清、孫少英等眾好友，談畫論道，切磋畫藝。

1969年秋我應夏威夷大學之聘，全家來美，在夏大教書三十三年，於十年前退休。四十多年來常與少英 一起參加台灣全國水彩畫聯展，保持聯繫。

這次他的新書《水之湄－日月潭水彩畫記》出版，邀我寫篇序文，欣然從命，並祝願此書為初學水彩畫的朋友提供一些靈感和助益。

Searching for Beauty in My Mind's Eyes

Professor Retired, Art University of Hawaii At Hilo Linus Chao

The publication of *Searching for Beauty* has promoted the cultural spirit and artistic influence in Taiwan. The Luan Art Co. Ltd. enhances the quality of Taiwan's tourist industry by cultural and creative endeavors. Such profound, far-reaching vision has greatly impacted on Taiwan's culture, economy, society and education.

This precious painting album grants the readers clarity in the midst of delusive secularity and serenity in the midst of turmoil.

After arriving at Sun Moon Lake, I saw this bright mirror surrounded by a cluster of mountains. The mountain light and lake reflection combined to form a beautiful scene of tranquility, purity and immensity, endowing me with a feeling of peace and transcendence. The reality is entangled with dream states and the longing is blooming along with hopes. Clear-headedly I came to realize here is exactly the water bank as described in ancient literature. Numerous writers, poets, artists and painters have sojourned here, impressed by unique sensations each time. Water has created too many essential meanings in the living philosophy of Chinese. There are as many as 437 words in the dictionary formed with water radical.

A beautiful landscape with mountains and water has to be immortalized through the color brush-pen of a painter. A stroke at an instant could leave an unforgettable page in the history of art.

Shao-yin lives closely by the water, able to paint from nature at any time, in every season. Therefore, he could gain the advantage of timeliness and locality. His mastery of watercolor and sketching is good at fully representing the scenic atmospheres at dawn or dusk, bringing the viewers back to the feelings of nature. All the scenic spots around the lake can be depicted by painting. He has lively demonstrated these rural temperament and local feelings, affectionately and infatuatedly through his paint brushes, on the paper.

His brushwork is simple and skillful, either adding washes or applying flat colors. And for the basic composition, he leaves proper white space in the picture plane in order to integrate the overall aesthetic with subjective sensations in a proportionate way. His works, endowed with simplicity and sublimity, are romantic and literarily temperamental, giving the viewers sufficient space to appreciate and interpret on their own.

I have known Shao-yin for more than five decades. We both have spent our lives in artistic work, come from Qindao, Shandong, and now are 80 plus years old. Fortunately, we are still healthy, more vigorous with age. We both love watercolor and to paint from nature. We visit the mountains and wade the waters, combining our work and hobby. All our friends and students are also refined people of the same line, sharing the same passion untiringly.

We met in 1957. I graduated from Normal University and was enlisted for reserved officer service. After I had completed the 3-month training at Staff School, I was transferred to Kinmen Defense Command and pointed as Second Lieutenant Art Officer. Then I made the acquaintance of several young elite painters in the army, such as Li Qi-mao, Shu Tseng-chih, Sun Shao-yin, etc. After I had retired from my military service, I went to Japan to study in 1959. In 1961, I returned to Taiwan and took the position of the first Director of Sun Moon Lake Teacher's Hostel. At that time, Shao-yin had also retired from his military service, so I invited him to work at the Hostel to take charge of art and photography. He has solid foundation in calligraphy and is very good at sketching and watercolor painting.

We had worked at Sun Moon Lake for two and half years. In our leisure time, we would row a used single-paddle canoe to tour the lake. Once, after the dinner of Mid-Autumn Festival, we suddenly had the mood to row the canoe under the moonlight accompanied by a bottle of wine. We headed for Dehua Village, hoping to visit Mao Wangye and White Peony at night. The lake scenery and mountain shadows looked like a fairy land as lighted up by moon, which was very intoxicating.

In 1963, I went to the United States to receive training at Disney Animation Studio. Two years later, I returned to Taiwan and worked at Guangchi Program Service in Taipei, along with Shao-yin and several young painters. We founded the Animation Department and produced several short films such as *Letter of Uncle Stone*.

I lived in Dunhua Building, often visited by many painter friends during weekends, including Master Ma Pai-sui, Max Liu, Wang Lan, Xi De-jin, Luo Hui-ming, Deng Guo-ching, Sun Shao-yin, etc. We discussed painting and reasoned the truth, learning the art of painting from one another.

In the autumn of 1969, I accepted the position at Hawaii University and moved my family to the United States. I had taught at Hawaii University for 33 years and retired 10 years ago. For more than 40 years, I have often joined the National Watercolor Group Exhibition of Taiwan with Shao-yin and kept our contact.

This time, *Searching for Beauty* his new album of Sun Moon Lake watercolors, is about to be published, and I was invited to write a foreword. I was more than happy to do so. I sincerely wish this book would offer some inspirations and assistance for beginners in watercolor painting.

生命的昇華與自在

新故鄉文教基金會董事長　廖嘉展

涼亭、魚池、荷花，笑聲和著美圖的幸福，在1999年9月21日這天凌晨1點47分，有了分野。

台灣在此刻遭受百年來最大的地震襲擊，孫老師在劇烈的搖晃中驚醒，洗腎已7個月的小女兒嚎叫聲、東西摔落聲，夾雜在一起，他急促地由4樓奔到3樓，把已摔落床下的女兒從雜物堆中拉出來。在一片漆黑中，父女倆膽驚心顫地爬到樓下，赤腳逃到馬路上，相互依偎著，餘震一直不斷……。

地震前，我喜歡來到孫老師的舊居，就在那水池上的涼亭，享受著茶水點心，然後越過馬路來到老師的畫室，水泥板牆掛著圓形砧板寫著「孫少英畫室」，一進門就可看見師母與大女兒的素描，這是老師最喜歡的兩幅作品。裡頭的書桌上，堆著各種資料，老師在此閱讀，寫日記，也在此教畫。

地震後，畫室傾頹，連著畫室旁的古厝都一起拆除，只留下一棵老含笑，兀自佇立，吐露著孤寂的芳香。

這段期間也是孫老師辛苦的開始，震前，小女兒開始洗腎，每到固定時間他就騎著那部老摩托車，載女兒去埔里基督教醫院，到盧錫民醫師負責的透析中心洗腎，父女情深，這是我看過最令人動容的畫面。震後，他安頓好女兒之後，看見那麼多人投入救災工作，「別人拿鋤頭救災，我老伙子拿畫筆留下記錄，也盡一點貢獻！」他如此期勉自己。

災難使人喪失勇氣，不敢面對，甚至放棄，更何況要在災難的現場以畫筆紀錄，儘管現場寫生的危險性很高，孫老師雖身處災區，但有一股使命感驅使著他，他每天騎著機車，帶著泡麵、餅乾和礦泉水，在烈日下、殘垣中到處寫生，把地震後悲慟的景像，畫成一張張的作品，彙集成《九二一傷痕》，留下歷史的見證。

在921地震重建階段，他以水彩和素描兩種方式，為重建工作留下了寶貴記錄，《家園再造》就是描寫這些災後的動人故事。

孫老師除了以921地震為主題的創作豐富之外，用水彩來描繪日月潭風光，更是令人讚嘆。日月潭距離孫老師家僅16公里，60年代孫老師曾在日月潭教師會館任職，日月潭一直是他創作靈感的源頭，也是最喜歡的題材之一，百畫不厭。他先後出版《水彩日月潭》和《日月潭環湖遊記》，在921地震14週年的紀念日，欣聞孫老師的新書《水之湄》日月潭水彩畫記即將要出版，囑我寫序，真為他驚人的行動力所感動。

孫老師作畫速度求快、構圖求準、主題求明，重視自然物像的光影交錯，所以能掌握住那筆下的極美瞬間。這些年來他跑遍台灣，還出版《阿里山遊記》、《台灣小鎮》、《台灣離島》、《台灣傳統手藝》等畫冊，豐沛的創造力與入世的觀察力，以田野現場為師的寫生行動藝術，無人能出其右。他的水彩畫與素描，已到達爐火純青的階段，以素描為底，色彩為體的彩墨變化，在化繁為簡的過程中，令人瞥見他的明快自如的真本性。

已故的埔里基督教醫院院長紀歐惠曾說：「埔里是個很特別的地方，每個人來埔里都有他的使命，我們要做好準備，讓上帝來揀選我們。」孫老師就像被上帝揀選的使者一樣，用彩筆為埔里，為台灣留下諸多精彩的畫作。

或許，就是這份生命的昇華與自在，讓孫老師可以如此一路走來。

Sublimity and Freedom in Life

Chairman of New Homeland Foundation Liao Chia-Chan

The happiness of laughter mixed with beautiful pictures of pavilion, fishpond and lotus was changed at 1:47 am on the morning of September 21, 1999.

At this moment, Taiwan was suffering an attack from the greatest earthquake in a century. Master Sun suddenly woke up in severe shocks. The cries of his youngest daughter who had already received kidney dialysis for 7 months mixed with the sounds of things falling. He hurriedly rushed to the third floor from the fourth and pulled out his daughter that fell down from her bed in the midst of random objects. In complete darkness, the father and the daughter, trembled with fear, climbed down to the ground floor and ran to the street on bare feet. They held each other while the aftershocks continued...

Before the earthquake, I loved to visit the old home of Master Sun. In the pavilion above the pond, we enjoyed tea and snacks. Then we crossed the road to his studio where a round cutting board marked with "Sun Shao-Ying Studio" was hung on the concrete wall. At the entrance, the sketches of his wife and elder daughter could be seen and these two works are his favorite. On the desk inside was stacked with all sorts of materials. Master Sun was reading, writing journals and teaching painting here.

After the earthquake, the studio was crumbled and dismantled along with the adjacent old house. There only remains an old banana magnolia, standing alone and spreading its fragrance in solitude.

This period marked the start of Master Sun's painstaking. Before the earthquake, his youngest daughter had begun kidney dialysis treatment. At the regularly scheduled time, he would ride his old motorcycle bringing his daughter to Puli Christian Hospital to receive the treatment at the Dialysis Center directed by Dr. Lu Hsi-min. The loving father-daughter relationship is the most touching scene that I have ever seen. After the earthquake, he settled his daughter and saw so many people devoted to relief efforts. So he urged himself that, "Others are carrying hoes to save the victims. I as an old man could hold my paint brushes to record them, which is my humble contribution."

Disasters deprive people of their courage, making them escape reality or even surrender, to say nothing of recording the disaster scenes with brushes. Despite the high danger of painting the reality on the spot in the disaster zone, Master Sun was driven by a sense of mission. Every day, he rode his motorcycle and brought with him instant noodles, cookies and mineral water. Under the scorching sun, he drew the ruined scenes everywhere, creating numerous works which represent the painfully sad images after the quake. These works were compiled into the album, *The Scars of 921 Earthquake*, bearing witness to history.

During the rebuilding phase after 921 Earthquake, he used watercolors and sketches to leave precious records for the reconstruction. *Rebuilding Our Homeland* is the album depicting these appealing aftermath stories.

Master Sun, in addition to prolific creation on the subject of 921 Earthquake, represents the scenery of Sun Moon Lake by watercolors which are even more marvelous. The distance is only 16 kilometers from Master Sun's home to Sun Moon Lake. In the 1960s, Master Sun had been working in the Sun Moon Lake Teacher's Hostel. Sun Moon Lake has always been a source of his creative inspiration and also one of his favorite subjects. He would never get tired of painting it. He has published *Watercolors of Sun Moon Lake* and *Round Trip of Sun Moon Lake*, respectively. On the14th anniversary of 921 Earthquake, I was pleased to know that the new book of Master Sun, *Searching for Beauty*, is going to be issued soon. I was invited to write a preface. I am really moved by his amazing achievements.

Master Sun emphasizes fastness in painting, accuracy in composition, clarity in the subject matter, and the interactive light and shadow of natural objects, therefore he could grasp the extremely beautiful moment under his brushwork. In recent years, he has traveled across Taiwan and published albums such as *Scenic Journey of Alishan, Taiwan Townships, Off-shore Islands of Taiwan, Traditional Arts of Taiwan*, etc. It is exceptional for his abundant creativity and keen observation of real life, as well as his art of sketch actions taking lessons in field sites. His watercolors and sketches have reached high perfection. The variations in color and ink, based on sketching and embodied in coloring, reveal his true nature of spontaneity in the process of abstracting.

The late Director of Puli Christian Hospital, Alfhild Jensen Gislefoss, once said, "Puli is a very special place. Everyone has come to Puli on one's own mission. We should be prepared to let God choose us." Master Sun is like a messenger chosen by God, leaving numerous wonderful paintings for Puli and Taiwan with his paint brushes.

Perhaps, it is such sublimity and freedom in life that has led Master Sun all the way through.

《水之湄》出版構思

發行人　盧錫民

　　當我被催促著要寫出版緣由時，我突然想到現在剛好是大學指考放榜時刻，許多考上第一志願的學生會接受媒體訪問，他們的抱負往往是「濟世救人」或是「打擊犯罪」、「主持正義」等等。那麼盧安藝術的第一次出版是基於甚麼理想與抱負呢？我從小時候就喜歡收藏，想不到現在真的成立了藝術公司，這期間放棄的與啓動的諸多過程，回想起來，那内在的動力是甚麼？那無非就是「美的追尋」，它真是既抽象又實際，既庸俗又深奧，端看它是掛在嘴上的名詞，或是靜慮思密後的動詞！

　　埔里是我的原鄉，而孫老則是埔里女婿，埔里是孫老的第二故鄉。20年來孫老到處寫生，畫遍台灣和離島，但和孫老的水彩畫迸出最大火花的還是那山水精靈－日月潭。以前日月潭的遊客並不多，長久以來我一直把日月潭當成是獨享的後花園，但自從開放大陸人士來台觀光之後，它已成為遊人如織的首選景點。

　　而這天成美景經孫老之水彩妙筆揮灑之後又多出一種人文之美。家鄉有此美景，有此大師，遂有集結成書出版，以饗大衆之衝動與構想，整個過程也算是「美的追尋」，或曰「美在何方？」《詩經》秦風「蒹葭」有云：「所謂伊人，在水一方。」「所謂伊人，在水之湄。」溯源尋美，極具美感，故取書名為《水之湄》。

Thoughts on *Searching for Beauty*

Publisher Lu Hsi-Min

When I was prompted to write a publisher's note, it came across my mind that the results of college entrance exam were just released and many No.1 students would be interviewed by media talking about their aspirations such as "saving others", "beating crime" or "advocating justice." So upon what ideal and aspiration was the first publication of Luan Art Co., Ltd. based? I have loved collecting since my childhood. I have never thought I would really found an art company later in my life. In my recollection now, what was the inner drive for the repeated abandonment and initiation during this phase? It is nothing but "the search for beauty." It is indeed both abstract and realistic, and vulgar but profound. It depends on being a word of mouth or action after careful thoughts.

Puli is my hometown. Master Sun is the son-in-law of Puli, his second hometown. For 20 years, Master Sun has painted outdoors everywhere across Taiwan and small islands. But the biggest spark has been generated between Master Sun's watercolors and the nature spirit of Sun Moon Lake. In the past, the tourists of Sun Moon Lake were rare, so I had regarded it as my personal backyard for a long time. Yet since Taiwan was opened to Chinese tourists, it has become a top scenic spot that attracts numerous visitors.

Such natural beauty is added with cultural aesthetics by Master Sun's exquisite watercolors. My hometown has generated such beautiful scenery and such a master, therefore I was motivated by the idea to compile a book to share with the public. The entire process can be seen as a "search for beauty" or "where is beauty." In the poem "Jian Jia" of the Odes of Qin, *Shi Jin* (Book of Songs), there are lines: "the person of whom I think, is somewhere about the water.... the person of whom I think, is on the bank of the water." To trace beauty to its origin is very aesthetical, thus I have titled this book as *Searching for Beauty*.

享受寫生

孫少英

　　我家住在埔里，離日月潭很近，然後常騎機車去寫生。我很喜歡繞湖轉一圈，從金龍口左轉，經文武廟、玄奘寺、到玄光寺，然後從頭社回來。開車太快，我不會開車，搭便車不自由。騎自行車又費力，畫具也不好帶。騎機車最大的好處是，慢慢騎，發現好的地方，立刻停下，畫完，立即上路。

　　日月潭湖岸線很曲折，形成許多湖灣，這些湖灣是我寫生最好的目標。湖灣經年停泊漁民的竹筏、四角網、漁船、船屋以及浮嶼。

　　四角網是日月潭最大的特色，長長的竹筏上搭一間簡樸的小屋，竹筏一端用長竹捍或鐵架張起一個偌大的四角網，造型很美，從任何角度看，都是寫生的好題材。有些較高大的船屋搭在浮台上，大半附設數組四角網，屋內放置漁具為主，漁民有時候在船屋裡住宿。也有漁民會邀請親朋好友來渡假，水上待客，真是有情調，好主意。

　　浮嶼是用竹子遍造成一個大底盤，上面敷土種草種花，時間久了，植物都長得很高大，遠看好像一個小山丘，浮嶼底下，漁類、蝦類常年滋生，是漁民的最大資產。浮嶼配四角網，是我最愛的題材，百畫不厭。

　　日月潭有許多大飯店如涵碧樓、日月行館、大淶閣、鴻濱等，景觀都很好，我常在他們樓頂的陽台上居高臨下俯視日月潭寫生，廣闊的湖面，是一種大面美。湖灣裡的船屋和四角網是一種角落美，各有不同的味道。

　　我畫日月潭，以張數論，已數不清，日月潭國家風景管理處幫我出版了一本《水彩日月潭》；自已也出版了一本《日月潭環湖遊記》，而這一本取名《水之湄》，出自《詩經》，取其意，也取其形。感謝盧安藝術公司全力策劃出版。書出版了，我仍繼續繞湖寫生，說不定還有第四本出現。

Enjoyment in Painting from Nature

Sun Shao-Ying

I live in Puli, nearby Sun Moon Lake, so I often go there by motorcycle to paint outdoors. I love to round the lake, making a left turn from Jinlongkou, via Wunwu Temple, Xuanzhuang Temple and Xuanguang Temple, and then returning from Toushe. Driving is too fast. I can't drive, and it is not free to get a lift. Riding a bike is strenuous and not convenient to carry art tools. The best advantage for riding a motorcycle is slow and easy to make a stop when finding a good scene and hit the road again right after painting it.

The costal line of Sun Moon Lake is very winding, forming many arms. These arms of lake are the best subjects of my nature paintings. Docked at these bays are bamboo rafts, four-angel nets, fishing boats, boathouses of fishermen and small floating islets all year round.

The four-angel net is the biggest feature of Sun Moon Lake. A simple hut is built on a long bamboo raft with a large four-angle net supported by long bamboo rods or iron stands at the end. It has a beautiful form, a very good subject of nature painting viewed from any angle. A few taller boathouses are built on a floating platform, mostly accompanied by several sets of four-angle nets, mainly for storage of fishing tools or sometimes accommodation of fishermen. Some fishermen would invite their relatives and friends for vacation. To entertain guests on the water is a very good idea, and also extremely romantic.

The small floating islet is a big bottom plate made with woven bamboo, on top of which soils are covered for planting flowers. After a certain period of time, plants are grown and tall. From a distant view, it looks like a small hill. Under the small floating islet, fish and shrimp are flourishing all year round, which are the biggest property of fishermen. The small floating islets accompanied by four-angle nets are my favorite subject, which I have never been tired of painting.

There are many big hotels around Sun Moon Lake, such as Lalu, Wen Wan Resort, Del Lago, Apollo Resort, etc. They all have fantastic views. I often overlook Sun Moon Lake from their rooftop balconies and paint outdoors. The vast lake surface is beautiful in its immensity. The boathouses and four-angle nets inside the arm of lake are beautiful implicitly like a corner. Each of them features a different flavor.

I have painted Sun Moon Lake in large volumes. In 2003, Sun Moon Lake National Scenic Area Administration has published a catalogue for my works, *Watercolors of Sun Moon Lake*. 4 years later, I have also published the book, *Round Trip of Sun Moon Lake*, on my own. This book is the third one and titled *Searching for Beauty*, whose Chinese title comes from *Shi Jing* (Book of Songs) for its meaning and forms. I am grateful for the efforts in publishing by Luan Art Co. Ltd. After this book is printed, I will continue to round the lake for painting outdoors, so there may be the fourth book in the future.

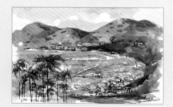

日月潭主要景點示意圖
Main Tourist Spots of Sun Moon Lake Sketch Map

貓囒山 Mt. Maolan

文武廟 Wunwu Temple

朝霧碼頭 Chaowu Pier

竹石園 Bamboo Rock Park

水社 Shuishe

涵碧半島 Hanbi Peninsula

向山 Xingshan

北旦 Beidan
(金盆阿嬤 Grandma Jinpen's Stand)

頭社 Toushe

拉魯島
La Lu Island

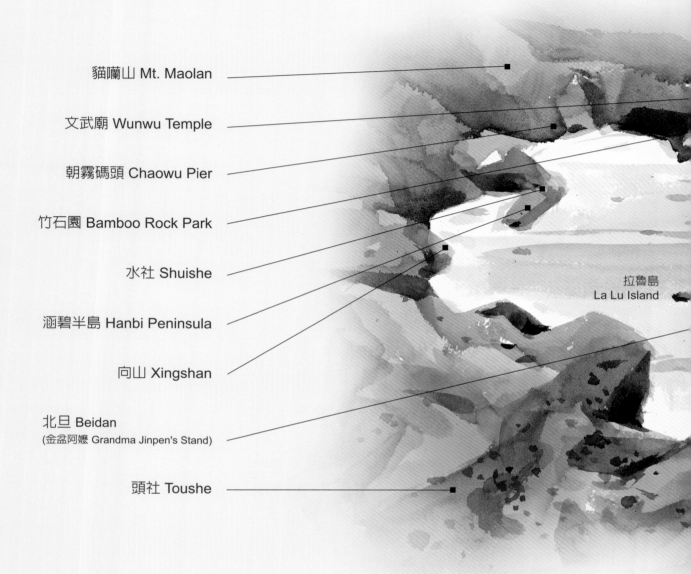

松柏崙 Songbolun

大竹湖 DaZhu Lake

水蛙頭 Shuiwatou

青年活動中心 Youth Activity Center

日月村 Sun Moon Village
伊達邵 Yidashao

聖愛營地 Holy Love Campsite

土亭仔 Tutingzai

玄奘寺 Xuan Zhuang Temple
慈恩塔 Ci En Pagoda
玄光寺 Xuan Guang Temple

沙巴嶺 Shabalan

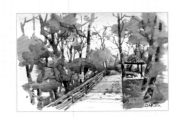

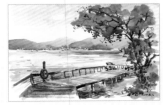

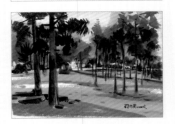

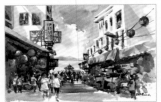

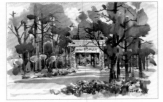

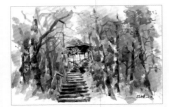

目次
Contents

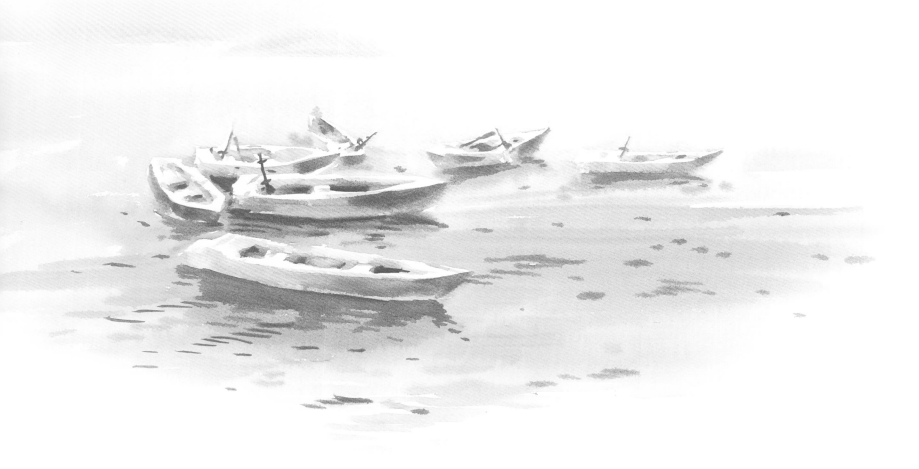

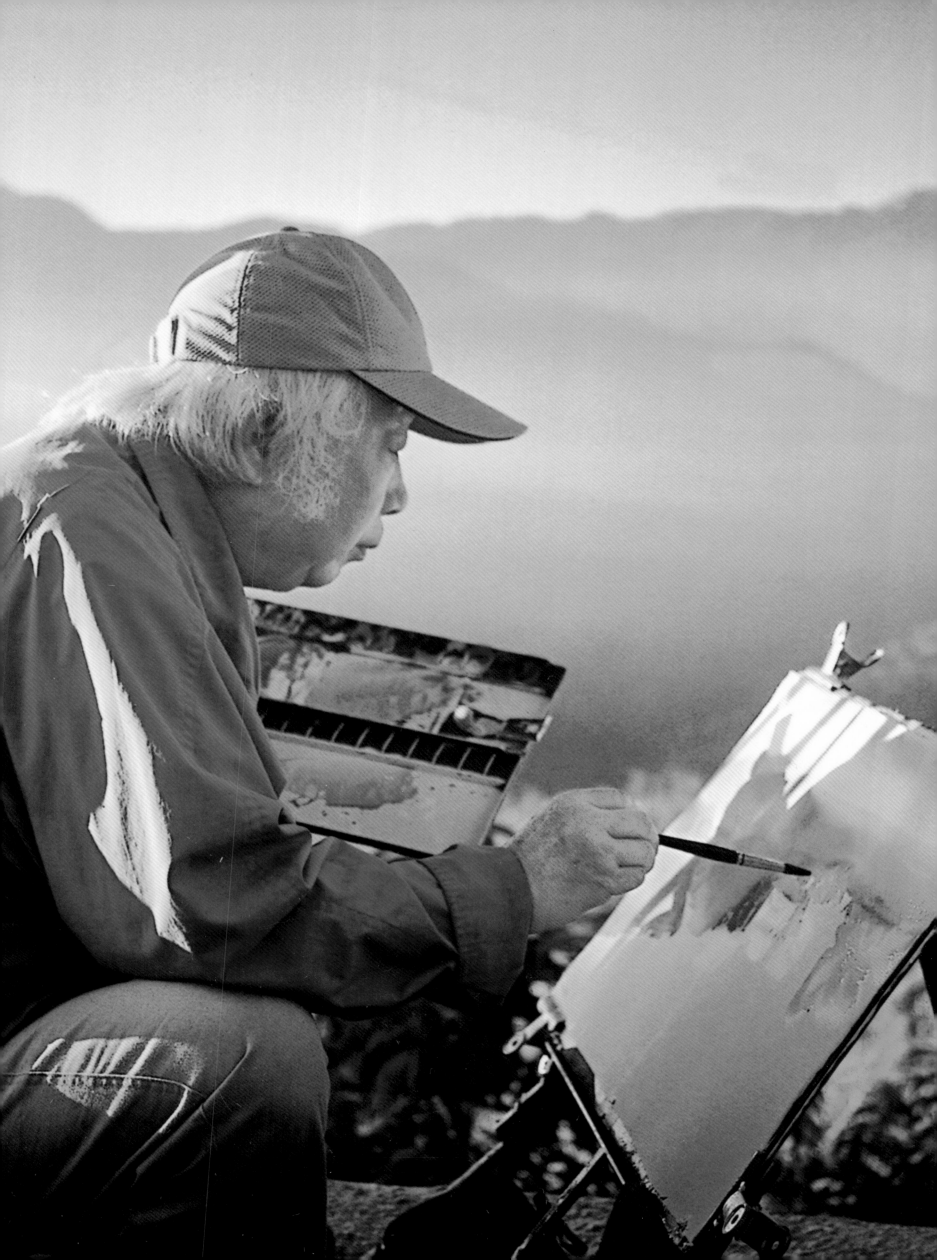

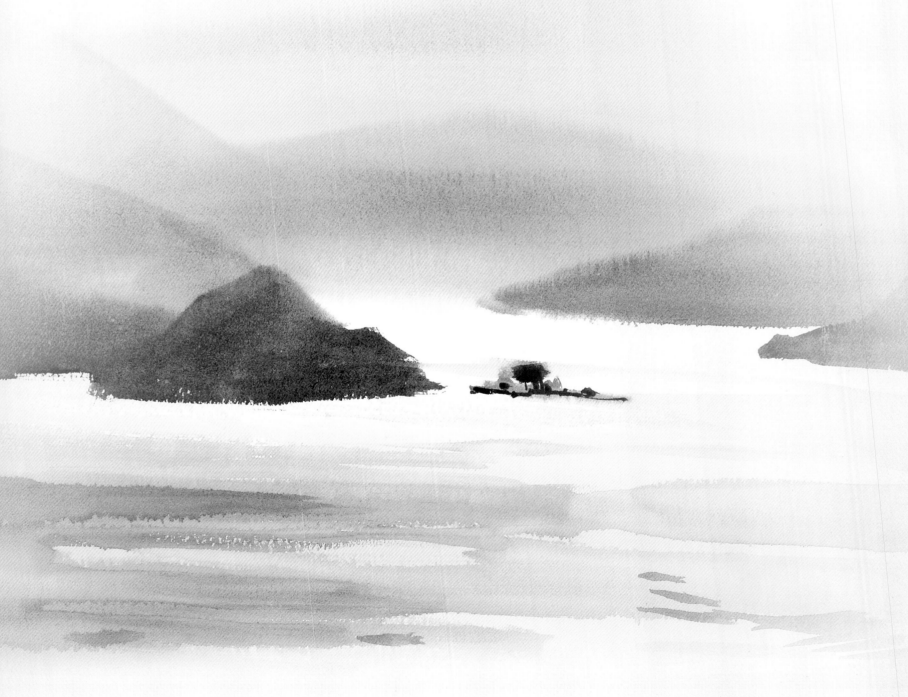

我的畫法和想法　　孫少英

　　我喜歡寫生，數十年來從未間斷，畫水彩或素描。有人以寫生為畫稿，我則以寫生為成品，大自然是素材，也是畫室。近幾年，我寫生都是系列性的，如日月潭、阿里山、小鎮、離島等，寫生兼旅遊，樂趣無窮。

　　這些系列作品，除了每年舉辦展覽以外，都已編輯出書，同時我也選擇部份作品，配上短文，投到報刊雜誌發表。朋友說我一鴨三吃，我自己也覺得這都是寫生的意外收穫。

另外，我覺得寫生對我還有兩項好處：

一、腦中形狀圖庫豐富：寫生多了，會記住很多形狀，譬如山、水、樹、房屋、街道、市場、人物、動物、植物等等。在畫室作畫時，腦子隨意組合一下，就是一張完整作品，幾乎不需要翻箱倒櫃到處找資料。人常說，繪畫是造型藝術，藉寫生，記形狀，是畫畫創作的豐富資產。我有時看畫展，展場中，如果是畫面多樣豐富，證明這位畫家有寫生經驗。如果是千篇一律，看一張等於看全部，證明這位畫家不懂得寫生。

二、創立「一點延伸法」，畫圖不打草稿：俗語說，熟能生巧，畫多了，畫熟了，畫任何東西，都不需要打草稿。譬如畫街景或市場，畫面很繁雜，不打草稿，可省掉很多時間。更重要的是，繁瑣的草稿打完了，畫畫的樂趣也沒有了，即使畫完，因為精神不濟，難有好作品。不打草稿，像寫書法一樣，下筆沒太多考量空間，如行雲流水，這才真正達到畫畫的樂趣。

　　曾有人問我，這麼繁雜的畫面，不打草稿，怎麼會這麼有把握。我思索過，我確實在熟練中，練出一套方法，我取名「一點延伸法」。這套方法，單純用文字很難說清楚，必須以畫面舉例分解說明，或是當場示範。讀者如有興趣，請參閱拙著《從鉛筆到水彩》一書，這本書裡有專頁舉例說明。

　　有一天，我突然想起來，石濤畫語錄裡曾提到「一畫法」，我立刻把書找出來，仔細研讀一番，我發現石濤的「一畫法」，跟我的「一點延伸法」，十分相似。後來我研讀《吳冠中全集》，發現有很大篇幅是解說石濤畫語錄。吳冠中說，「一畫法」不是具體畫法，是一個抽象概念。為此，我再次研讀石濤畫語錄，我覺得吳冠中的說法不正確，因為石濤既然用「法」字，應該是具體方法，怎麼可能是抽象概念呢！用我的「一點延伸法」，來解釋石濤的「一畫法」，可能還有些道理。

數十年來，畫了許多，也看了許多，我把形形色色的畫風分成五類，試述如下：

一、超寫實類：照相夠寫實了，超寫實的畫家能夠畫的比照片還細膩逼真，一張畫要畫一週或數月，看了真是令人嘆為觀止。近幾年，台灣許多年輕人都畫這類畫，我想，這一方面是興趣，一方面可能是市場導向。憑良心說，這類畫，我非常佩服，但並不喜歡，打死也做不到。

二、簡化寫實類：齊白石有一段話，我覺得很好：「作畫妙在似與不似之間，太似為媚俗，不似為欺世」。蘇東坡有一段話也不錯：「論畫以形似，見與兒童鄰」。我的看法是，既稱為寫實，雖要簡化，仍需重視基礎，在基礎之上追求變化、趣味和意境。我自己應歸為這一類。

三、變形類：有些人天生不喜歡傳統素描，或是天生畫不準。也有人畫傳統畫膩了，就走向變形，有人變得很美，也有的變得不美。表現派大師孟克（Edvard Munck 1863-1944）的著名畫作《吶喊》，是這類畫最好的例子，目前身價高的不得了。但我卻一直覺得那張畫無比拙劣。

四、抽象類：本來是沒有具體形象的意思。最近看到吳冠中對抽象的解釋，他以「風箏不斷線」做比喻，說抽象還要保留一點形象的影子，以跟「無形象」有所區別。目前在畫界，這種畫風蠻多的。比寫實省事，也被譽為現代，可能也有賣點，何樂不為。

五、無形象：也可說是徹底的抽象，或說有形無象。康定斯基（Wassily Kandinsky 1866-1944）應該是最具代表性的畫家。這類畫重視點線面、黑白灰、律動、塊面以及心靈感受的綜合效果。有人對這類畫讚美不已，有人覺得莫名其妙，各有各的道理，絕不能以是與非來論斷。

畫水彩畫了這些年，我也把水彩畫分成兩類：

一、以特殊技巧製造優良效果：我所謂的技巧，是畫筆之外的各種方法，如撒粒、塗留白膠、使用石膏粉、膠帶、刮、擦、磨、印等，用特殊技巧做出來的效果，的確非常誘人討好。但要看各人的個性和興趣，有人樂此不疲，有人覺得太麻煩，太工藝味，難有定論。

二、純以畫筆展示實力：這類畫家作畫就是靠幾支筆，筆是萬能，像書法一樣，一筆是一筆，講求筆法、筆力、筆觸、筆性。我的畫法，似乎應該歸到這一類。

下面是我的一些淺薄經驗：

我先說我的用具，年輕時各種顏料都用過，王樣、利百代、龍牌、櫻花牌、牛頓等，最後固定用日本HOLBEIN，三十年來再沒換過。它彩度、透明度都很好，不褪色。不過，不知什麼顏料相混，日久會產生一些小色點，好在對畫沒有傷害，反倒有點特殊效果，所以我一直沒有在意。我的畫筆也全部是HOLBEIN。紙張一直用ARCHES。近年常畫大幅水彩，ARCHES有捲筒紙，長三十呎，寬四呎，隨意裁用。

水彩很難學，這是畫畫的人都承認的。早期我摸索了很久，參考了許多國外畫冊，等畫熟練了，才真正體會到畫水彩的樂趣。

一般人都比較重視色彩的運用，譬如用色要大膽，有創意，多變化。這固然重要，但我覺得明度掌握更為重要，所謂明度，就是黑白灰的搭配，要得當。譬如紅花綠葉，彩度都很高，明度則很接近，畫水彩就要把明度拉開，即一種加深，一種變淺，這樣畫面才會對比明快，否則會黯淡無神。

留白是水彩畫非常必要的技巧，有人用白粉來填補，畫面會污濁不爽，也不調和，水彩乾淨俐落的味道出不來。我的方法是，在該留白的地方，用乾筆只畫陰影部份，做為留白的記號，塗外沿和大面時，小心把白留出來。一張畫，留白留得好，使白佔到適當的比例，這張畫視覺效果一定很好。

初畫的人，畫起來一定很拘謹，畫一拘謹，灑脫的味道就沒有了。俗語說，藝高膽大，熟能生巧，這應是排除拘謹的不二法門。

畫寫實的人，也要有一些抽象觀念，譬如非主題的地方，使它朦朧一點，不重要的地方，一筆帶過，省了事，還討好。

馬白水說過，畫水彩要有水有彩。水彩畫太乾，的確不好，沒有潤味。要有適度的流動感，才能顯出水彩的特性。在室內畫，先泡水是一個辦法，在室外寫生，則需用刷子全部或局部刷水，真正要控制好，還是要經驗。

水彩畫重疊容易，交錯最難，譬如一堆雜草，莖葉相互穿插，超寫實的畫家，會巨細靡遺的精確描繪出來。簡化寫實的畫家，要用寫意的手法，在簡化中，把雜草的神態及莖葉相互穿插的層次表現出來，這不但是技巧，而是靈巧。我常想，這種智慧性的靈巧，才是真正的藝術。

我最後說一句，作畫能得心應手，靈巧、愉快都來了。

My Paintings and Thoughts Sun Shao-Ying

I like to draw from nature, and I have continued to do watercolors or sketches for several decades. Some people take nature drawings as sketches, but mine are my works of art. Nature is my source of subjects, and also my studio. In recent years, my paintings from nature are all in series, such as Sun Moon Lake, Ali Mountain, small towns, islands, etc. I paint when I travel, which gives me unlimited pleasures.

In addition to annual exhibitions, all these series of works are already published. Meanwhile, I have also selected some of my art works, accompanied with short essays, to be presented in newspapers or magazines. My friends say that I am shrewd to present my works in three ways, which I consider to be unexpected bonus for my paintings.

Besides, I feel that nature painting has given me two advantages:

1. I have abundant images in my brain like a databank: With more experiences in nature painting, I tend to remember many forms, such as mountains, water, trees, houses, streets, markets, figures, animals and plants. When I paint in the studio, I randomly assemble images restored in my brain and easily a complete work of art is created without any effort to search for materials. People often say that painting is plastic art. By means of nature painting, the memories of forms are plentiful assets for creative works. Sometimes I visit art exhibits and if I see the paintings with rich formal variations, so I know this painter is experienced in drawing from nature, but if they are all very similar in composition, then I know this painter is not good at nature painting.

2. I invented the method of One Stroke Extension to do without sketching: It is said that practice makes perfect. If you are experienced and skillful in painting, you don't need to sketch before painting anything. For example, when you paint a street or market scene which requires a complex composition, you could save a lot of time without sketching. What is more important is that you would have run out of the pleasure in painting when you are done with detailed sketches. Even if you finish painting, you would not create a good work because you have already exhausted. To do without sketching is like calligraphy that you don't think too much when you use the brush and you act spontaneously, which is the true pleasure in painting.

I was once asked how I could have been so confident without sketching to paint such complex compositions. I thought and knew that I have matured to create a set of methods, which I call One Stroke Extension. It is hard to explain clearly in words this set of methods, which require illustrated step-by-step instruction or real-life demonstration. If the readers are interested, please consult my book, *From Pencil to Watercolor*, which contains instructional examples.

One day, I suddenly remembered that Shi Tao once mentioned about One Stroke Method in his book. I immediately took the book and carefully studied it. I found the One Stroke Method of Shi Tao is very similar to my method of One Stroke Extension. Later, I studied *The Complete Works of Wu Guanzhong* and discovered many pages of explaining Shi Tao's book. Wu Guanzhong mentioned that One Stroke Method is not a concrete painting technique but an abstract concept. Therefore, I once again studied Shi Tao's book but disagreed with Wu Guanzhong, because Shi Tao had used the word "method," so it must be a concrete technique, rather than an abstract concept! To use my method of One Stroke Extension to explain Shi Tao's One Stroke Method might make more sense.

For several decades, I have painted a lot and seen a lot. I divide the various painting styles into five categories as the following:

1. Surrealism: Photography is very realistic, but surrealist painters can create works far more subtle and lifelike than photos. A painting takes a week or months, which is marvelous. Recently, many youths in Taiwan have painted this way. *I think they might be interested or led by market. To be honest, I admire such paintings very much.* Yet, there is no way I could do it.

2. Simplified Realism: There is a quote by Qi Baishi which I admire, "The marvel of painting lies between resemblance and non-resemblance. Extreme resemblance is kitsch, but non-resemblance is cheating." There is also a good quote by Su Dongpo, "To judge painting by resemblance is a childish view." My opinion is that realism, even simplified, still needs to emphasize the basis. From the basis, variation, playfulness and aesthetic state could be attained. This is the category I belong to.

3. Transformation: Some people dislike traditional sketching by nature or are incapable of lifelike drawing. There are also people who are fed up with traditional painting and turn to transformation. Some become more beautiful, but some become unbeautiful. *The Scream*, a famous painting by the Expressionist master Edvard Munch (1863—1944) is the best example of this category, which is highly priced now. But I always think this painting is very bad.

4. Abstraction: It originally means there is no concrete form. Recently, I read about the explanation of abstraction by Wu Guanzhong who referred to it as "kite with an endless string." He said abstraction still reserves some traces of form, distinct from "formlessness." Presently in the painting world, there are a fairly large amount of works in such style. It is easier than realism and

praised as modernism, which could be quite popular in the market. So, why not do it?

5.**Formlessness:** It can also be called complete abstraction or non-representation. Wassily Kandinsky (1866-1944) should be the greatest painter of this kind. This category of painting focuses on the synthetic effect of point, line, plane, black-white-gray, rhythm, mass and spirituality. Some people admire such paintings very much, while some other people are baffled by them. They all have their sensible reasons, so there should not be any judgment.

After painting watercolors for so many years, I have also divided watercolors into two categories:

1.**To create excellent effects with special techniques:** The techniques I refer to are various methods besides paint brushes, such as spray of salt grains, application of white glue, use of terra alba, tape, scraping, rubbing, grinding and printing. The effects made by special techniques are very attractive and admirable. Yet it depends on individual tendency and interest: some never get tired of it, but some find it too troublesome and technical. It is hard to form a consensus.

2.**To show the actual capability only by paint brushes:** These painters work with only a few brushes, and they are highly versatile in mastery. Like calligraphy, every stroke matters, featuring brushwork, strength, touch and style. My way of painting seems to belong to this category.

The following are some of my shallow experiences:

Let me elaborate on my art tools. In my youth, I have used all brands of pigments, such as Osama, Liberty, Dragon, Sakura and Newton. Finally, I have stuck to the Japanese brand Holbein for 30 years. Its pigments are excellent in color saturation and transparency, and also fade-resistant. However, without any idea of what color mixture, certain small color spots would be generated after some time, which are not harmful to the painting and could be deemed as a special effect. So I never mind it. All my paint brushes are Holbein and I use paper of Arches. In recent years, I have often painted large-size watercolors. Arches provides rolls of paper, 30 feet long and 4 feet wide, which could be cut to use easily.

It is difficult to learn watercolor, which is commonly agreed by most painters. In my early years, I had struggled for a long time and consulted many foreign albums. I have truly enjoyed the fun of painting watercolors only when I have mastered it.

Generally people emphasize more on the application of colors, such as boldness, creativity and variations. This is important, but I consider it to be more important to master the value, or brightness, which means proper mixture of black, white and gray. For example, red flowers and green leaves both have high hues, but are very close in value. In watercolors, the value should be intensified by deepening one and reducing the other in order to create a bright picture without seeming dim or pale.

It is a necessary technique in watercolor to leave white space. Some people fill it with white powder but it would blur the picture, unsuitable for the clarity and neatness of watercolors. My method is to draw only the shadowy part with dry brushes in the white space as its mark, and then carefully create the white space by drawing the outlines and masses. A painting definitely looks good visually if it has left proper white space and ensured a perfect proportion of whiteness.

The beginners in painting are always overcautious. A cautious painting loses its flavor of spontaneity. It is said that mastery makes boldness and practice makes perfect, which should be a good way to eliminate overcaution.

The realist painters also require some abstract ideas. For instance, the place irrelevant to the subject can be dim, or a rough brushstroke fills the unimportant part, which not only saves the effort but also makes it look good.

Ma Baishui once said that the painting of watercolors requires water and color. It certainly looks bad for a watercolor to be too dry, losing the feel of moisture. It needs certain fluidity to manifest the feature of watercolor. In the studio, a good way is to soak the paper in water in advance. In the outdoors, the paper needs to be brushed completely or partially with water. But it still takes experiences to truly master it.

In watercolors, overlapping is easy but interlacing is the most difficult. For example, a stack of weeds are formed by joined stems and leaves. The surrealist painters would carefully depict it in details and accuracy, but the simplified realists would represent the interlaced layering of stems and leaves and the manner of weeds in an abstract way. It is not only skillful but also ingenious. I often think this kind of spiritual dexterity is true art

Finally, I like to say that it is so much fun to paint freely and masterly.

水社

水社好像日月潭的門戶，到日月潭玩的人，大半先到水社。

水社有一個很大的遊艇碼頭，遊湖的人都在這裡買票乘船。

湖畔有商店街，名為名勝巷，有高級飯店、一般民宿、藝品店、餐館、咖啡廳、冷飲店、點心舖等，晚上人多，生意都很好。

碼頭邊有一處景點名為梅荷園，視野很好，經常遊客滿園。

Shuishe

Shuishe is like the doorway for Sun Moon Lake. Most tourists that visit Sun Moon Lake would stop by Shuishe first. There is a very large yacht pier where visitors would purchase the tickets for a boat ride. There are shopping streets along the shore, called Sightseeing Lane, comprising high-end hotels, ordinary B&B, souvenir shops, restaurants, cafes, beverage stores, snack shops, etc. The business is flourishing at night when there are big crowds. There is a scenic spot near the pier, named Plum Lotus Garden, which is usually packed with sightseers because of its fantastic views.

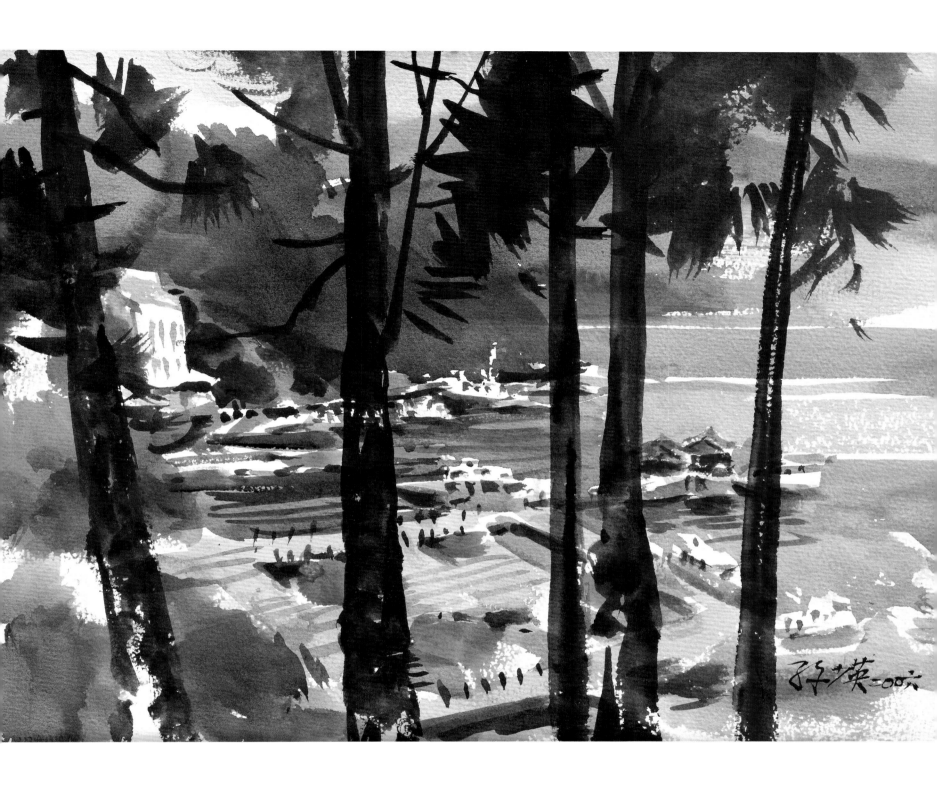

從樹間看水社碼頭

Shuishe Pier Scenery from the Woods

28.5×39cm 2006

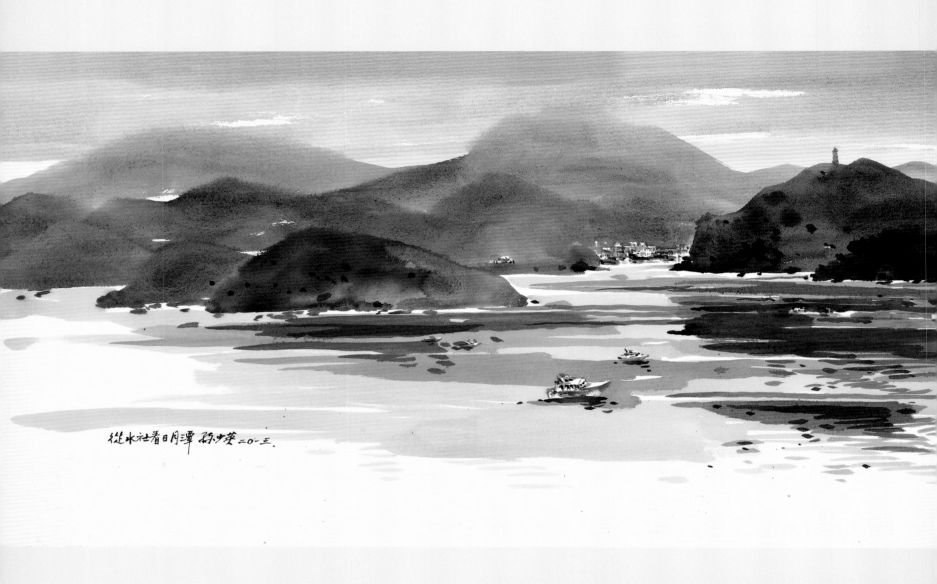

水社湖面

Lake Scenery at Shuishe

56.5×224cm 2013

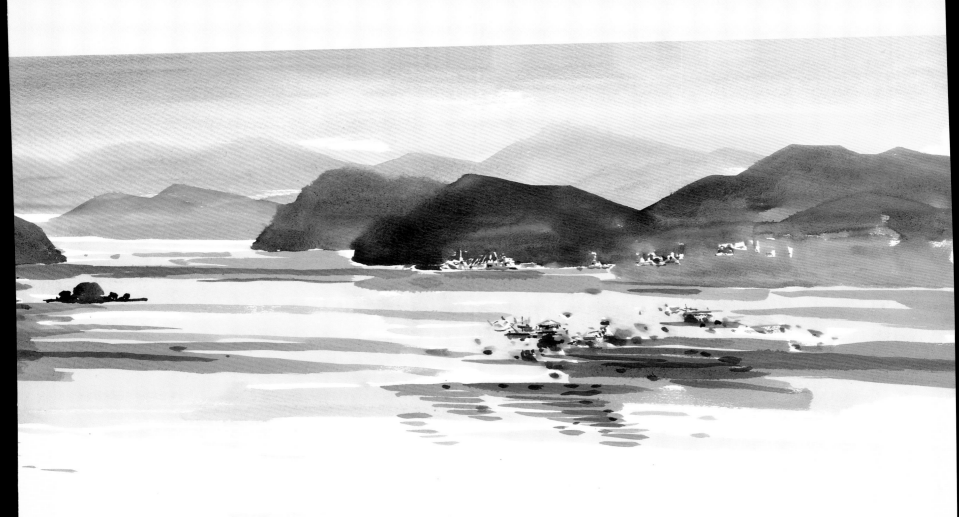

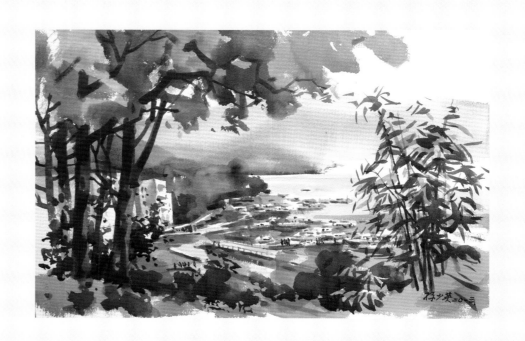

水社碼頭側面

Flank View of the Shuishe Pier

39×57cm 2013

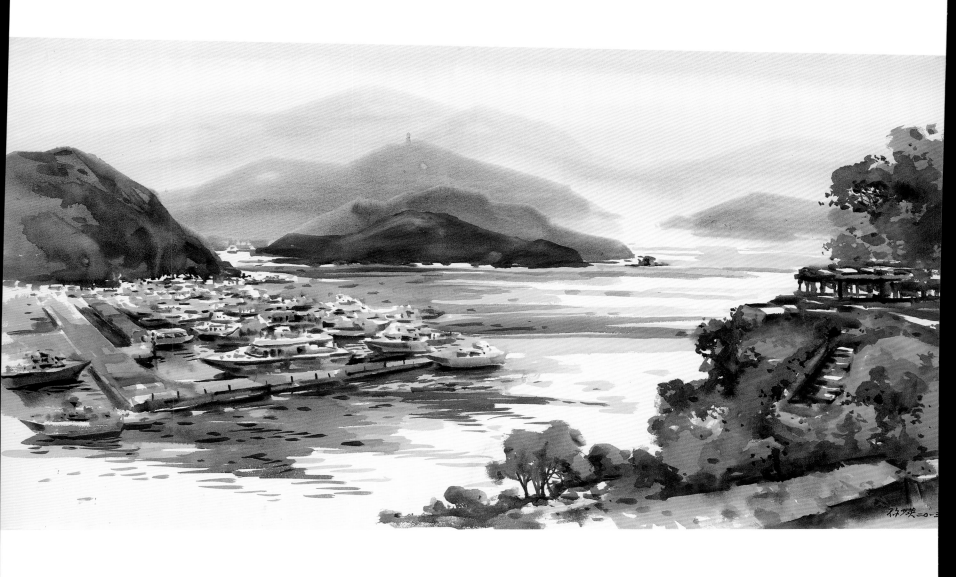

從梅荷園看水社碼頭

View of Shuishe Pier From the Meihe Park

76×148.5cm 2013

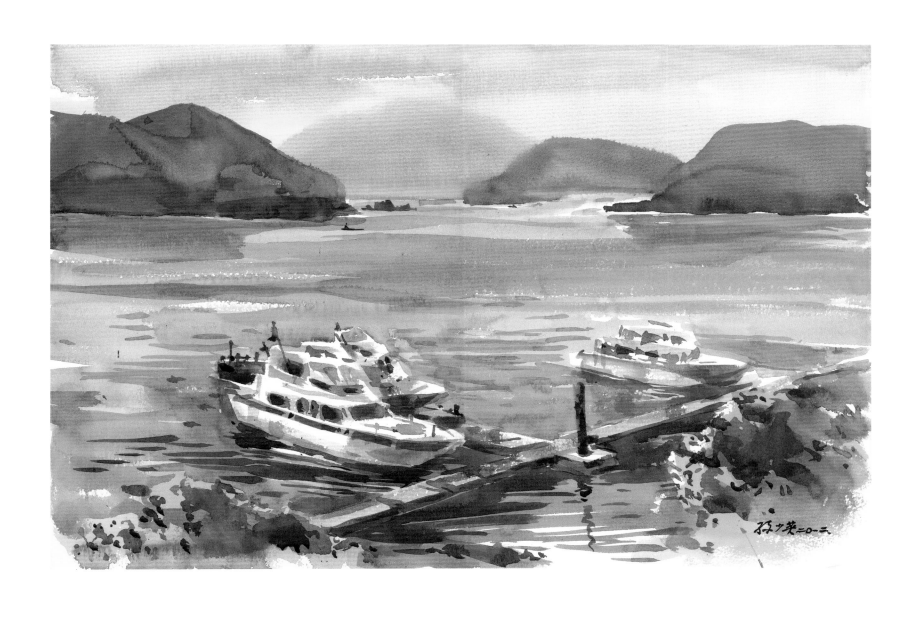

水社碼頭一角

A corner at Shuishe

39×57cm 2012

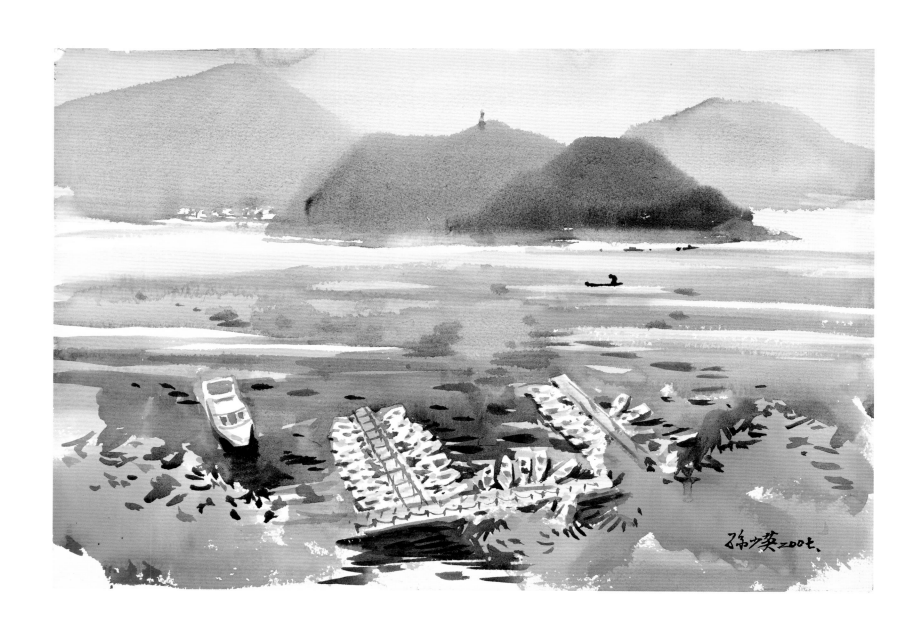

大淶閣景觀（一）

View of Hotel Del Lago

39×57cm　2007

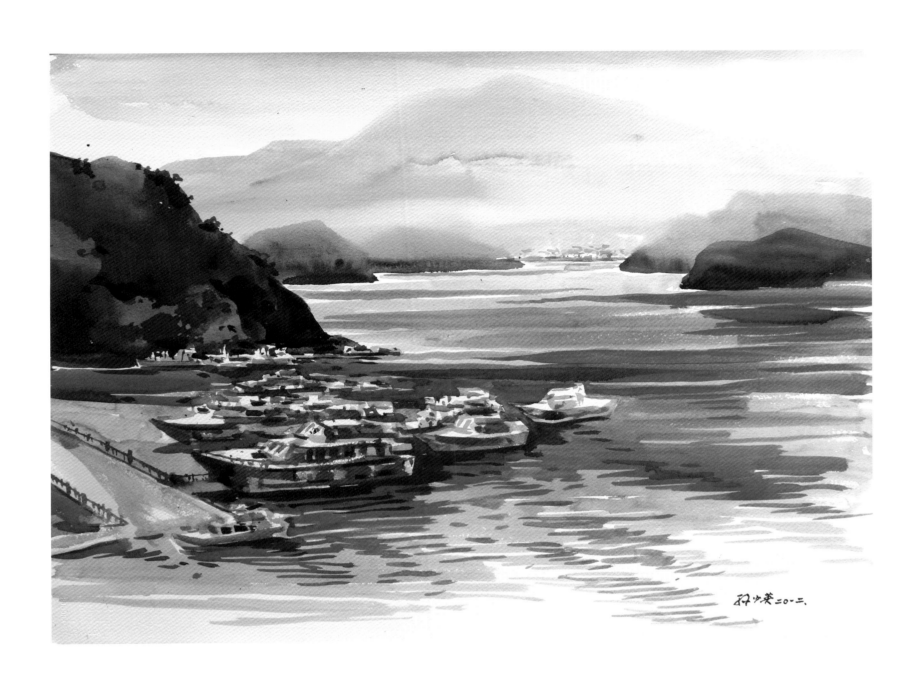

大淶閣景觀（二）

View of Hotel Del Lago

57×78cm 2012

萬人泳渡（一）

Ten-Thounsand Swimmers Crossing Sun Moon Lake

79×110cm　2013

萬人泳渡（二）

Ten-Thounsand Swimmers Crossing Sun Moon Lake

79×110cm 2013

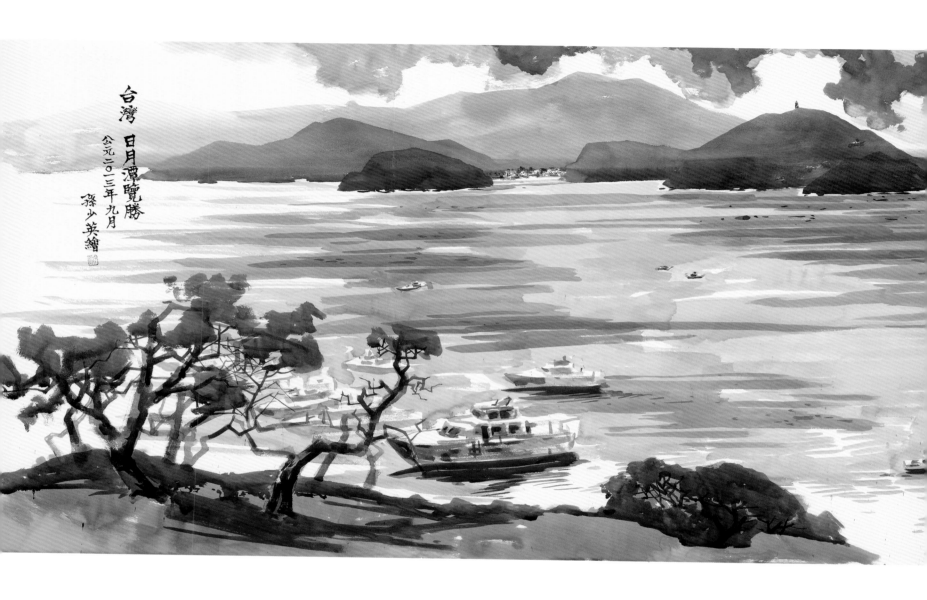

台灣　日月潭覽勝
公元二○一三年九月
孫少英繪

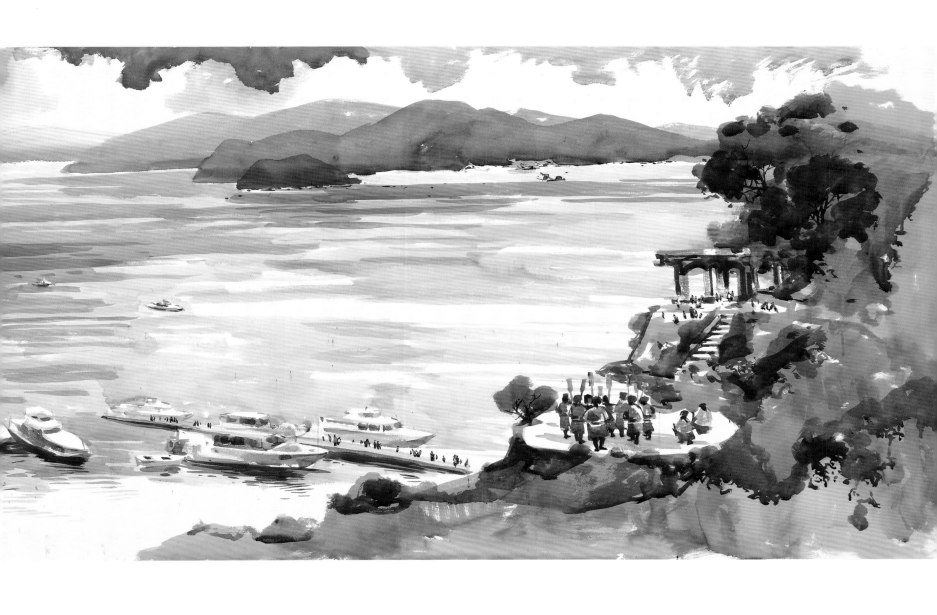

日月潭覽勝

Beautiful Scenic Spot of Sun Moon Lake

120×420cm 2013 現收藏於北京

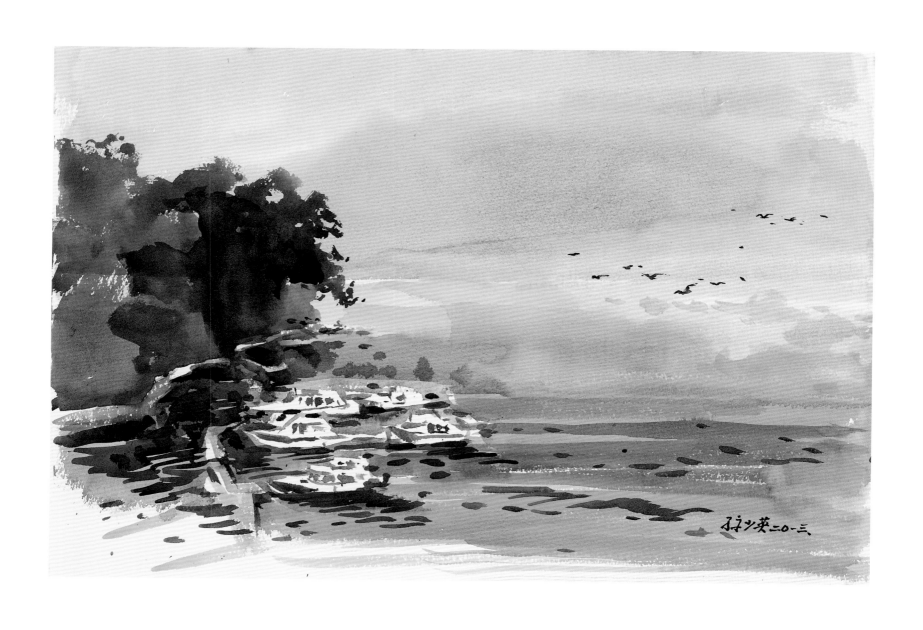

鴻濱景觀（一）

View of Apollo Resort Hotel

39×57cm 2013

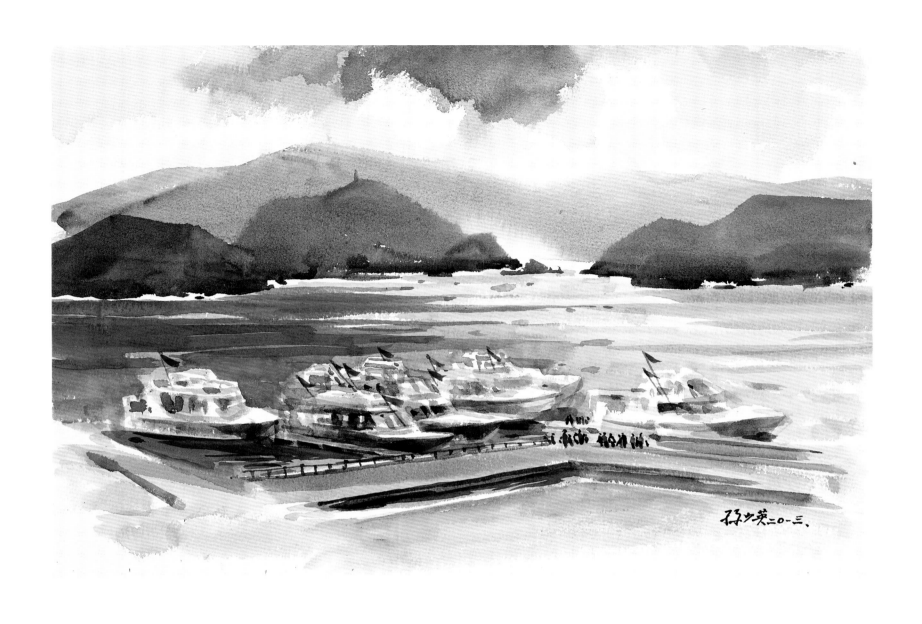

鴻濱景觀（二）

View of Apollo Resort Hotel

39×57cm 2013

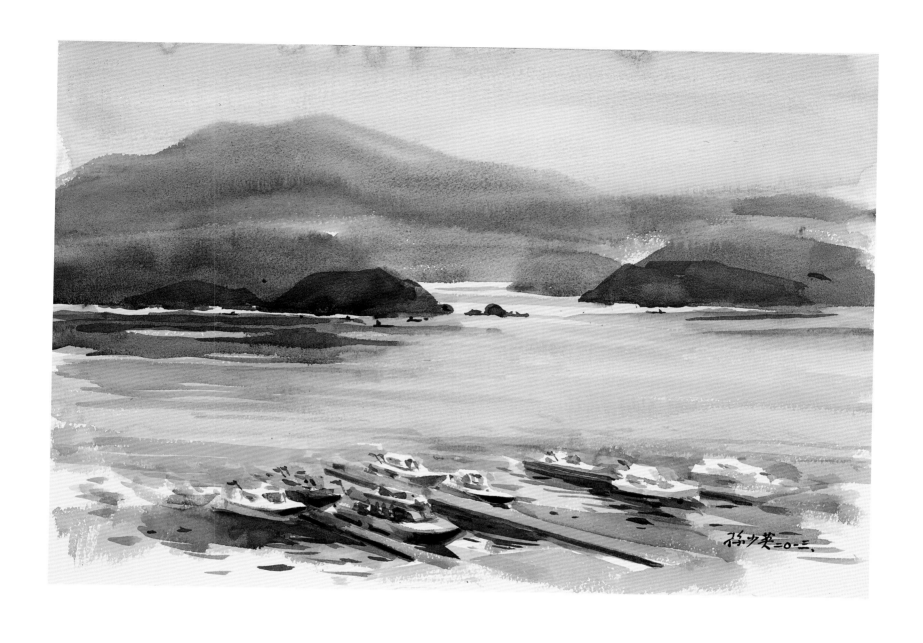

鴻濱景觀（三）

View of Apollo Resort Hotel

39×57cm 2013

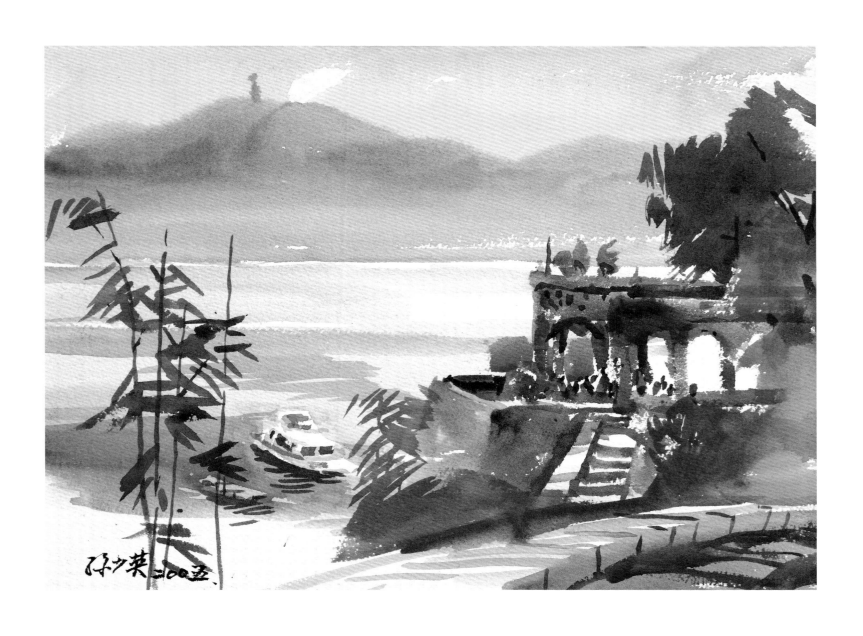

梅荷園

Meihe Park

28.5×39cm 2005

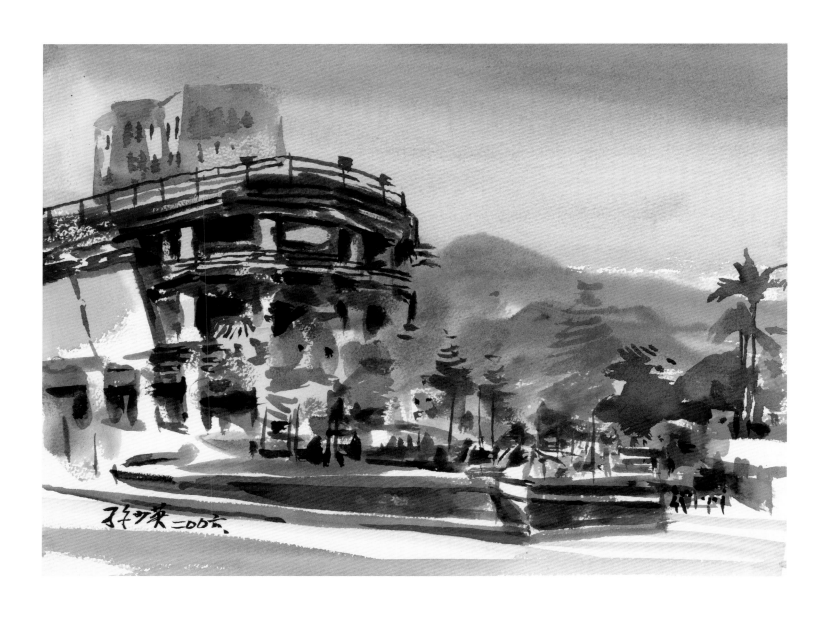

水社遊客中心

Shuishe Visitor Center

28.5×39cm 2006

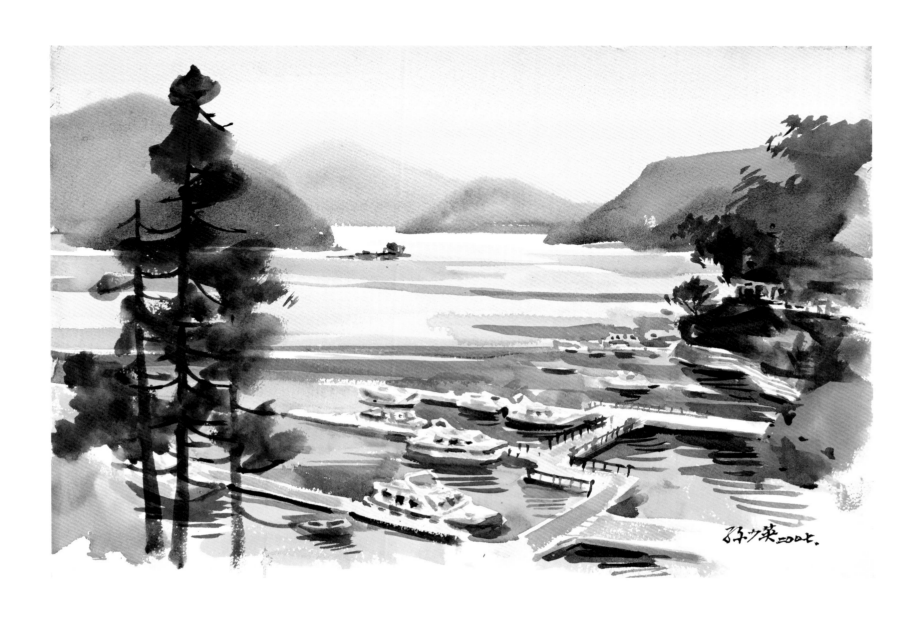

水社碼頭俯瞰

Bird's-eye View of the Shuishe Pier

39×57cm 2007

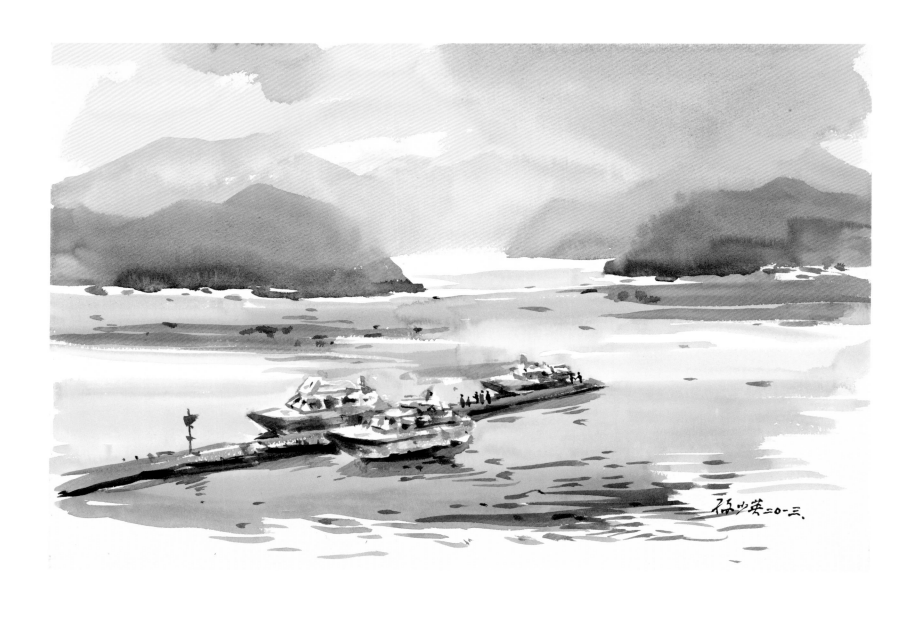

碼頭分支

A Branch of the Shuishe Pier

39×57cm 2013

岸上土地公廟

Earth God Temple on shore

39×57cm　2013

水社俯瞰

Bird's-eye View of Shuishe

38×148.5cm 2013

SPA Home景觀

View of the SPA Home

39×57cm 2013

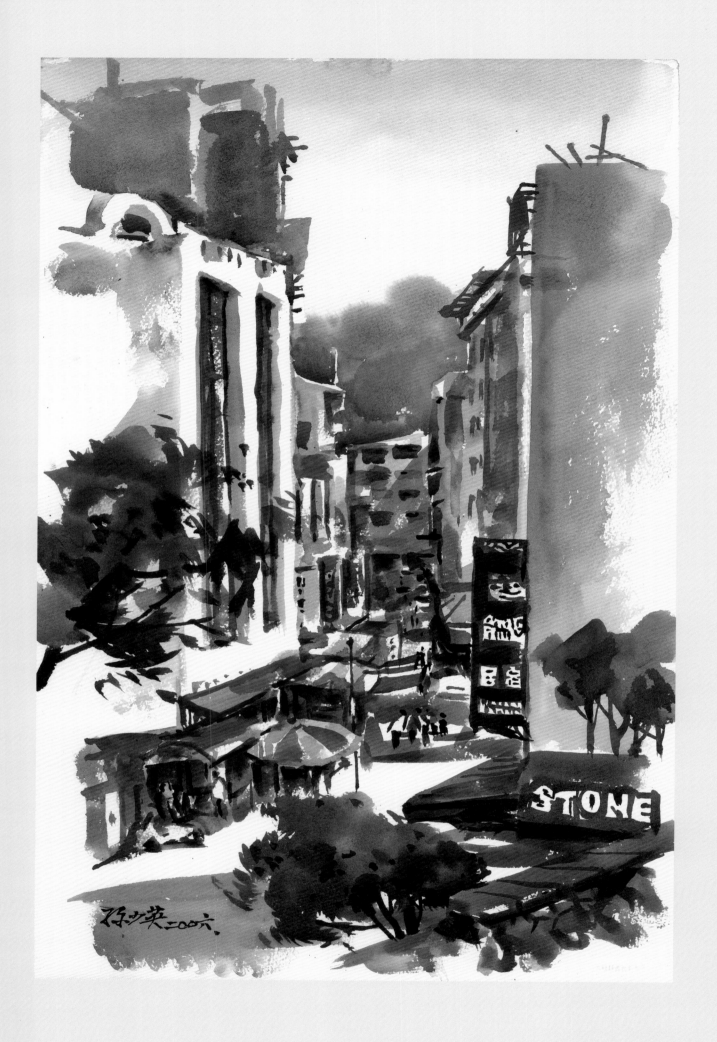

水社名勝巷

Sightseeing Lane at Shuishe

57×39cm 2006

紅薯餅店
Red Sweet Potato Shop
39×57cm 2013

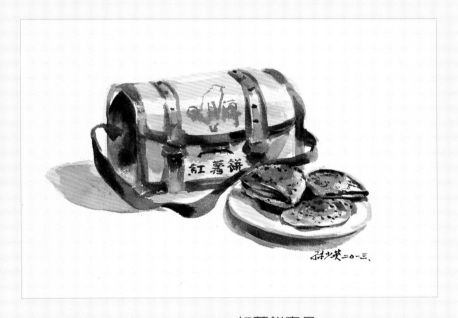

紅薯餅產品
Special Local Product – Red Sweet Potato
28.5×39cm 2013

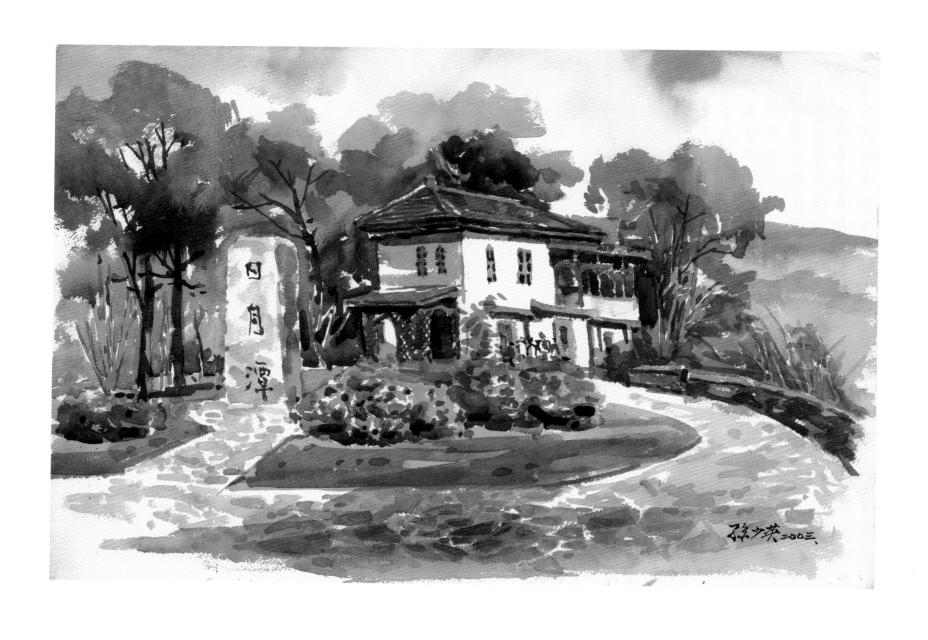

五星級廁所（現已改建為商店）

Five-star Toilet (a shop Now)

39×57cm 2003

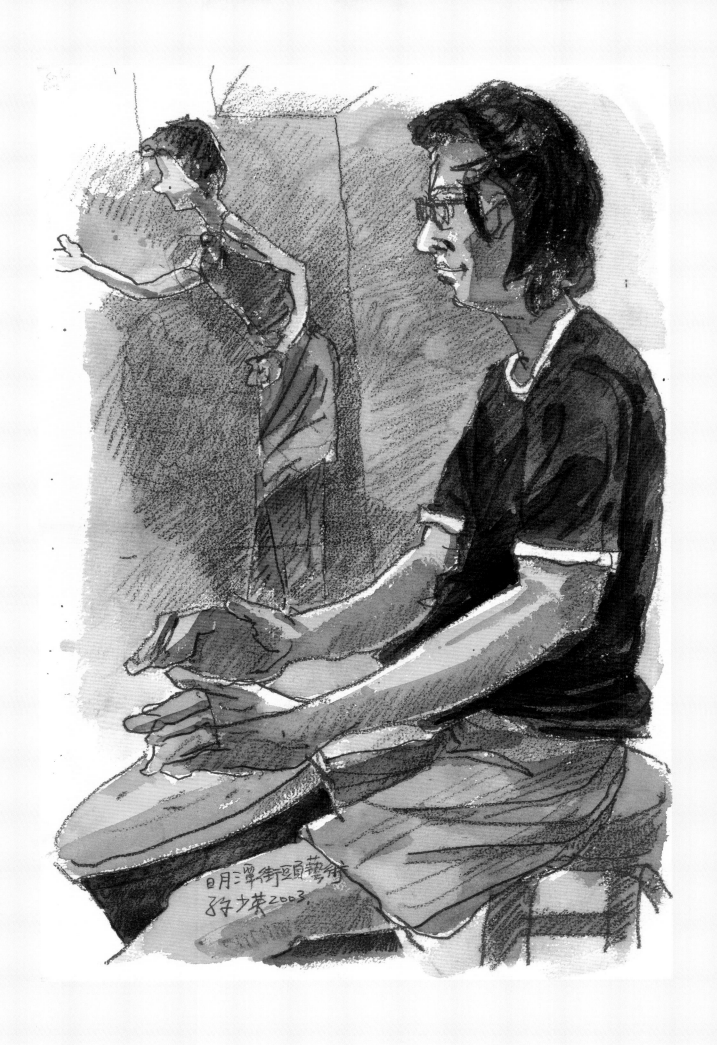

街頭藝人洪英沛表演手鼓

Show of Street Performer Yung-pei Hong
57×39cm 2003

梅荷園湖面

Lake Scenery of the Meihe Park

28.5×78cm 2012

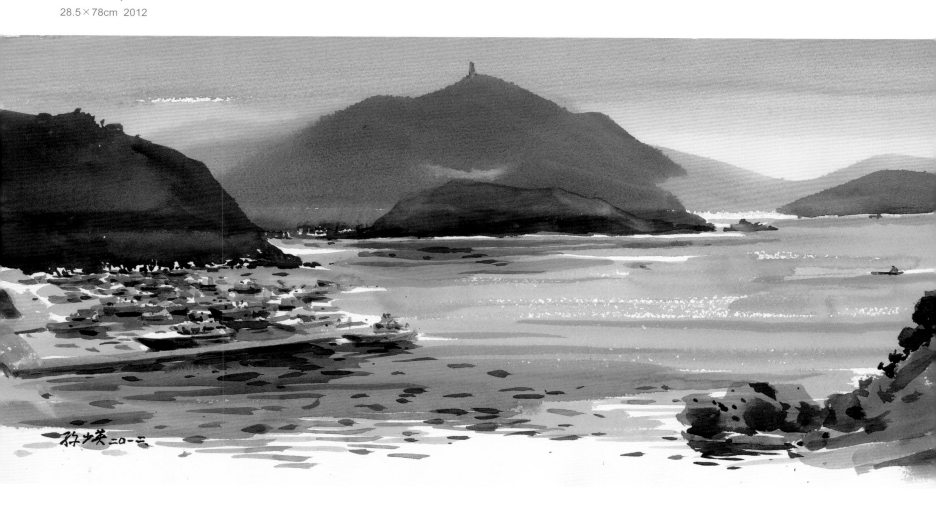

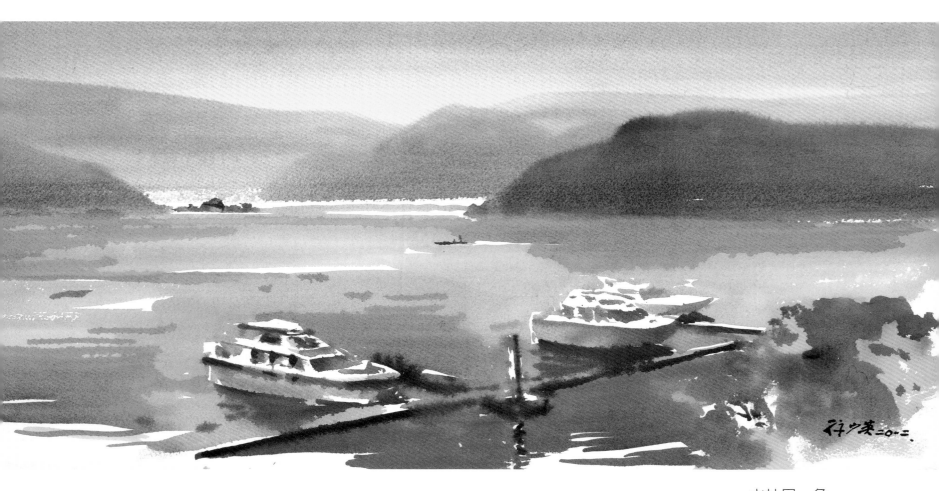

水社另一角
Another Corner at Shuishe
28.5×78cm 2012

水社清晨

Morning at Shuishe

57×114cm 2009

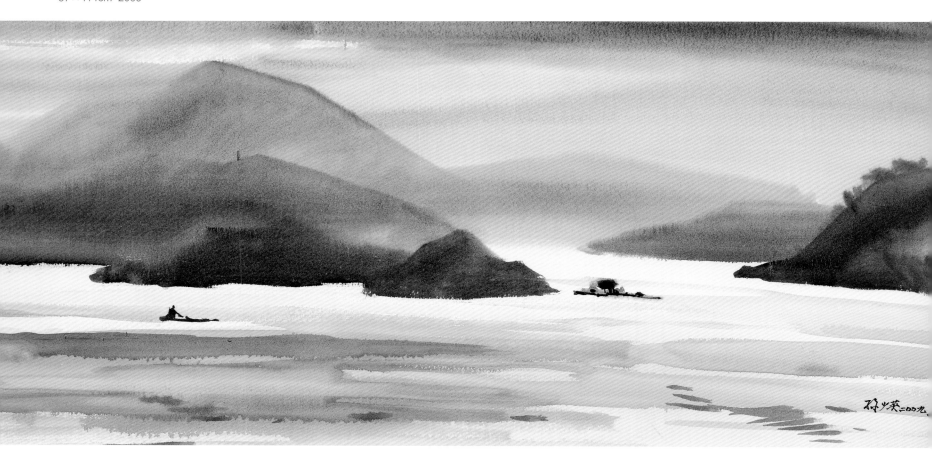

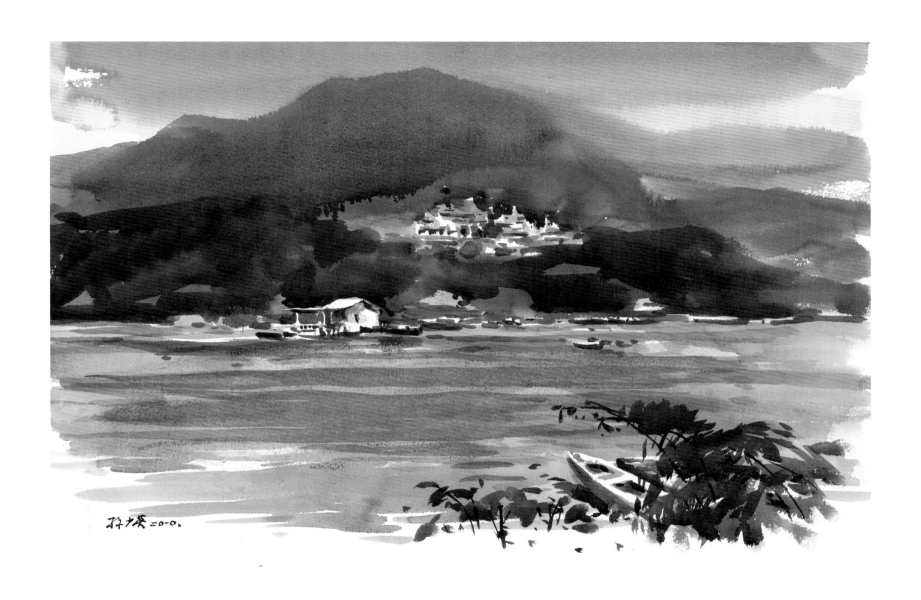

龍鳳廟遠眺

Distant View of the Longfeng Temple

39×57cm　2010

涵碧半島

涵碧半島上有三個大飯店：涵碧樓、日月行館、教師會館。湖畔有涵碧步道和專屬碼頭。早年，蔣公來日月潭渡假都是住涵碧樓，現在涵碧樓由鄉林集團經營，已擴大重建，但仍維持蔣公紀念館及蔣公觀景亭，使遊客賞景玩樂之餘，還有一個懷古念舊的空間。

Hanbi Peninsula

There are three big hotels on Hanbi Peninsula: Lalu, Wen Wan Resort and Teachers' Hostel. On the lakeshore are Hanbi Hiking Trail and a reserved pier. In early years, Late President Chiang Kai-shek had used to stay at Lalu Hotel when he spent holidays at Sun Moon Lake. The Lalu Hotel is now run by Shining Group, which has been extensively renovated, but still reserved Late President Chiang Kai-shek Memorial Hall and Observation Pavilion. So the visitors still have a nostalgic space for past memories besides pleasant scenic tours.

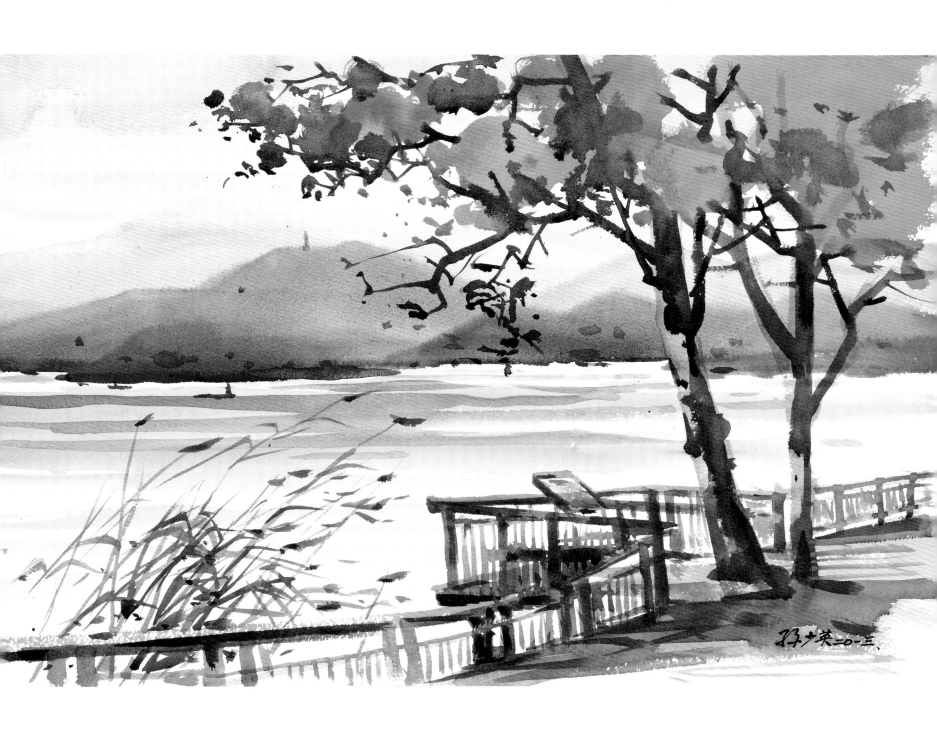

涵碧步道

Hanbi Hiking Trail

39×57cm 2013

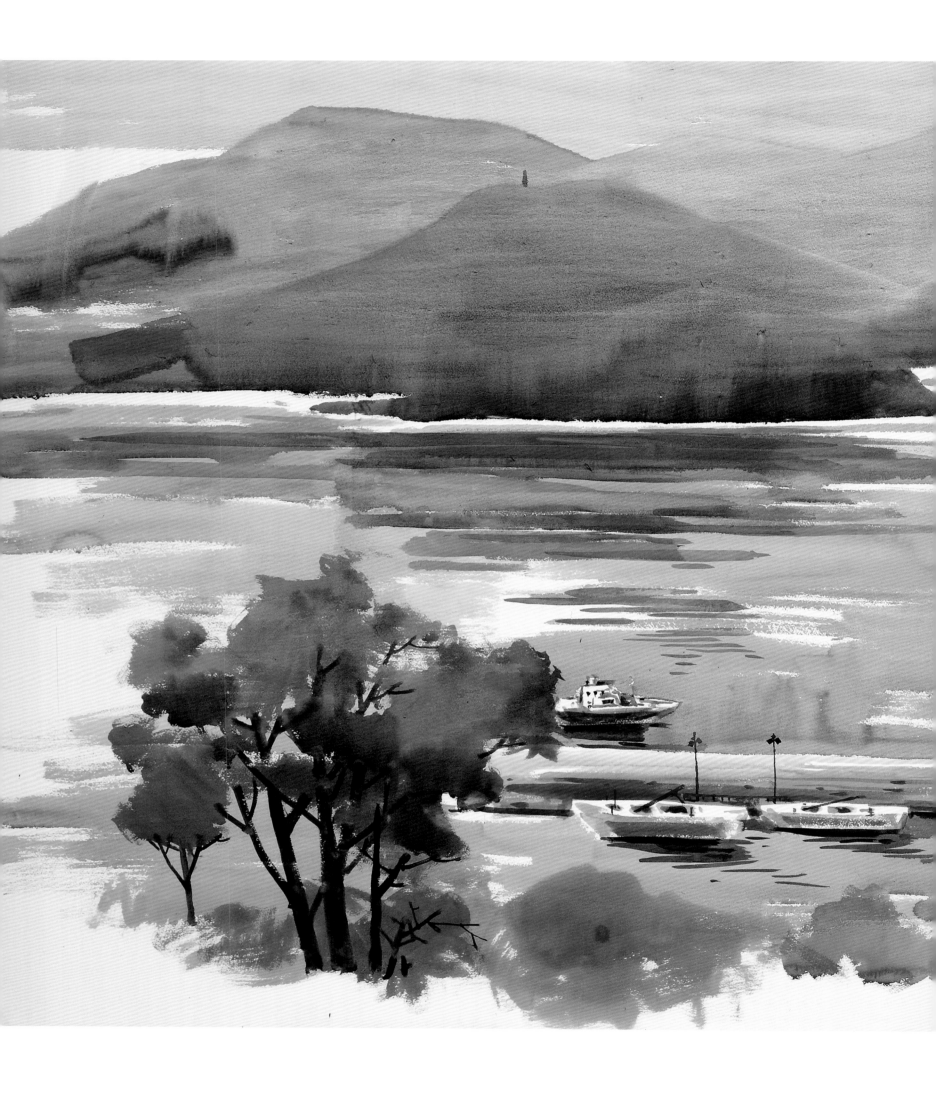

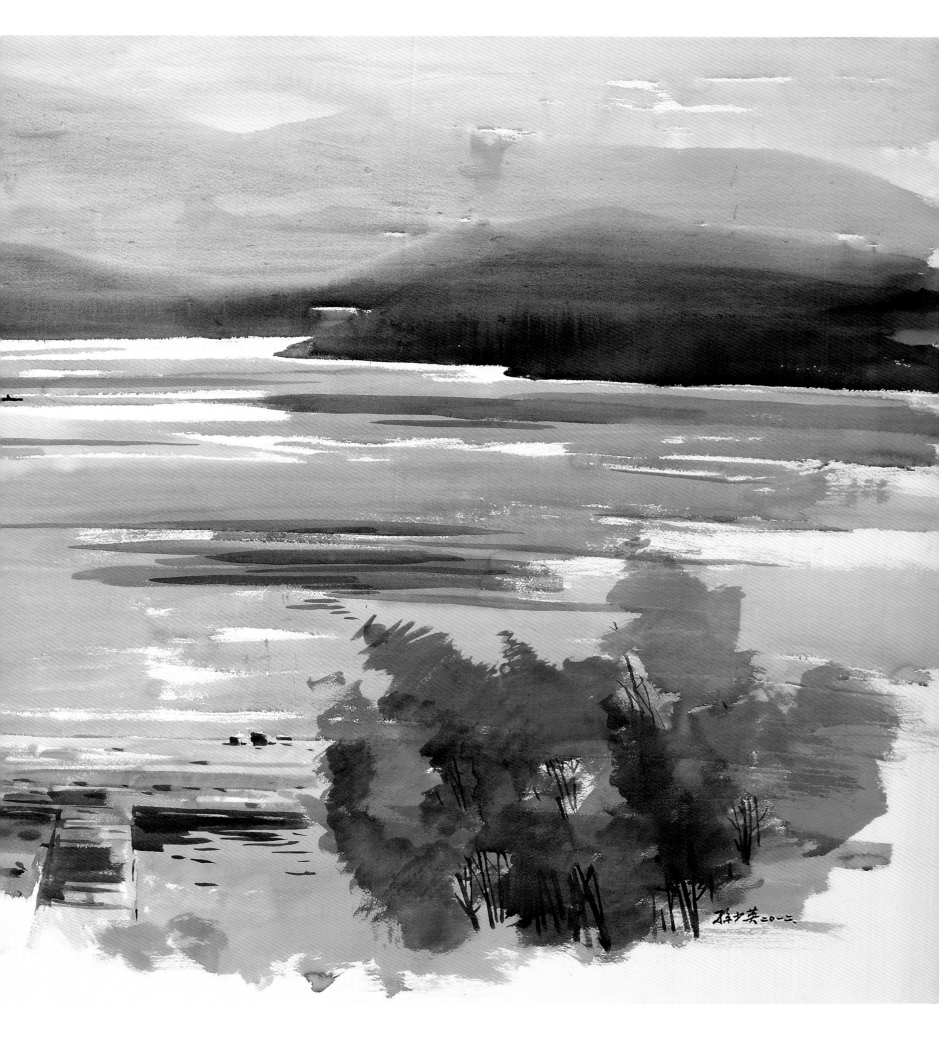

涵碧樓景觀
View of the Lalu Hotel
113×222cm 2012

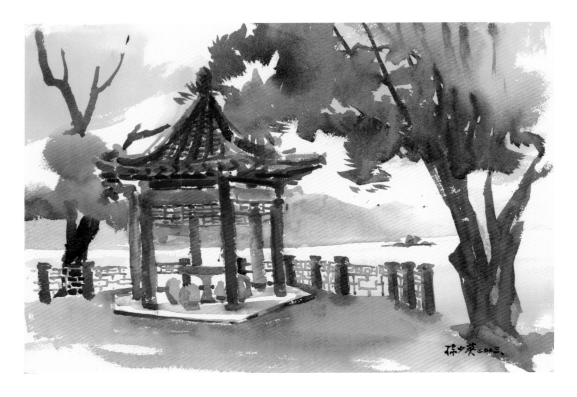

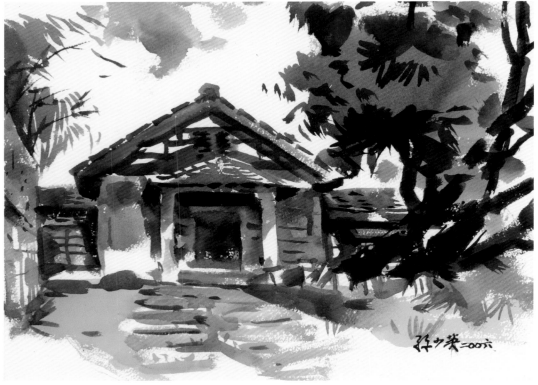

蔣公觀景亭

Late President Chiang Kai-shek Observation Pavilion

39×57cm　2003

蔣公紀念館

Late President Chiang Kai-shek Memorial Hall

28.5×39cm　2006

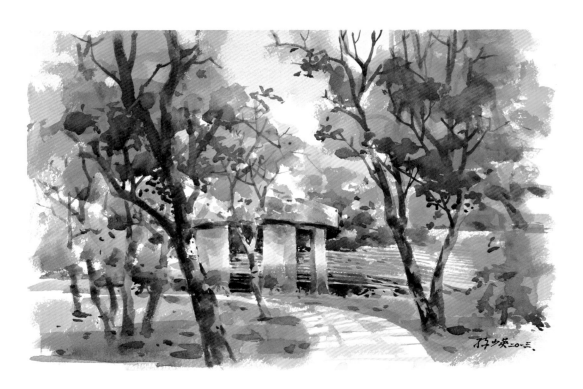

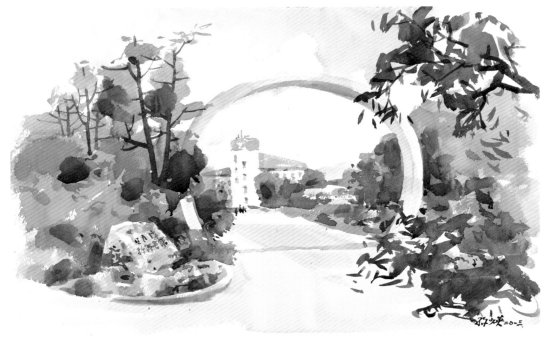

杏壇

Teacher's Place

39×57cm 2013

教師會館

Teachers' Hostel

39×57cm 2013

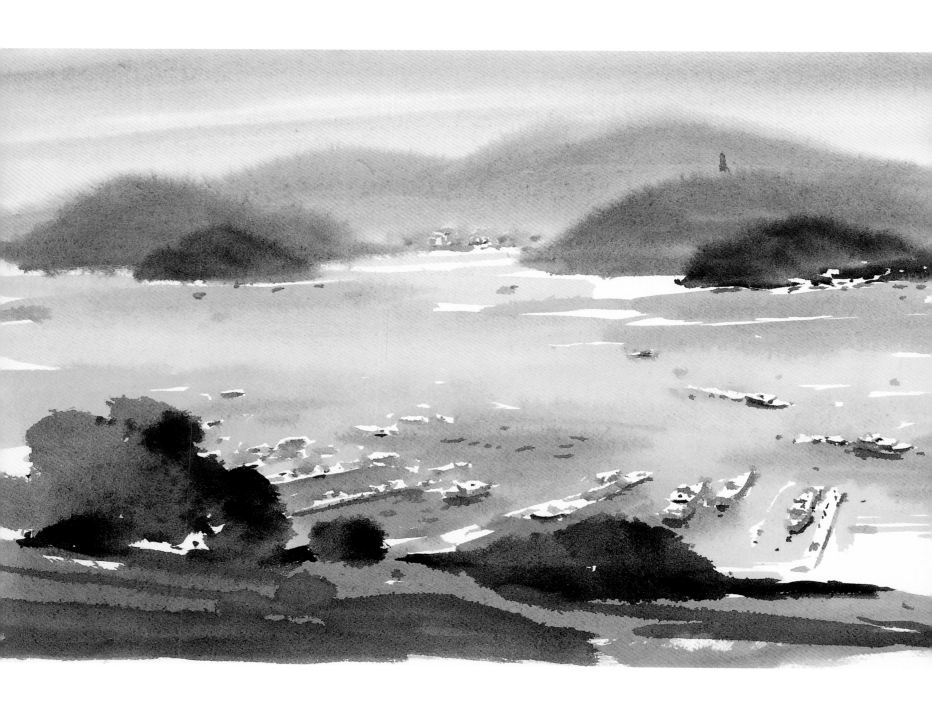

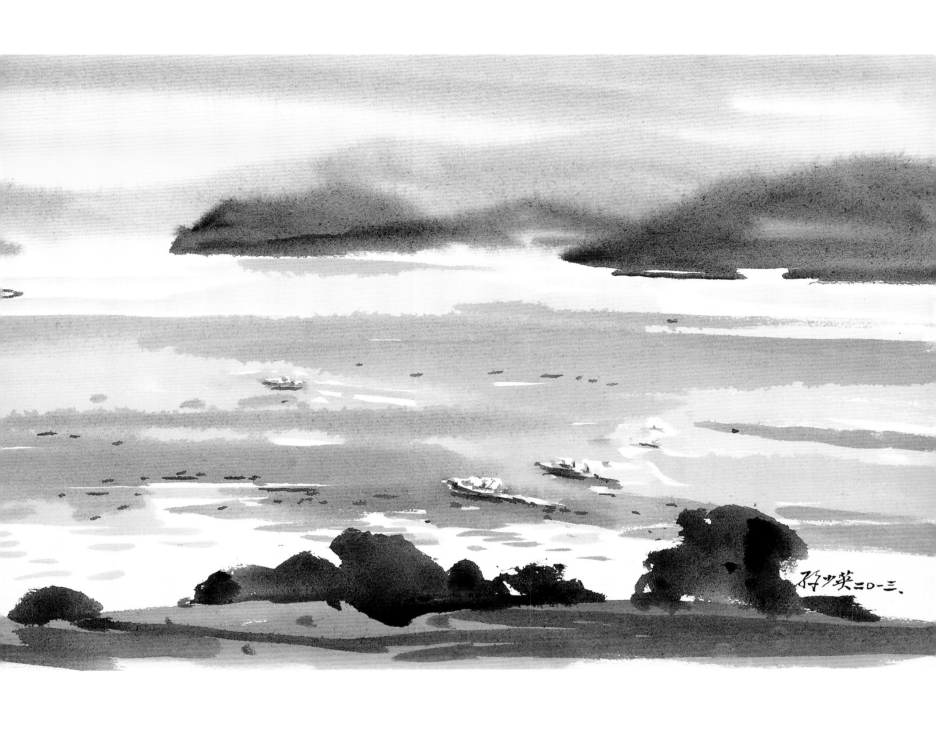

日月行館景觀

View of the Wen Wan Resort

37.5×114cm 2013

朝霧碼頭

朝霧因清早多霧而得名。

早期有小型碼頭，停靠舟船，隨著遊客增加，現已增建大型碼頭停靠遊艇，往來遊客眾多，僅次於水社碼頭。

每年萬人泳渡日月潭，都是以這裡為起點。施放煙火，也是以朝霧湖面為基地。

Chaowu Pier

Chaowu is named because of the foggy mornings. In the early years, there is a small pier to harbor boats. With the increase of visitors, it has been expanded into a large pier for yachts. The number of travelers here is second only to Shuishe Pier. Every year, the Sun Moon Lake Ten-Thousand Swimming Carnival chooses here as the starting point. The show of fireworks is also based on the lake surface of Chaowu.

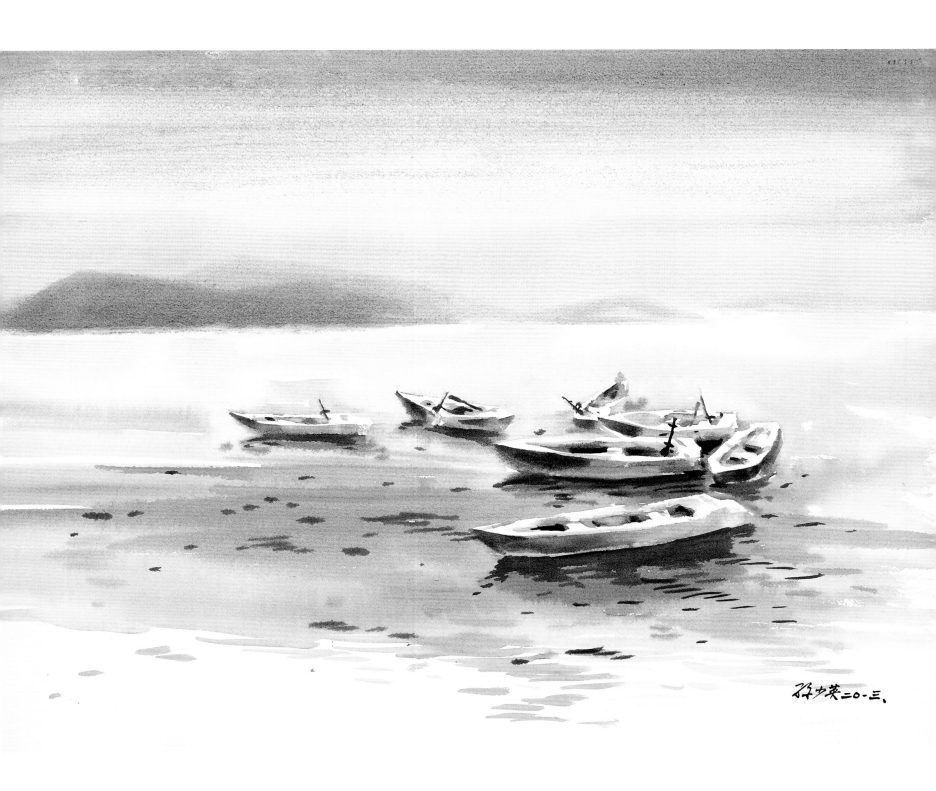

小舟群

Boats

57×78cm 2013

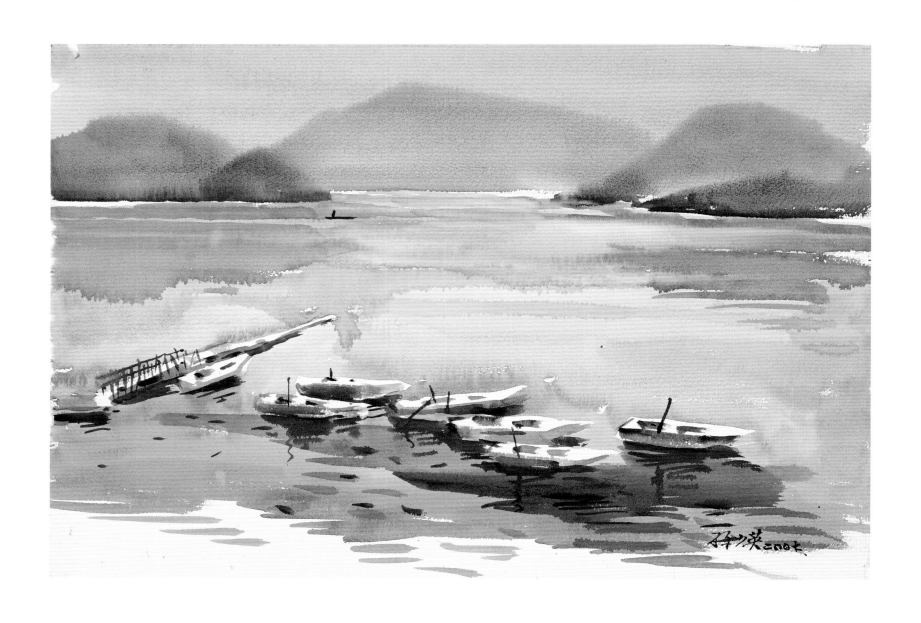

小型碼頭

Lovely Pier

39×57cm 2007

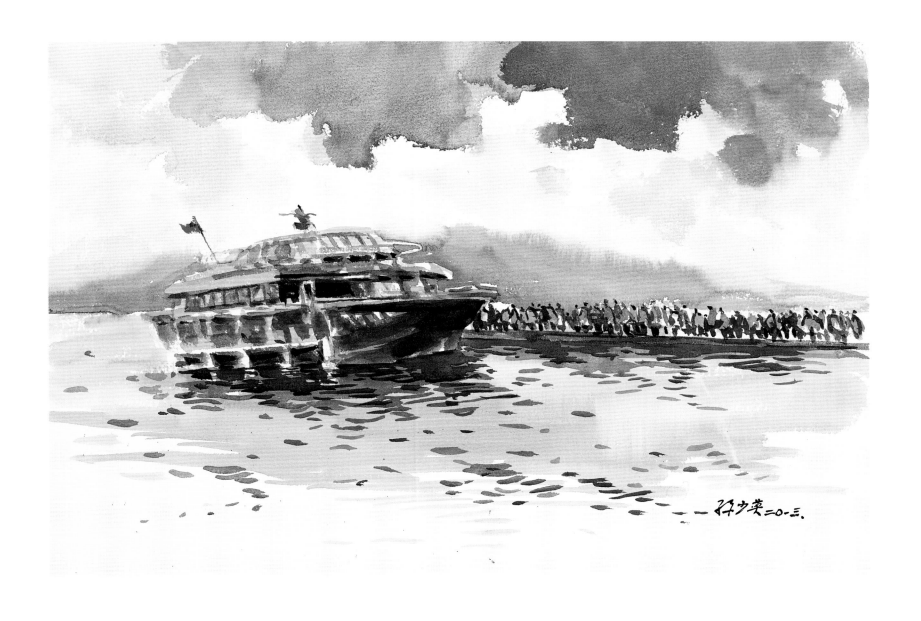

遊客排隊登船

Travelers in Line for Boarding

39×57cm 2013

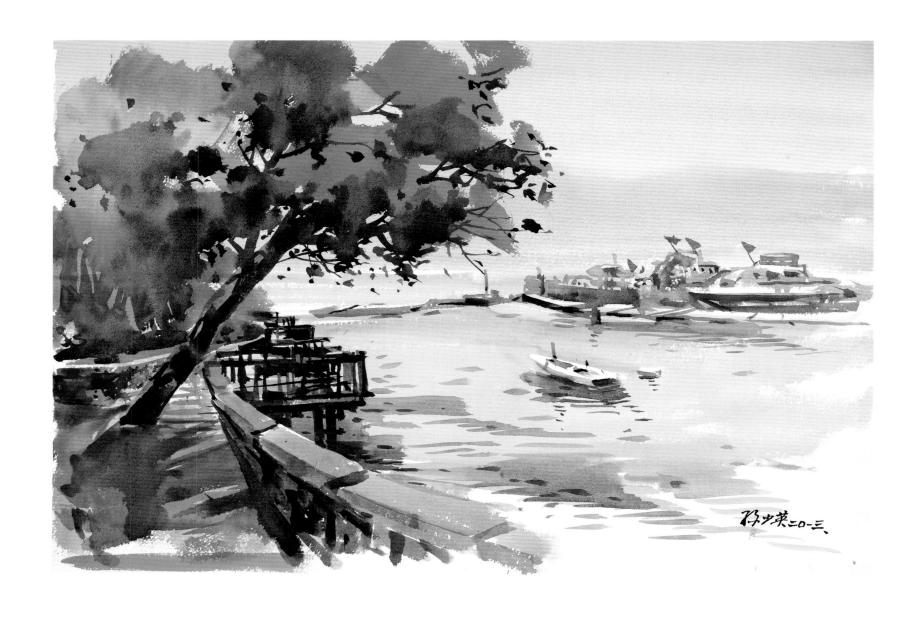

朝霧步道（一）

Chaowu Hiking Trail

39×57cm 2013

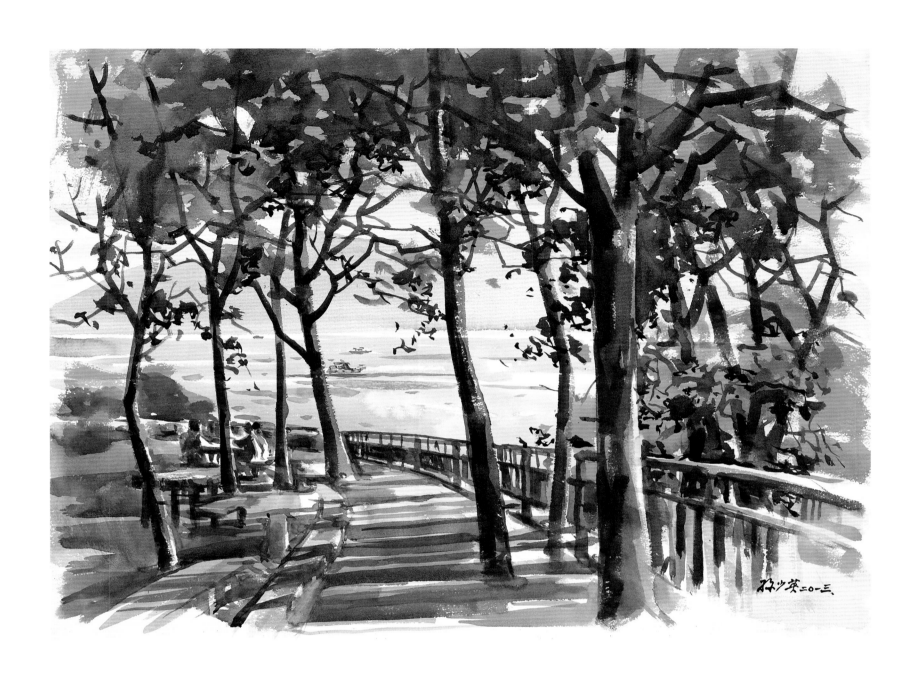

朝霧步道（二）

Chaowu Hiking Trail

57×78cm 2013

竹石園

竹石園因有雅石和修竹而得名。

園內有各種竹類石種，專人栽培維護。自古文人雅士多愛竹，鄭板橋專畫竹，蘇東坡喜畫朱竹，園內有一種紫紅色的竹子，非常可愛。坐在竹林的石凳上，從竹間透視湖景，常是攝影和寫生的愛好者，最喜歡的景色。

Bamboo Rock Park

The Bamboo Rock Park is named because of its refined rocks and trimmed bamboos. There are all sorts of bamboos and rocks, which are specially tended by experts. Since ancient times, most of the literati have favored bamboo. Zheng Banqiao specialized in painting bamboo, while Su Dongpo loved to paint red bamboo. In the park there is a kind of purple-red bamboo, which is very lovely. It is commonly the favorite scene for lovers of photography and painting outdoors to sit on the stone bench in the bamboo forest and see the lake through the foliage.

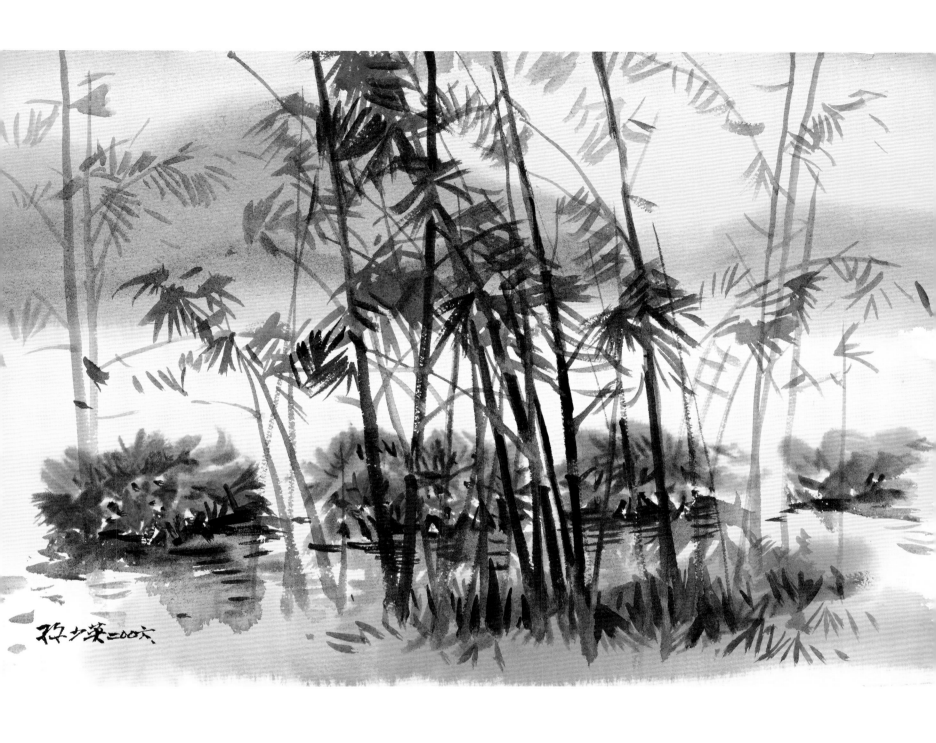

霧中賞竹

Bamboos in the Fog

39×57cm 2006

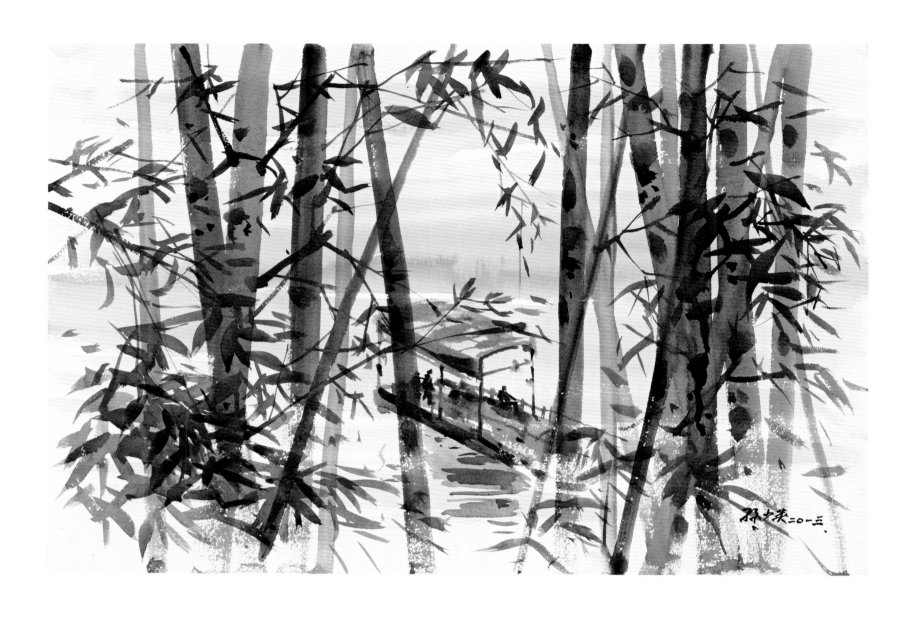

竹間漁舟

Fishing Boat Seen though the Bamboos

39×57cm 2013

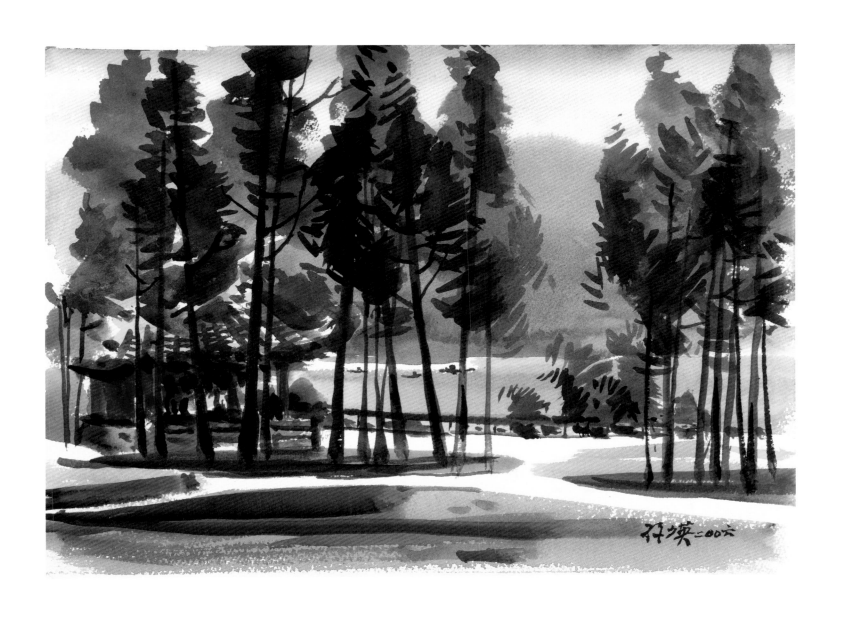

文武廟

文武廟主殿以供奉古聖先師孔子和武聖關公為主，另有其他神明分列其他殿堂。經年遊客眾多，香火鼎盛。

山門內左右兩座火紅色的巨大石獅，是已故企業家吳火獅所捐贈，火獅贈火獅，名實相應，世間美事。

山頂有廣大園區，老樹奇花，遊憩勝地。

廟產景聖樓，座落湖畔，景觀優美，常年旅客不斷。

Wunwu Temple

The main hall of Wunwu Temple worships Confucius, Great Sage and First Teacher, and Guan Yu, Saint of War. There are other deities residing in other halls. Numerous worshipers come to visit all year round and the burning of incense never ceases.

Two giant stone lions, as red as fire, sit on both sides of the main gate, which were donated by the late entrepreneur Wu Huo-shi, whose name means fire lion, so it became a beautiful anecdote.

There is a vast park at the peak where old trees and exotic flowers are flourishing, a famous tourist attraction.

The Jingsheng Building, a temple property, sits by the lakeshore, alluring visitors all year round with its beautiful scenery.

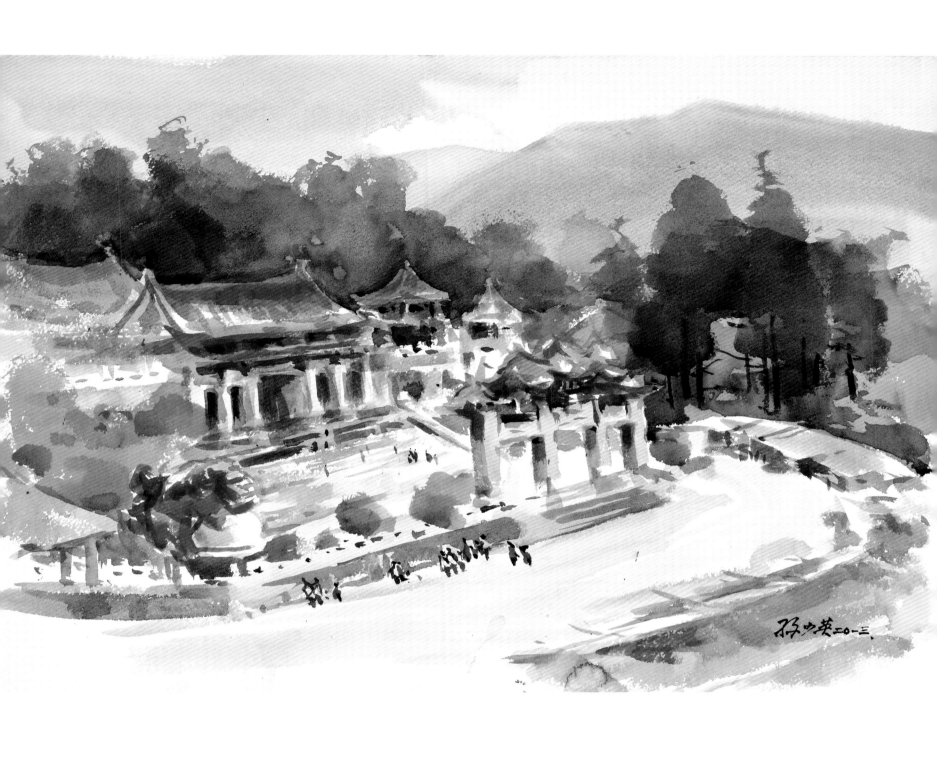

文武廟俯瞰（一）

Bird's-eye View of the Wunwu Temple

57×78cm 2013

文武廟俯瞰（二）

Bird's-eye View of the Wunwu Temple

39×57cm 2013

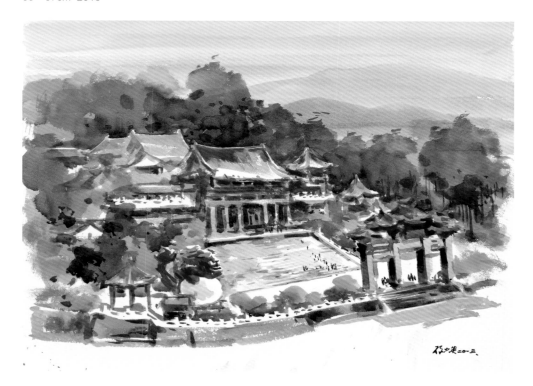

守門火獅

Gate-keeper Fire Lions

39×57cm 2003

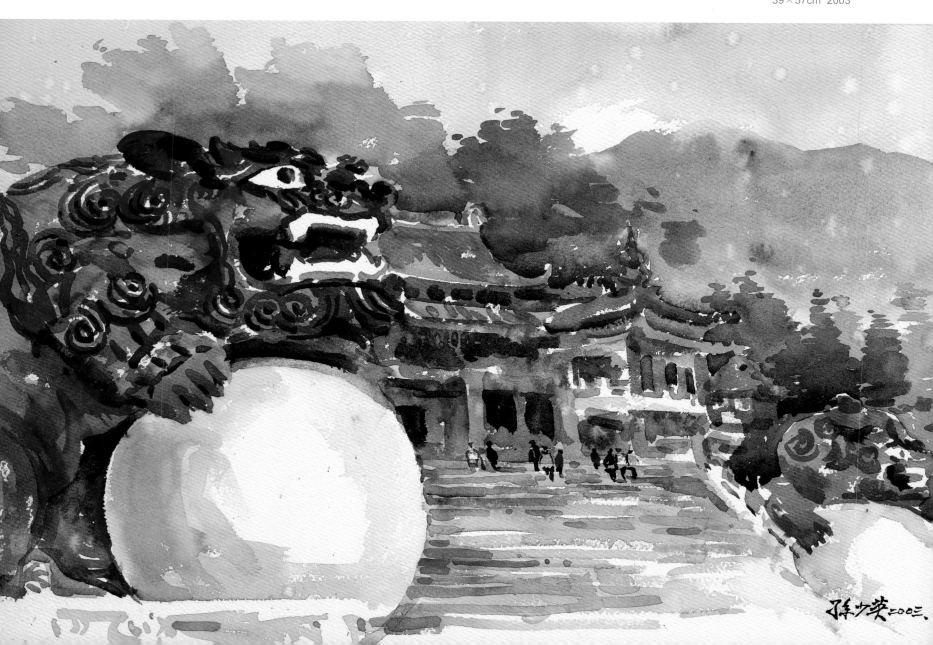

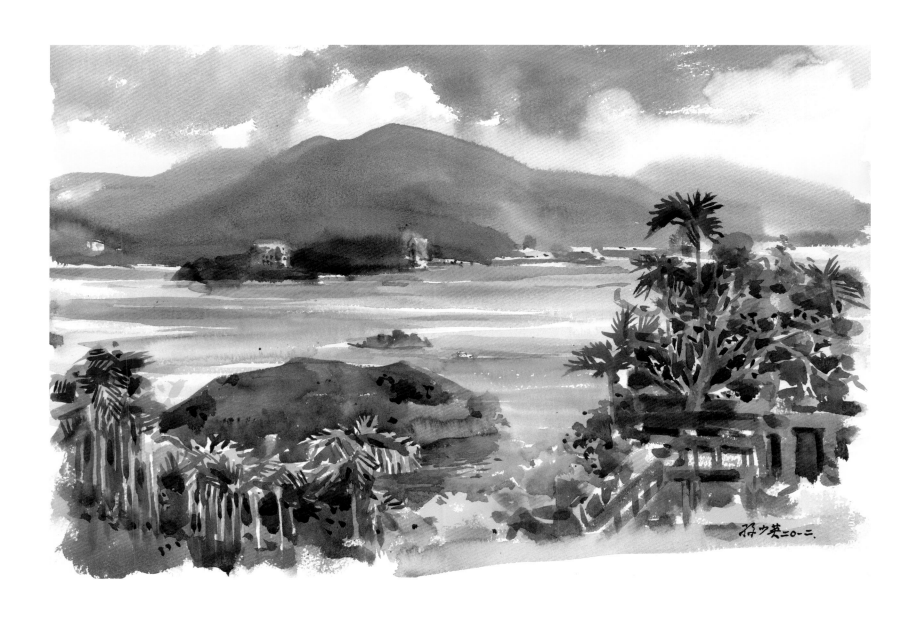

文武廟景觀（一）

View from the Wunwu Temple

39×57cm 2012

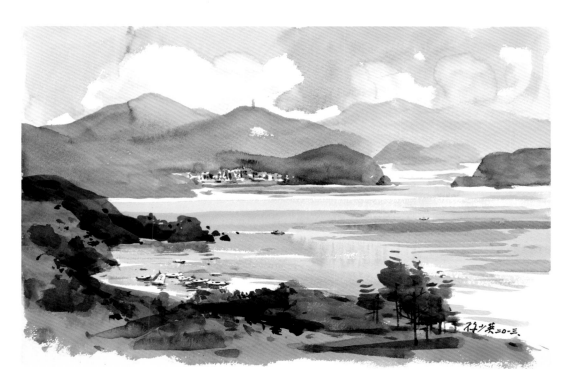

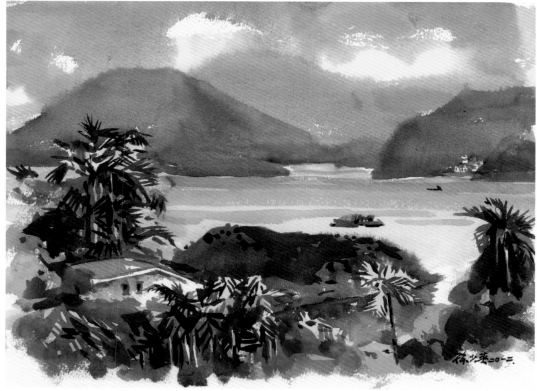

文武廟景觀（二）

View from the Wunwu Temple

39×57cm 2013

文武廟景觀（三）

View from the Wunwu Temple

39×57cm 2012

樹間看景聖樓

Jingsheng Building Scenery from the Woods

39×28.5cm 2006

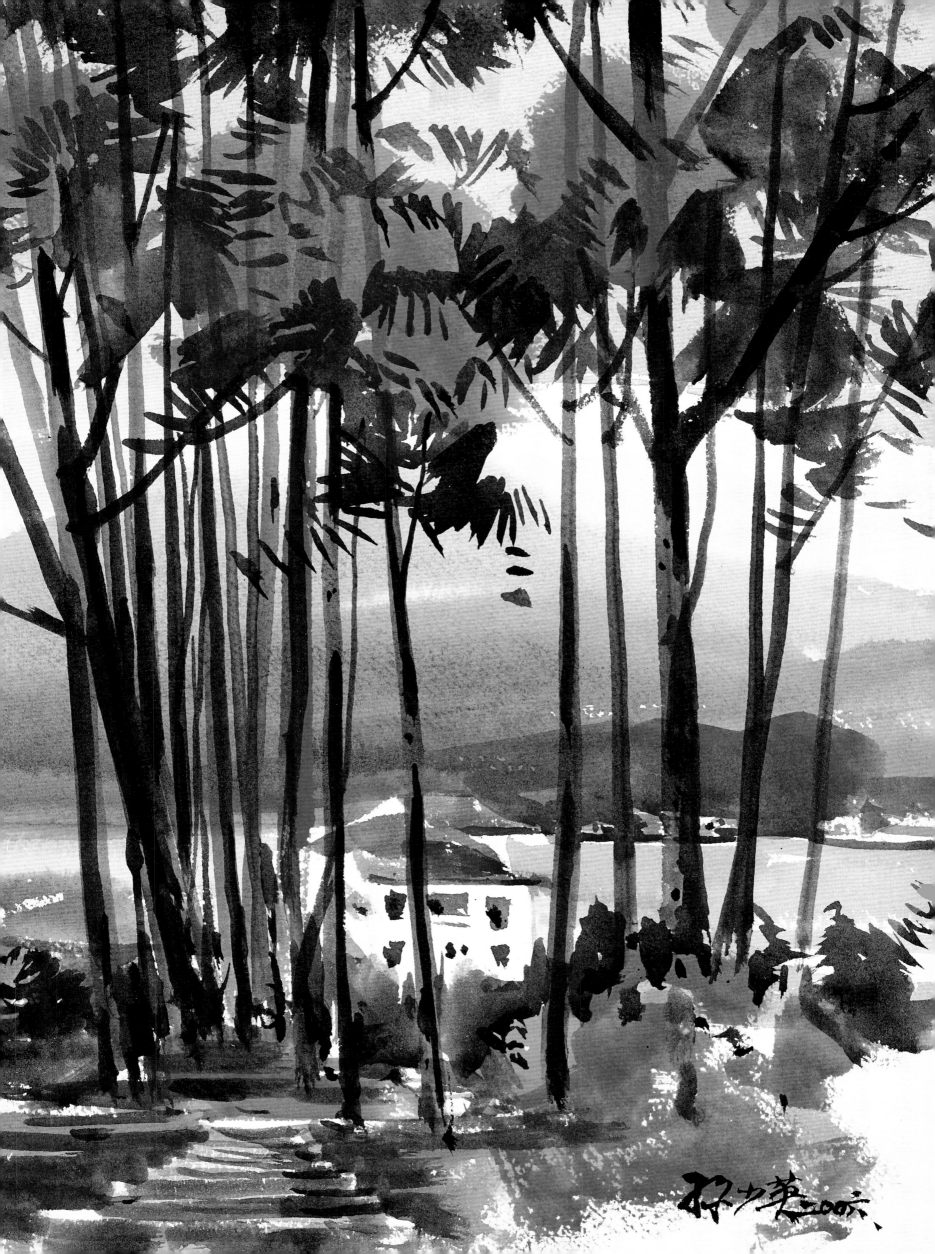

松柏崙

松柏崙是一個小型半島，有步道延向終點，沿途有數座涼亭，供遊客休憩、避雨。終端建有觀景台，遠望對岸美景，近看漁舟穿梭，台邊樹木參天，藤蔓繞空，因地處偏僻，遊客不多，獨坐台上，頓覺原始味道。

Songbolun

Songbolun is a small peninsula, with a hiking trail leading to the end. There are several pavilions along the route for visitors to rest or take shelter from rain. At the end is a viewing platform to look far into the beautiful scenery of the opposite bank and look near to the sailing of fishing boats. There are towering trees by the platform with climbing vines. Because it is a remote place, there are very few visitors. You could gain a sense of primordiality when sitting alone at the platform.

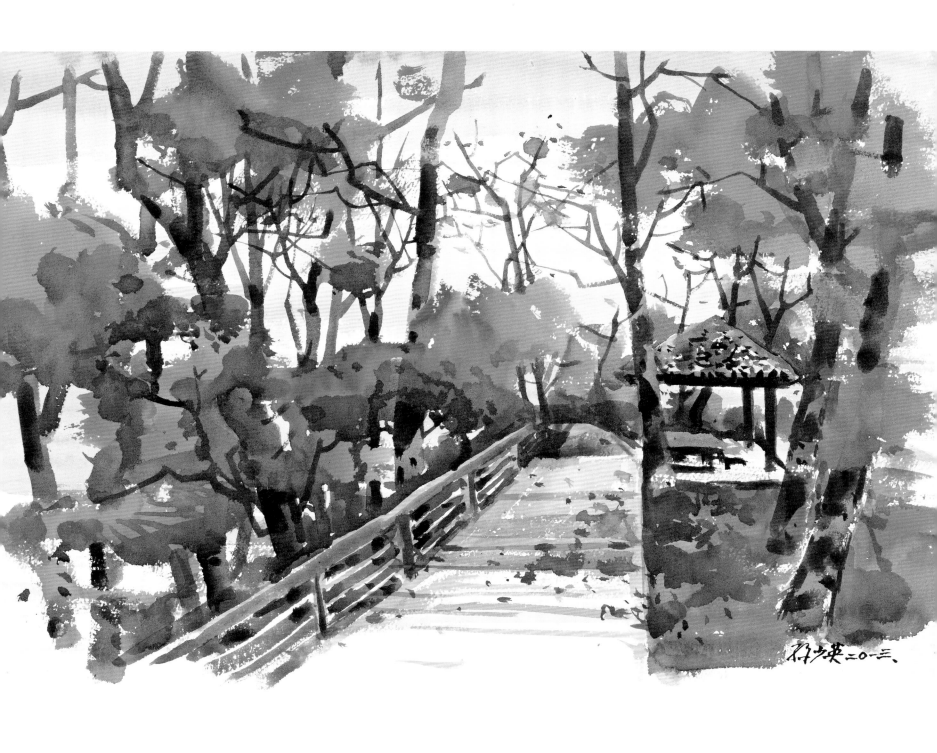

松柏崙步道與涼亭

Songbolun Nature Hiking Trail and Pavilion

39×57cm 2013

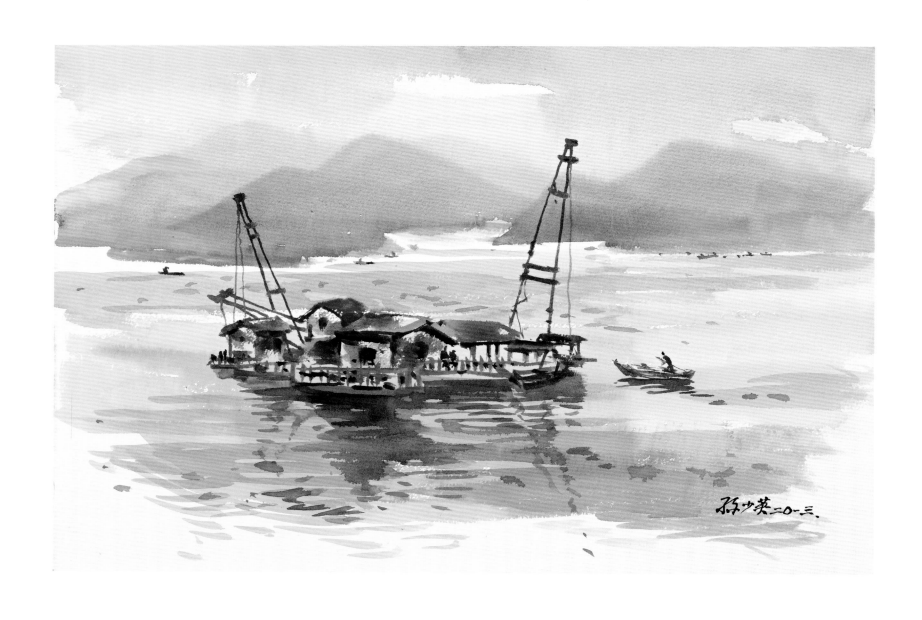

松柏崙湖面船臺（一）

Boat Platform at Songbolun

39×57cm 2013

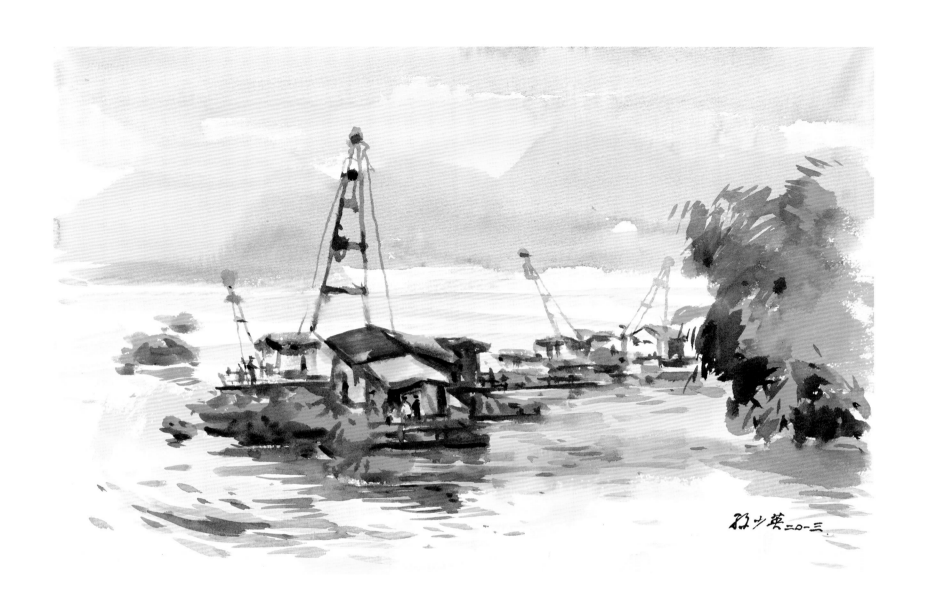

松柏崙湖面船臺（二）

Boat Platform at Songbolun

39×57cm 2013

大竹湖

水面形狀如湖，湖畔多竹。大竹湖名稱由來已久。

這裡是日月潭的進水口，從武界引水進來，夾帶很多泥沙，日久淤積，形成各種生態滋生的好環境。

步道盡頭經常有手持高倍望遠鏡賞鳥的人群；也有守著釣竿耐心享受等待的釣客。來往遊客，觀賞湖景，也順便與他們聊聊，無形中增添了彼此樂趣。

Dazhu Lake

The water surface shapes like a lake and abundant bamboos are growing by the shore. The name of Dazhu (large bamboo) Lake has been existed for a long time. This is the inlet of Sun Moon Lake, bringing water from Wujie with plenty of mud that has silted up the lake after a certain period to form various good eco-habitats. At the end of the hiking trail, there are often many people watching birds with high-powered telescopes, and also patient anglers holding fishing poles to enjoy the waiting. The passing tourists watch the lake scenery and also chat with one another, unexpectedly increasing the pleasure of visiting.

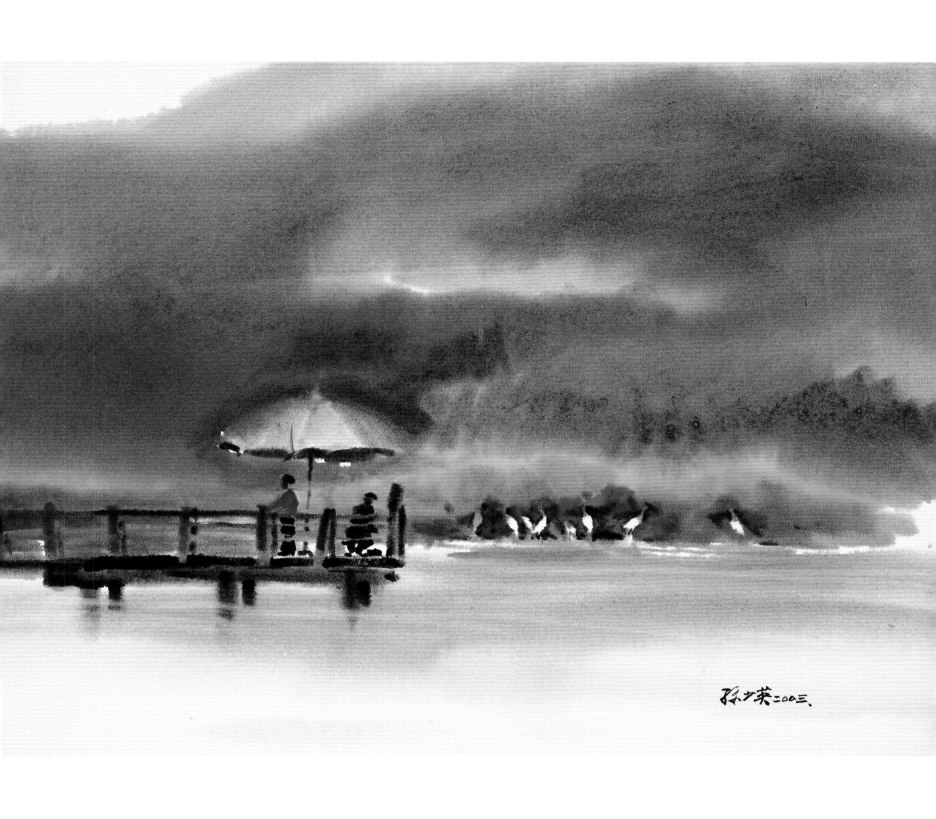

大竹湖垂釣

Fishing by Dazhu Lake

57×78cm 2003

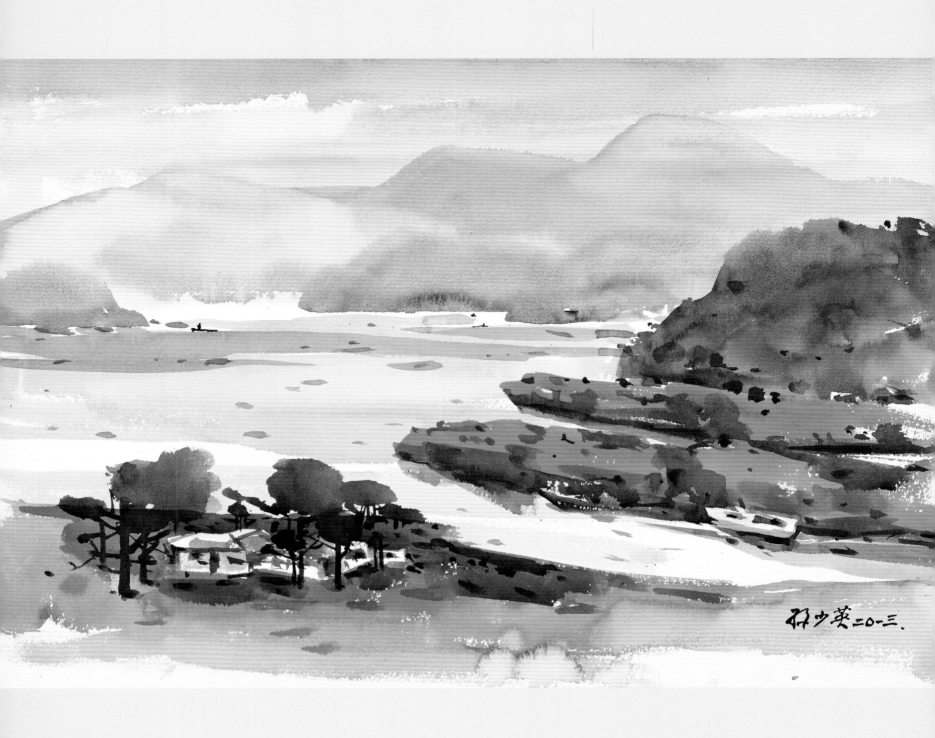

大竹湖俯瞰

Bird's-eye View of Dazhu Lake

39×57cm　2013

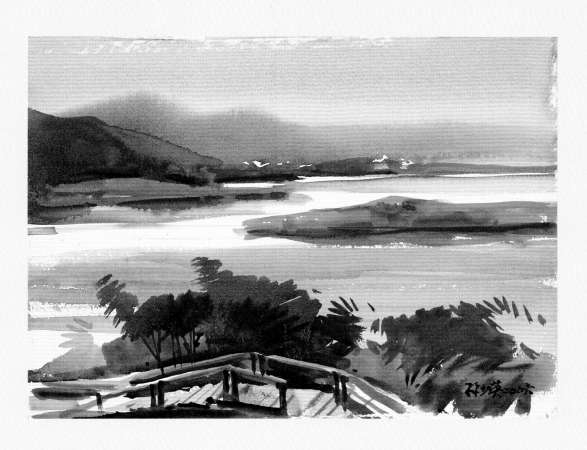

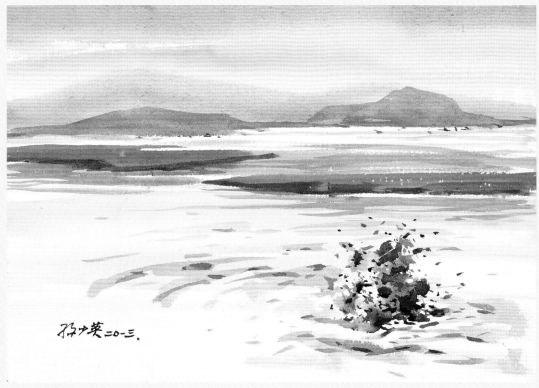

大竹湖步道

Dazhu Lake Trail

28.5×39cm 2006

大竹湖出水口

Dazhu Lake Outket

28.5×39cm 2013

水蛙頭

這裡有水上步道，步道邊有一座九隻青蛙疊羅漢的雕塑，雕塑是埔里畫家沈政瑩的作品，這件作品非常符合雕塑藝術的三個要素：含意、美感和趣味。

水滿時，只剩三隻，水枯時九隻全露，成了日月潭水位升降的最佳標誌。

Shuiwatou

There is a hiking trail on the water, beside which stands a sculpture of nine frogs piling up. It is a work by Puli painter Shen Zheng-ying, fully representing three elements of sculpting art: meaning, beauty and playfulness. When the water is full, there are only three frogs remaining and all the frogs will be exposed when the water is drained. It becomes a perfect mark for the changing water level of Sun Moon Lake.

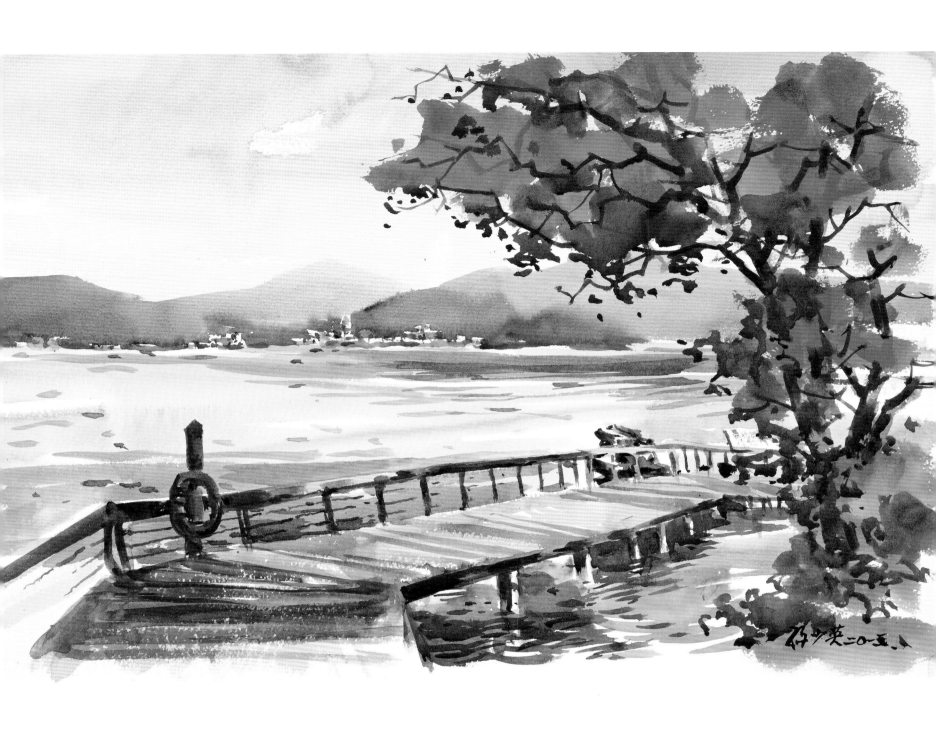

水蛙頭步道

Shuiwatou Trail

39×57cm 2013

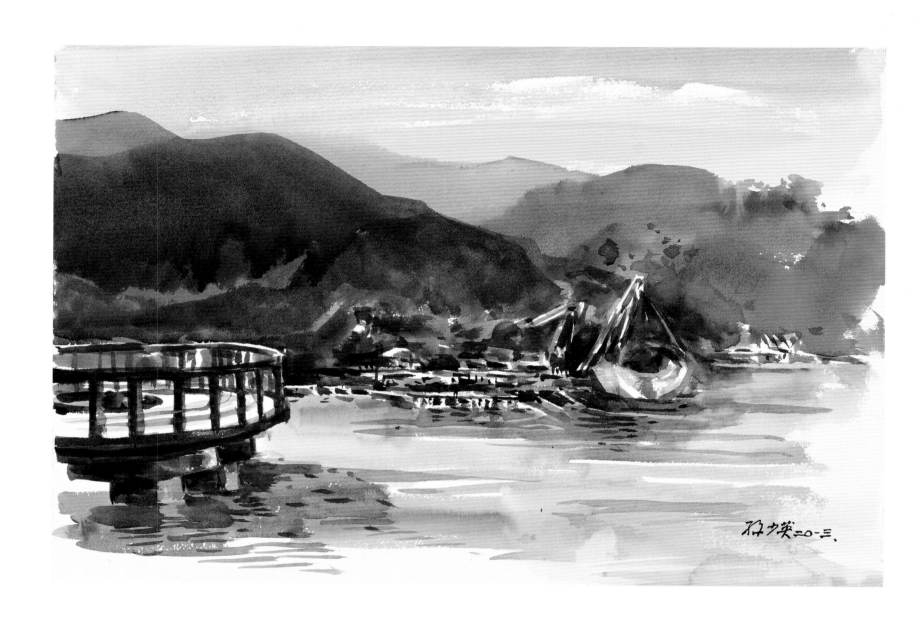

水蛙頭另一步道

The Other Trail at Shuiwatou

39×57cm 2013

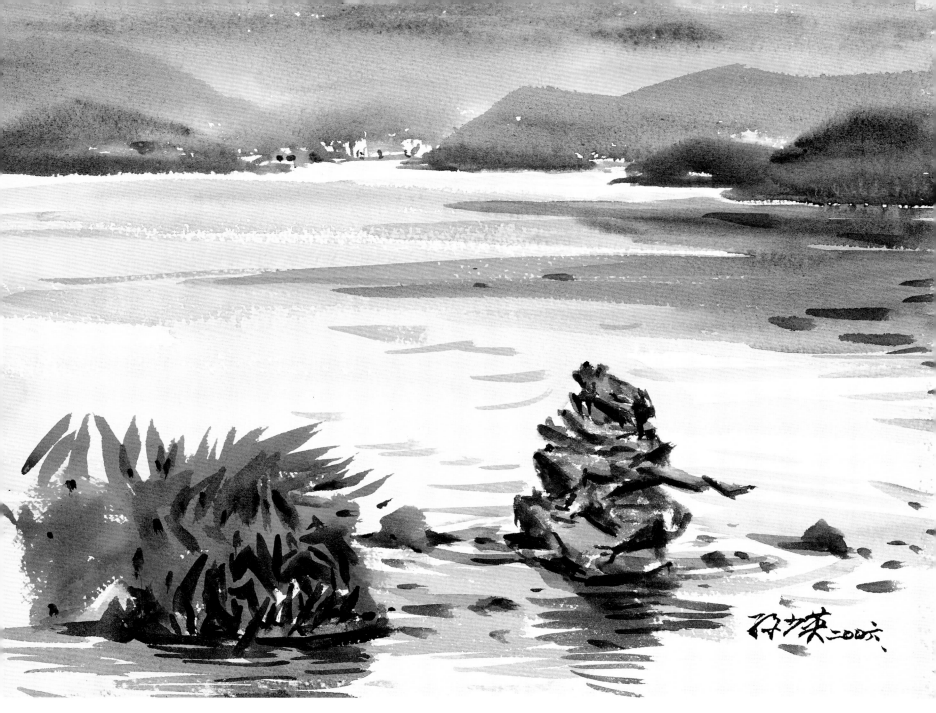

九隻青蛙雕塑（一）

Nine Frogs Sculpture

39×57cm 2006

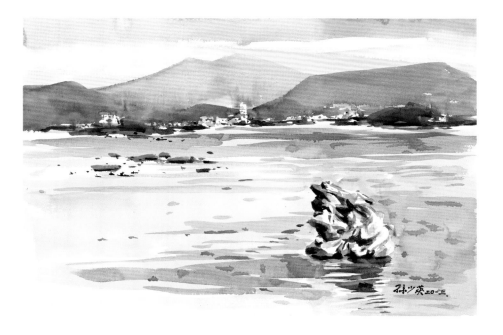

九隻青蛙雕塑（二）

Nine Frogs Sculpture

39×57cm 2013

聖愛營地

營地是由美籍安神父所創建，安神父過世後由埔里天主教會幸神父接手。

營地以提供年輕人露營為主，遊樂設施有輕舟滑板等，收費低廉。

到營地有水路和陸路兩種，水路由水社搭船約十分鐘可抵達。陸路則由環湖公路上的入口進入，路邊有標誌牌：「聖愛營地」，依坡下到湖邊約需十分鐘，這個入口約在水蛙頭與伊達邵之間，標誌很含蓄，要很注意才能看到。

Holy Love Campsite

The campsite was founded by American priest Rev. Richard Zeimet, which was taken over by Rev. Vincent Hsin of Catholic Church in Puli after he passed away. The campsite mainly provides a camping area for young people, including facilities like boats and skateboards at low cost.

You can get to the campsite either by water or by land route. It takes a 10-minute boat ride from Shuishe. The land route starts at the entrance on the Round-the-Lake Highway, following the sign of Holy Love Campsite. It takes about 10 minutes to get to the lake from the slope. This entrance is situated between Shuiwatou and Yidashao. The signpost is indistinct, requiring special attention.

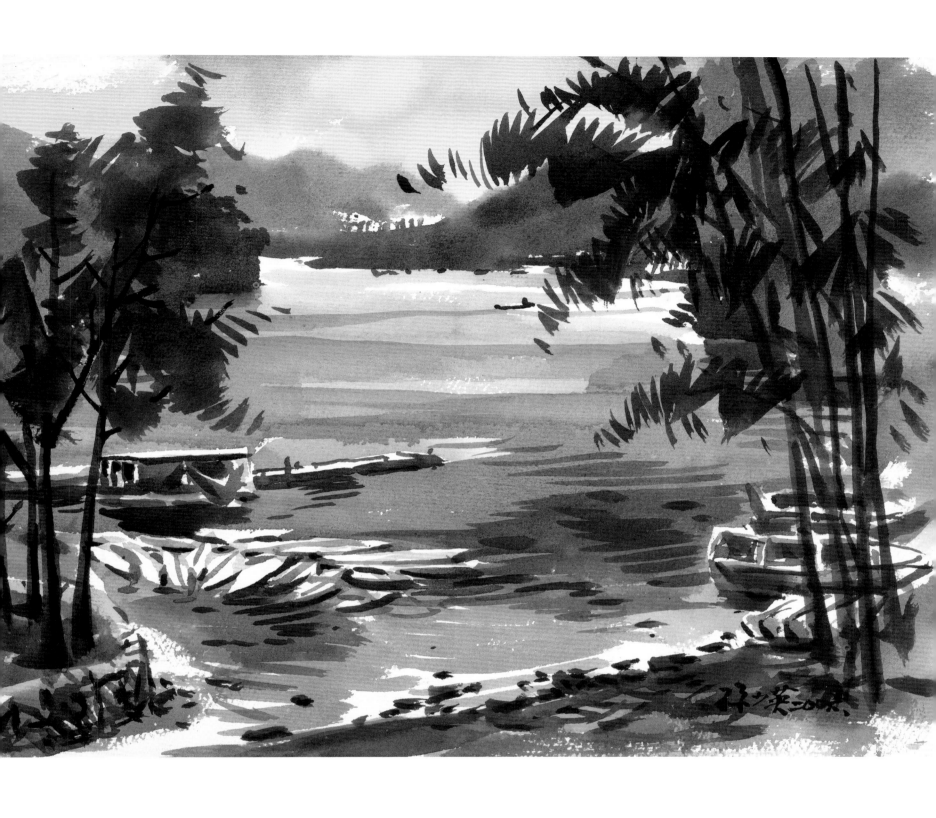

營地輕舟及划板

Boats and Canoes at the Holy Love Campsite

28.5×39cm 2006

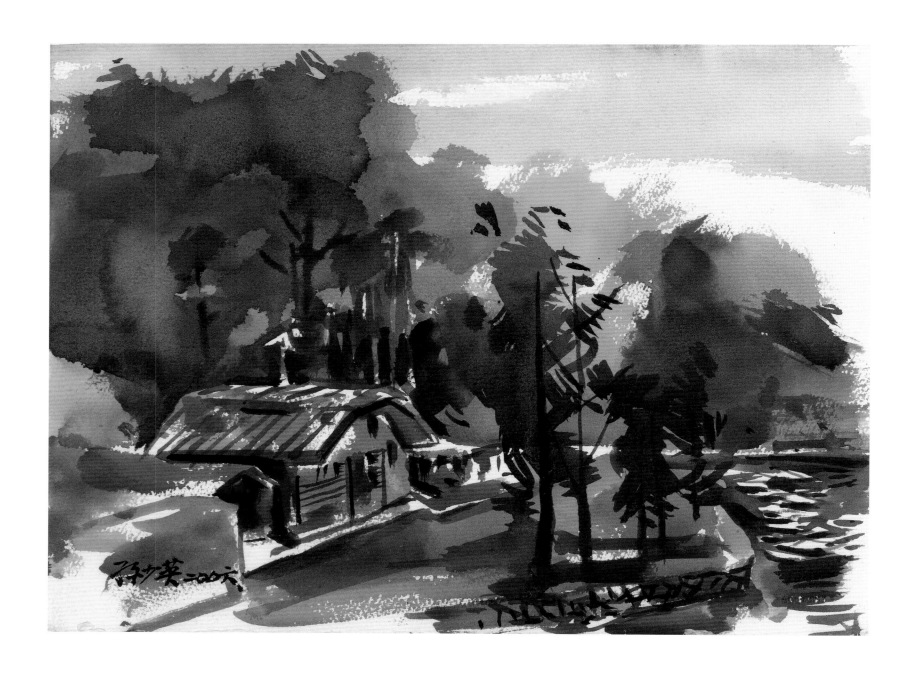

營地小屋

Cottage at the Holy Love Campsite

28.5×39cm 2006

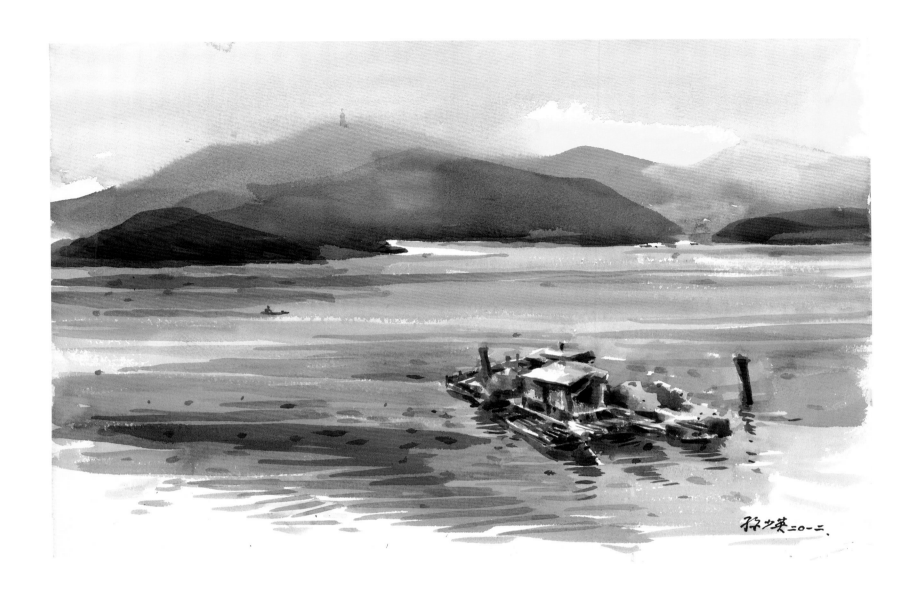

營地湖面

Lake Scenery by the Holy Love Campsite

39×57cm 2012

青年活動中心

青年活動中心是由青年救國團經營，位在伊達邵附近的山坡上，佔地廣闊，有新型別墅十餘棟，遍植梅樹、松樹、楓樹及櫻花。冬季賞梅、春季賞櫻、夏季松林中避暑、秋季賞楓。環境優美，渡假勝地。臨近有纜車站，通往九族文化村，高空觀賞湖景，另一番風味。

離開活動中心，過馬路，湖畔有大片茂密松林，林中露營，是另一種遊樂享受。

湖邊有水上步道，左通伊達邵，右達纜車起站，步道上的遊客經常絡繹不絕。

Youth Activity Center

The Youth Activity Center is managed by China Youth Corps, located on the hill near Yidashao. It has a vast area with more than 10 modern villas full of plum trees, maples and cherry blossoms. There are pleasures of appreciating plum blossoms in winter, cherry blossoms in spring, coolness from pines in summer, and maples in autumn. It becomes a holiday resort because of its beautiful environments. There is a cable station nearby leading to Formosan Aboriginal Culture Village.

To watch the lake scenes from sky is a different flavor. Leaving the Activity Center and crossing the road, there are dense pine forests where you can experience another kind of fun in camping in the woods. The trail above the lake leads to Yidashao on the left and the Start Station of Cable on the right, which is usually packed with visitors.

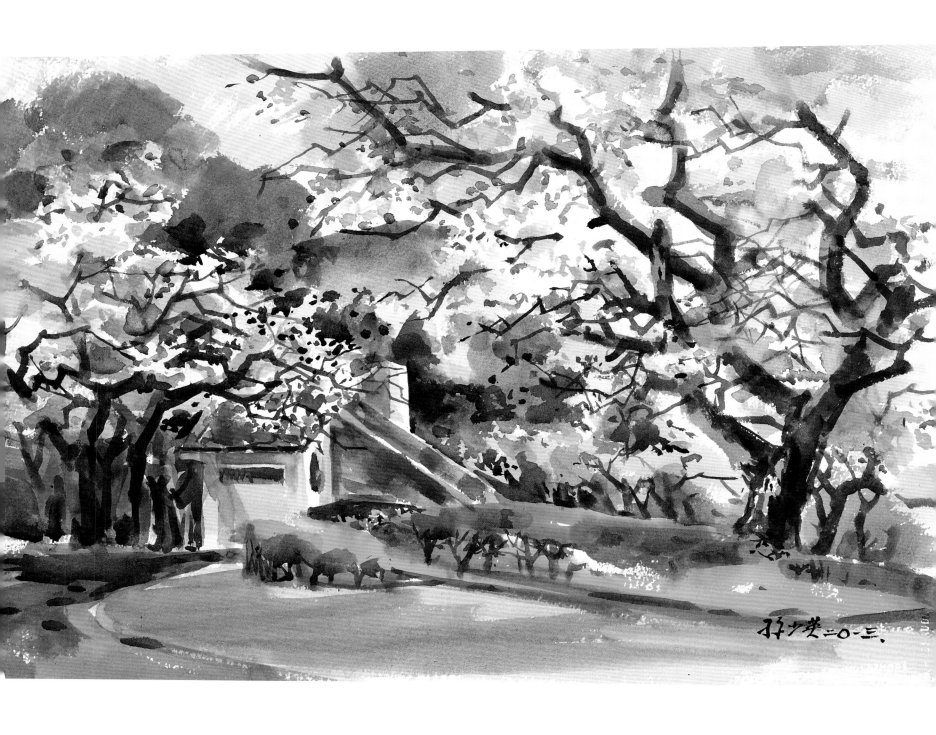

梅林與別墅

Plum Trees and a Villa

39×57cm 2013

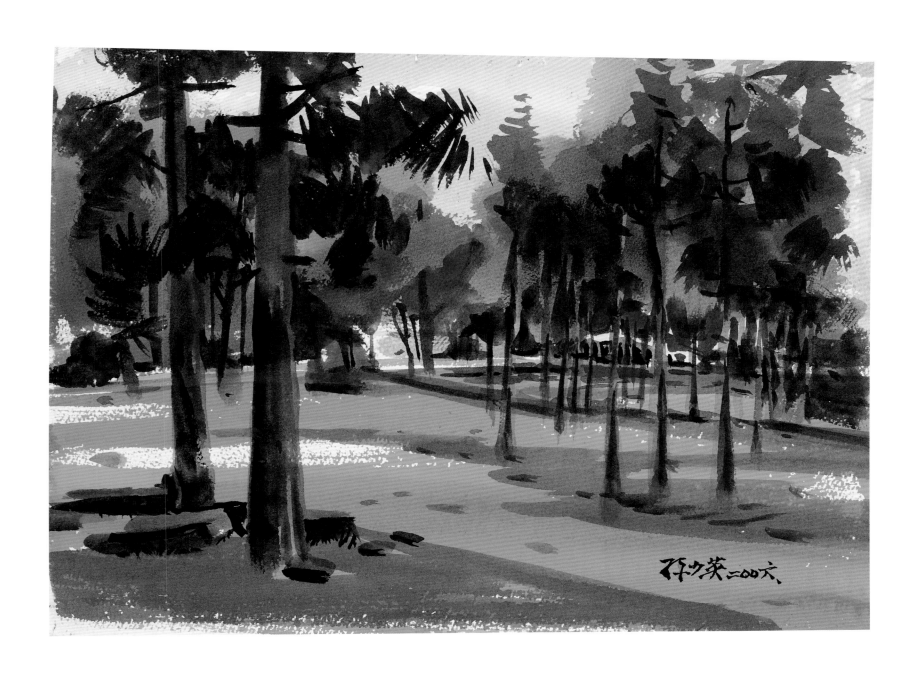

青年活動中心園區

Park of the Youth Activity Center

39×57cm 2006

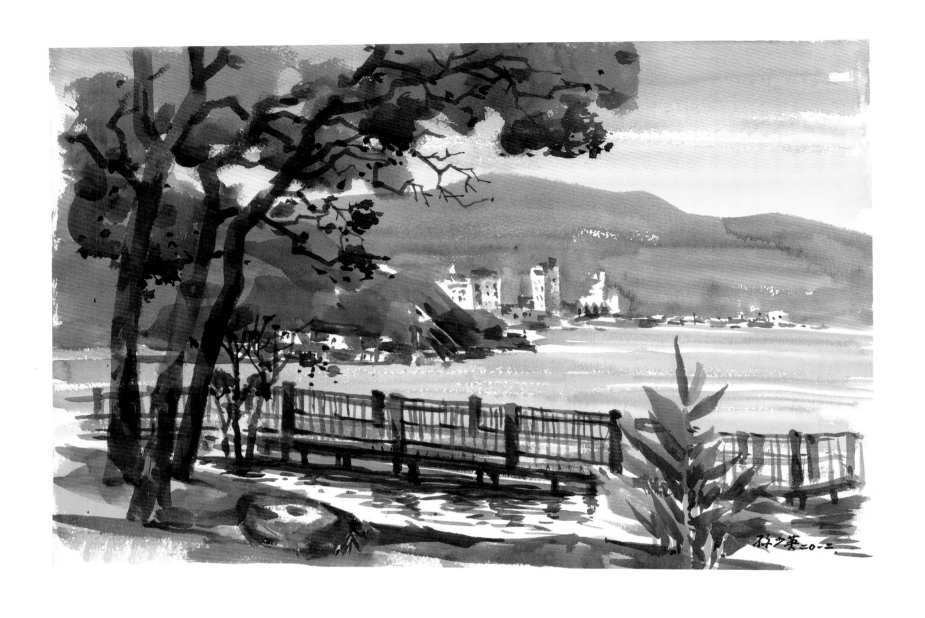

水上步道（一）

Trail above Sun Moon Lake

39×57cm 2012

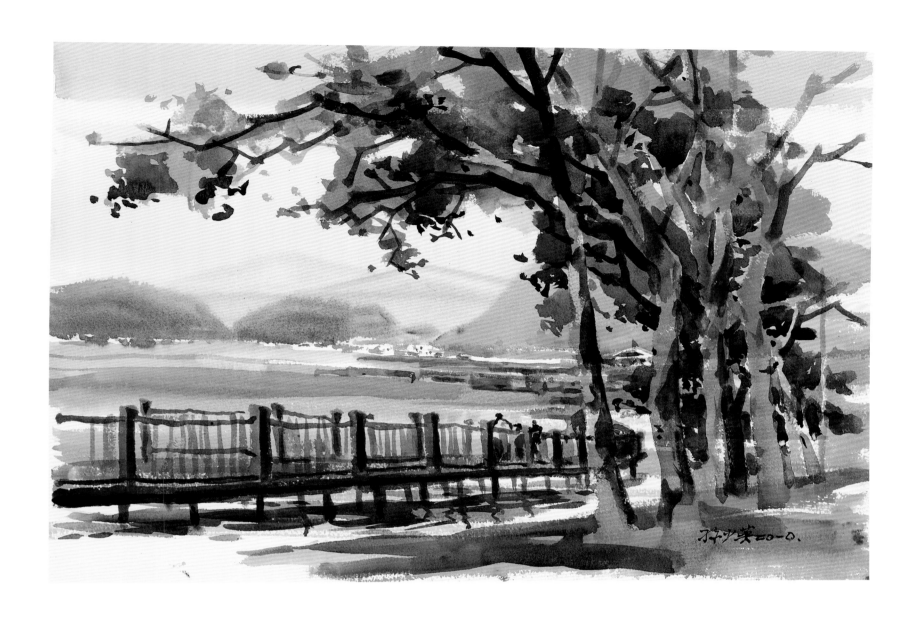

水上步道（二）

Trail above Sun Moon Lake

39×57cm　2010

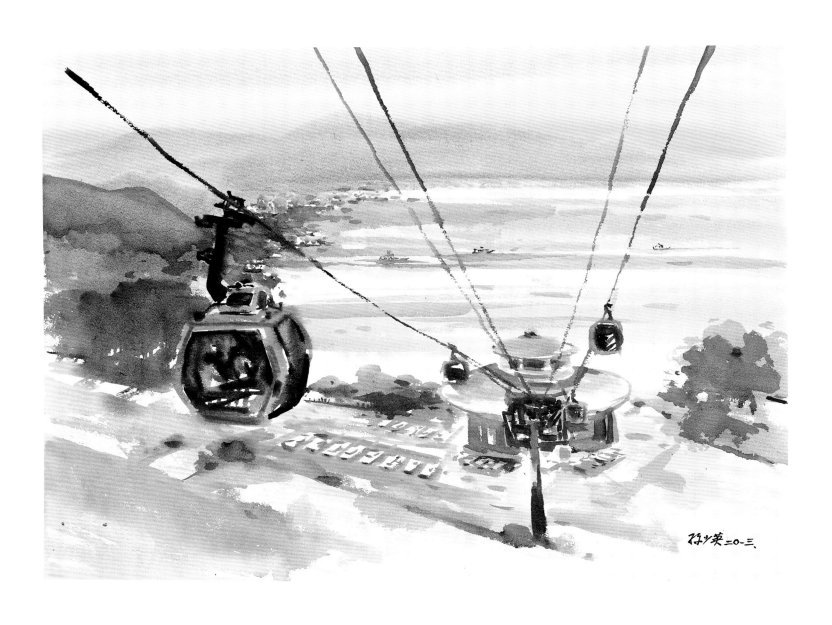

纜車起站

The Start Station of Cable

39×57cm　2013

日月村

日月村原名伊達邵，再早叫番社，是邵族原住民的原住地。

年長的人，該還記得五十年前番社的毛王爺和白牡丹、黑牡丹，當時他們極為爆紅，毛王爺早就過世了，漂亮的白牡丹也已七十餘歲，早已兒孫滿堂。

日月村湖岸建有公園和遊艇碼頭，設施良好，是來日月潭的遊客，遊覽路線的首選地標。公園內建有「伊達邵遊客中心」，提供各種旅遊資訊，遊客中心的建築，採遊艇造型，新穎美觀。

Sun Moon Village

The Sun Moon Village is originally called Yidashao, or Aboriginal Village in earlier time, which is a native settlement for the Thao indigenous people.

The elders should still remember Mao Wangye, White Peony and Black Peony of the indigenous village 50 years ago, when they were very popular. Mao Wangye had long passed away and the beautiful White Peony is already 70+ years old accompanied by many children and grandchildren.

There is a park and a yacht pier by the lakeshore of Sun Moon Village. The good facility attracts visitors of Sun Moon Lake to choose it as the top priority for their tour. The Yidashao Visitor Center is located in the park providing all kinds of tourist information. The building of Visitor Center is modernly and beautifully shaped like a yacht.

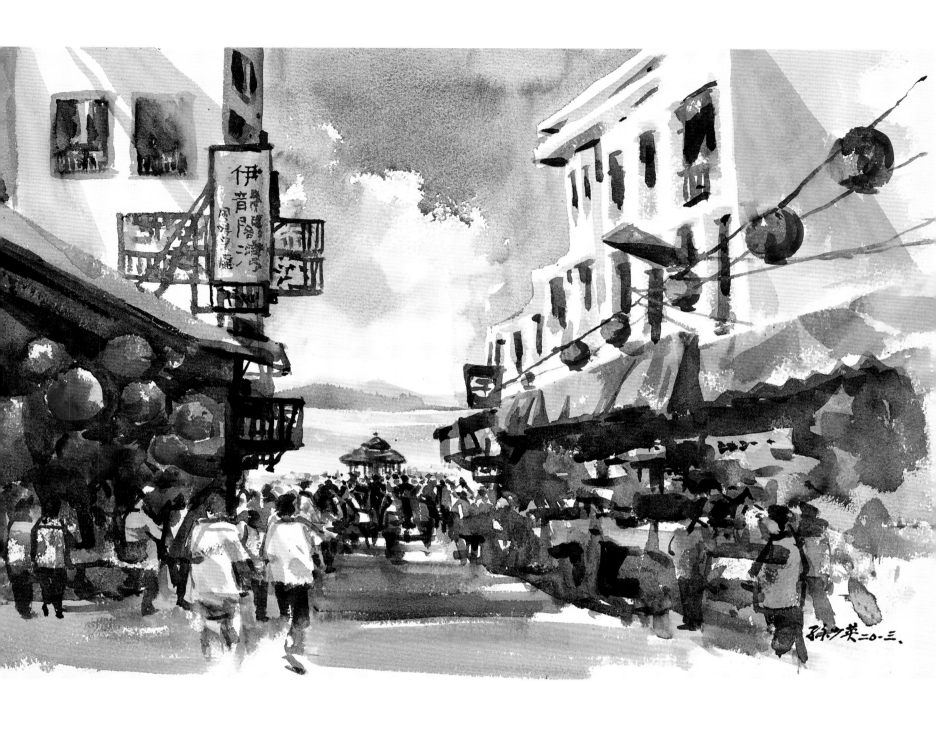

日月村街景

Street View at Sun Moon Village

39×57cm 2013

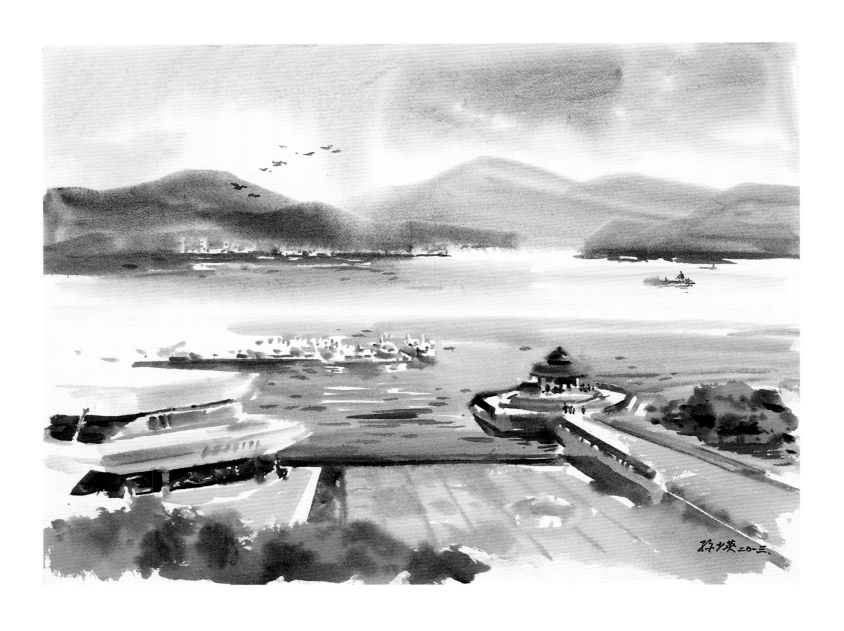

從水岸民宿俯瞰湖面

Bird's-eye Lake View from the Lakeside Guesthouse

39×57cm 2013

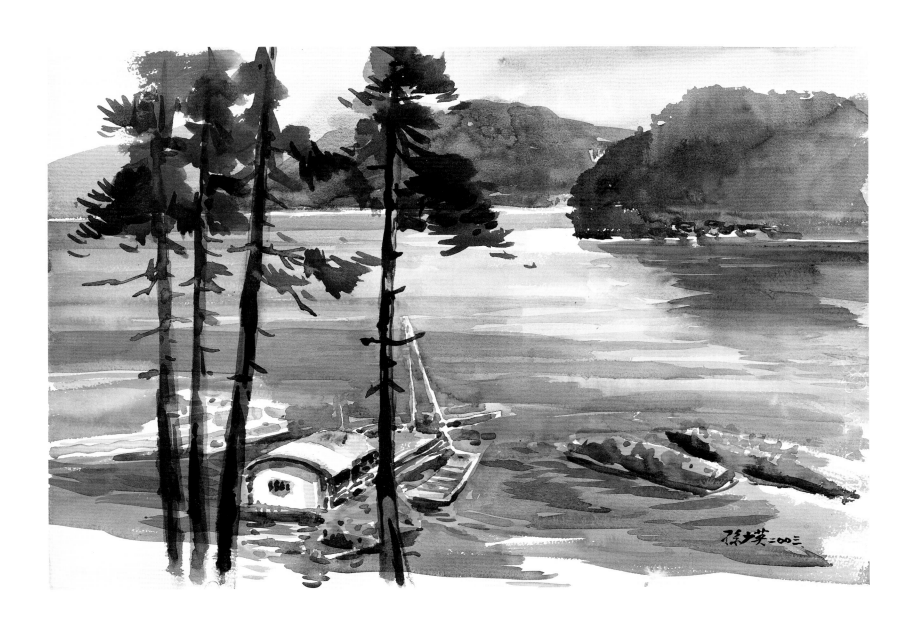

從路邊俯瞰湖面船屋

Bird's-eye Boathouse on Lake from the Path

39×57cm　2003

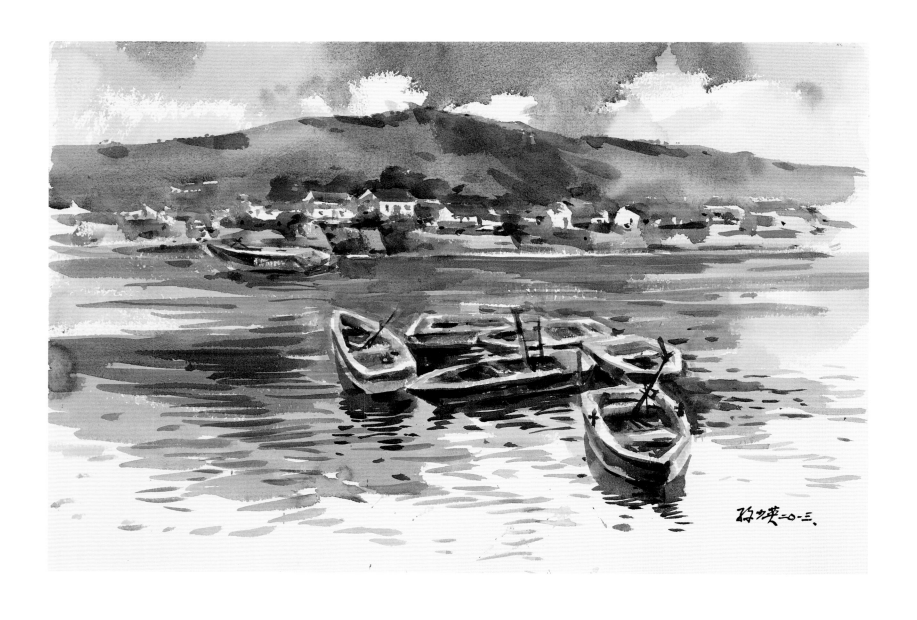

村邊漁舟

Fishing Boats by the Village

39×57cm　2013

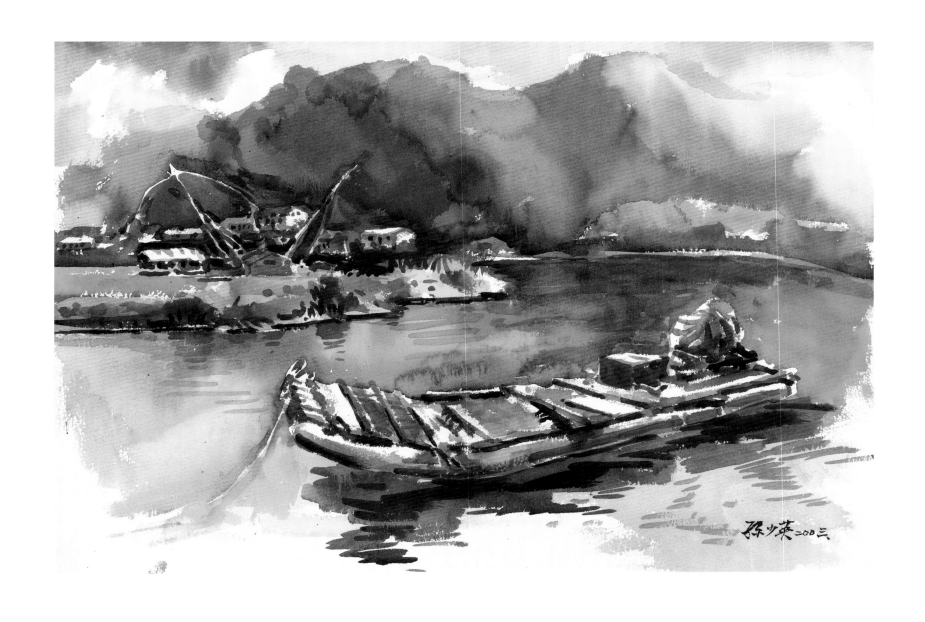

四平灣漁筏

Fishing Raft at Siping Bay

39×57cm 2003

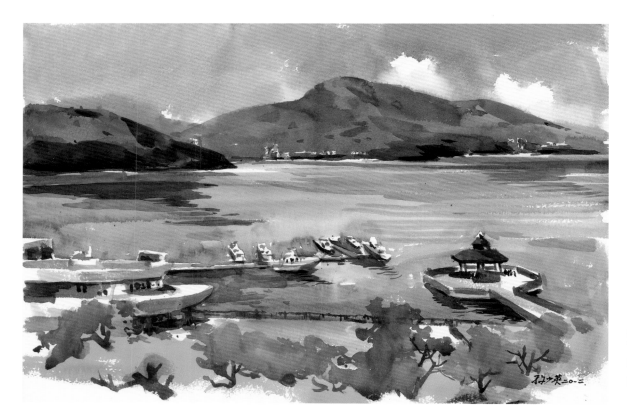

湖岸公園

Lakeside Park

39×57cm　2012

獨木舟

Canoes

39×57cm　2013

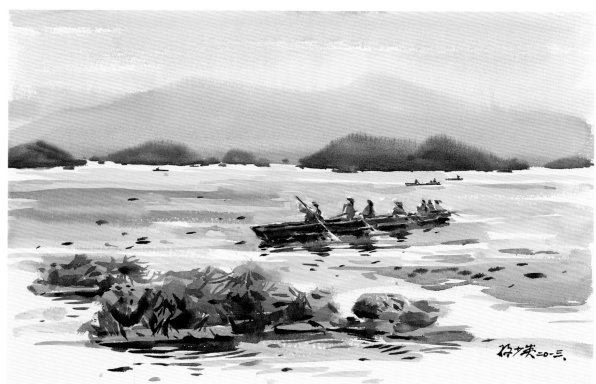

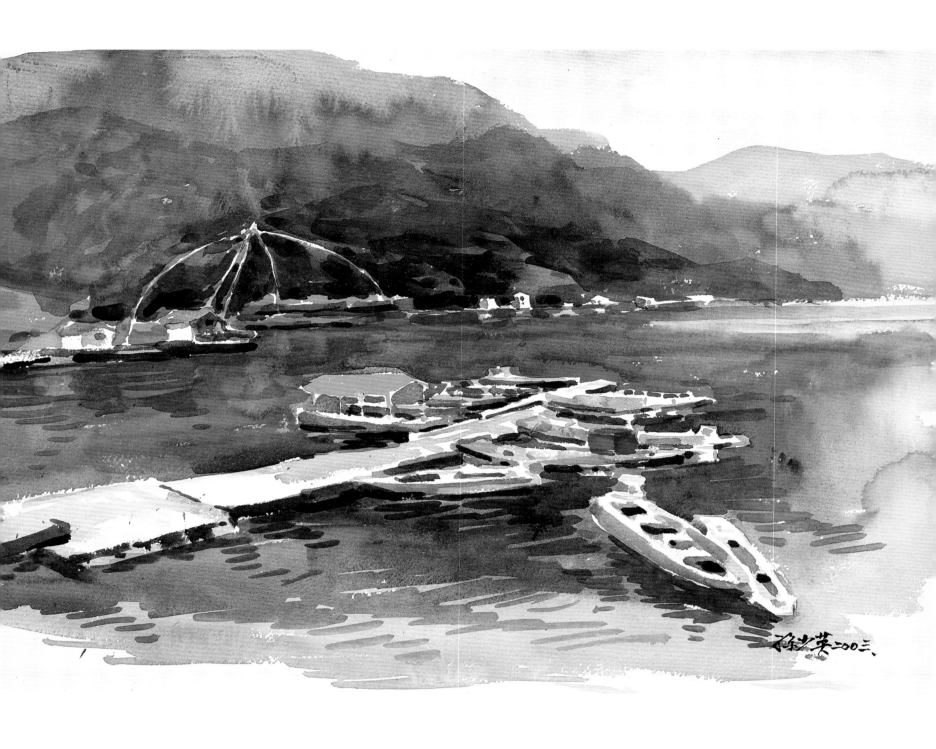

四平湖碼頭

Siping Bay Pier

39×57cm 2003

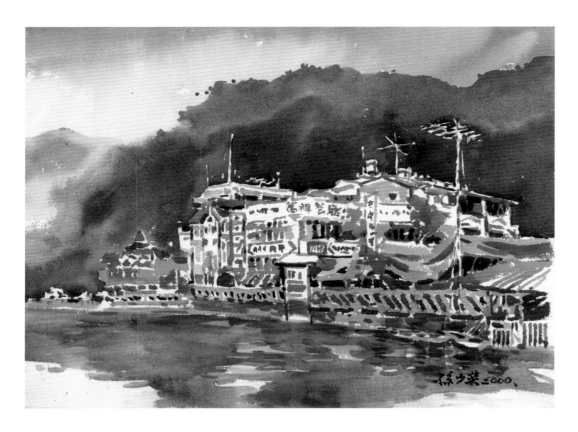

從湖面看日月村

Sun Moon Village Scenery from the Lake

28.5×39cm 2000

路邊茶攤

Tea Stand at the Roadside

39×57cm 2013

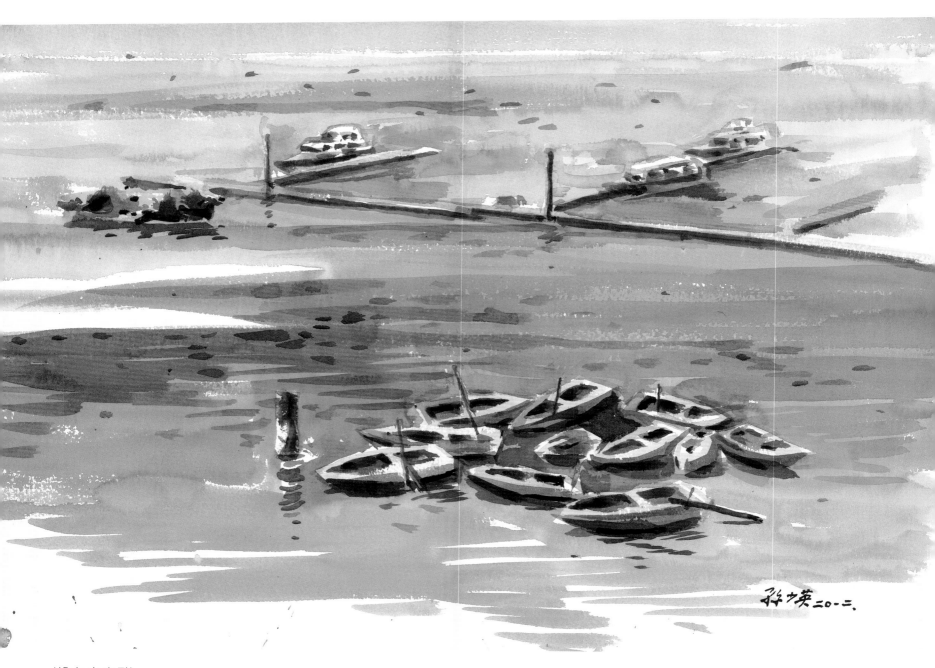

湖中小舟群

Small Boats in the Lake

39×57cm 2012

富豪群飯店

Full House Resort

39×57cm 2002

舞團石小姐

A Dancer

57×39cm 2013

袁家公主

Princess Of Shao

57×39cm 2013

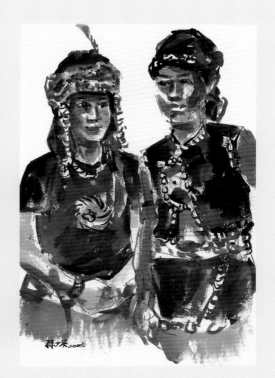

石磊頭目和采妮公主

Gang Leader Shilei and Princess Caini

57×39cm 2006

袁福田頭目

Gang Leader Of Shao

57×39cm 2003

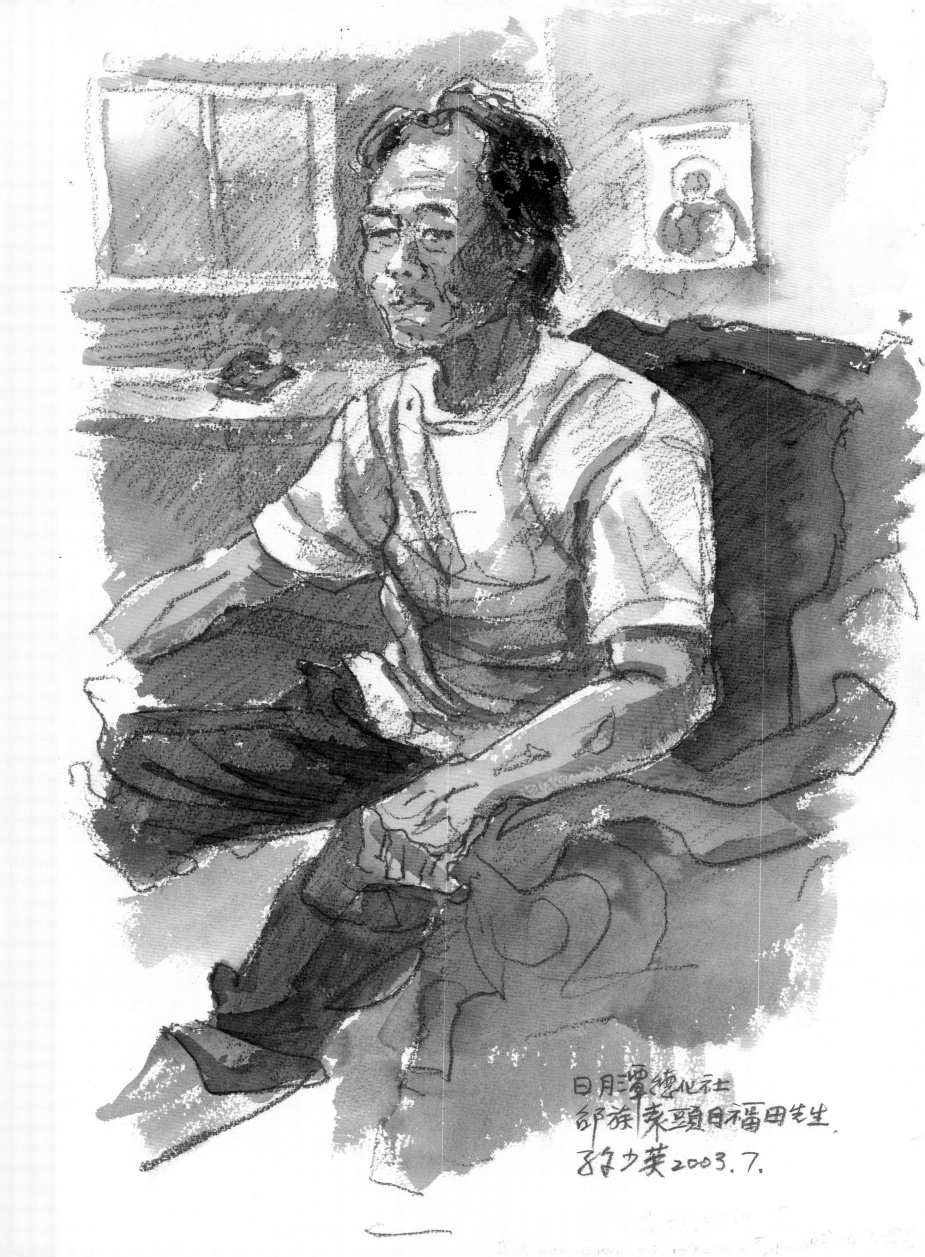

日月潭德化社
邵族素頭目福田先生
孔力英 2003.7.

伊達邵

伊達邵是邵族原住民九二一地震災難後重建的村落，村內清一色的邵族原住民，不像日月村的族群混合現象。

水社大山的登山口在村子的南端，登山遊覽的人很多，給儉樸的小村子帶來些許繁榮。

登山口有一家藝品店，是由伊達邵先生媽陳賢美女士和獨木舟達人丹明元先生開設，店內原住民的工藝品琳琅滿目，常是遊客駐足歇腳的好地方。夫婦倆待客熱誠，已成了遠近皆知的伊達邵靈魂人物。

Yidashao

Yidashao is a rebuilt village after 921 Earthquake Disaster for the Thao indigenous people. All the inhabitants in the village are the Thao indigenous people, different from the Sun Moon Village where various ethnic groups are mixed. The entrance of Shuishe Mountain lies in the southern end of the village. The numerous mountaineers have somehow boomed this small and simple village.

There is an handicrafts shop at the entrance, run by Ms. Wianmei Chen, a medicine woman of Yidashao, and Mr. Mingyuan Dan, a canoe expert. There are various indigenous handicrafts in the shop, a good place for tourists to stop by. The couple has become featured characters of Yidashao, known far and wide for their warm and sincere hospitality.

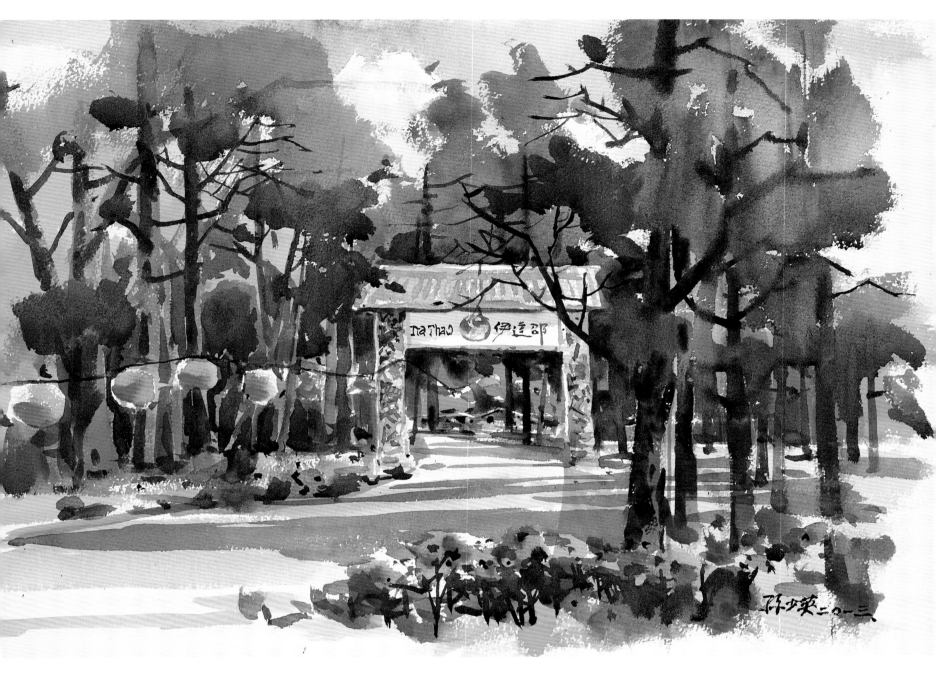

伊達邵大門

Yidashao Entrance Gate

39×57cm　2013

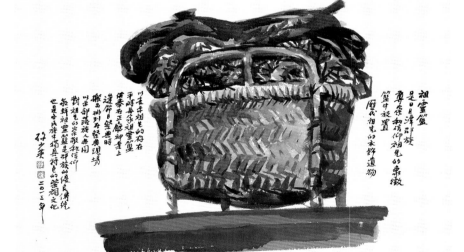

伊達邵祖靈籃

Yidashao Ancestor Spirit Basket

39×57cm　2013

伊達邵公共藝術

Yidashao Public Art Installation

39×57cm　2013

伊達邵母語教學牌

Signs of the Yidashao Native Language Teaching

39×57cm 2013

伊達邵靈鳥貓頭鷹雕刻品

Sculptures of the Yidashao God Bird—Owl

39×57cm 2013

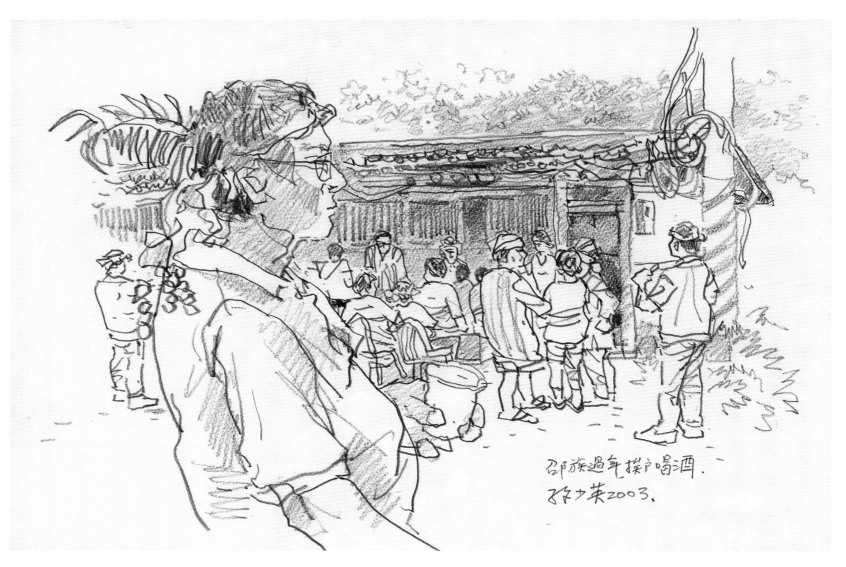

伊達邵過年喝酒歡樂

New Year Party at Yidashao

39×57cm 2003

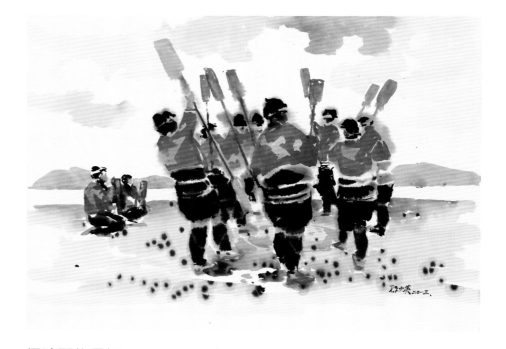

伊達邵杵音舞

Yidashao Pestle Sound Dance

57×78cm 2013

水社大山登山口

Entrance of Shuishe Mountain

57×78cm 2013

陳賢美在登山口的藝品店

Ms. Chen, Wianmei at a Craft Shop near the Entrance

57×78cm　2013

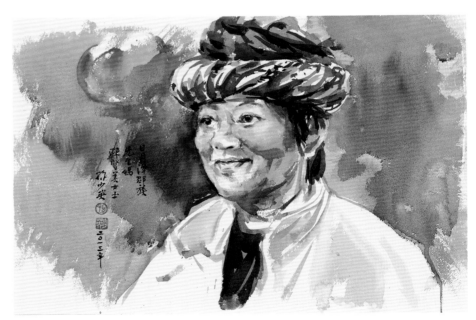

伊達邵先生媽陳賢美女士

Shuishe's Medicine Woman—Ms. Chen, Wianmei

39×57cm　2013

丹明元的獨木舟

Mr. Dan, Mingyuan's Canoes

39×57cm 2013

獨木舟達人丹明元先生

Canoe Expert Mr. Dan, Mingyuan

39×57cm 2013

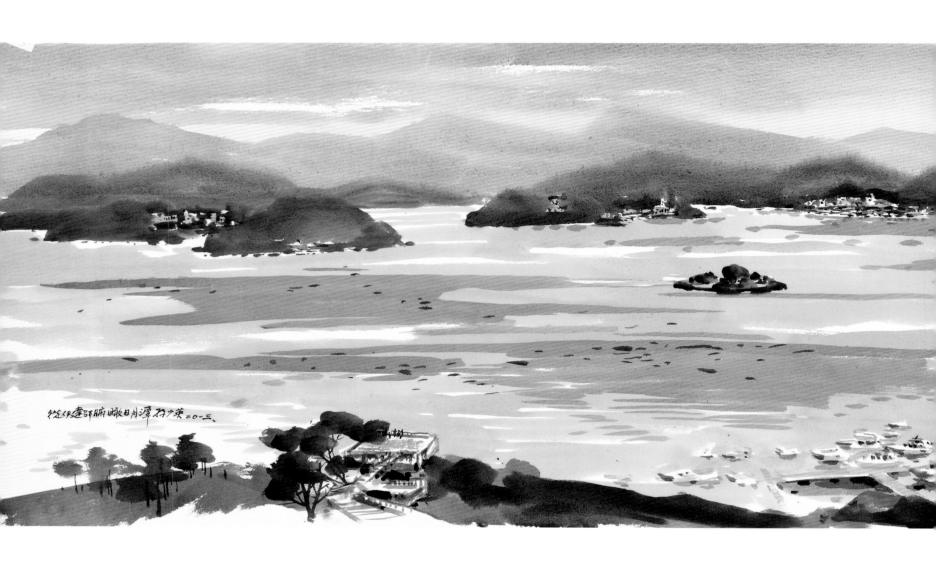

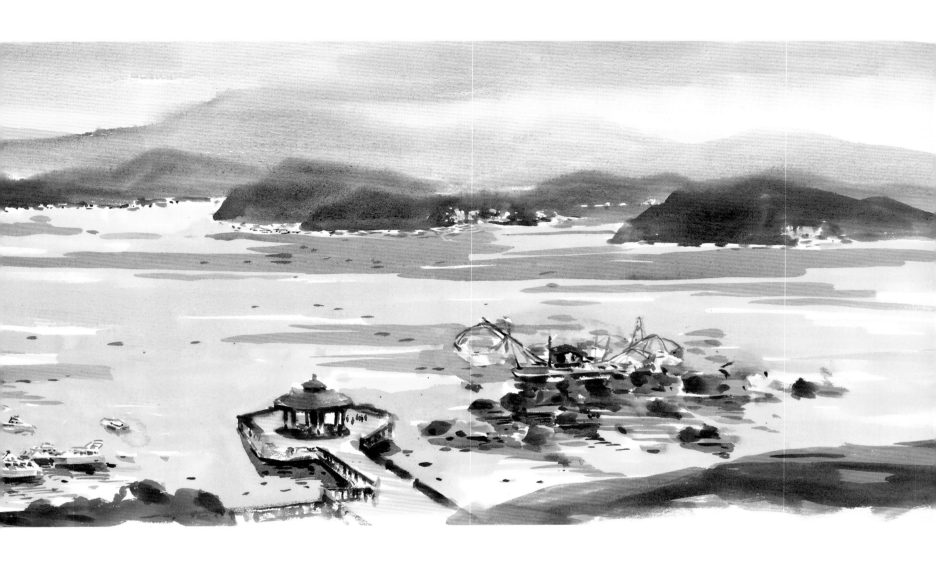

伊達邵湖面

Lake View at Yidashao

56.5×224cm 2013

土亭仔

土亭仔是伊達邵原住民的發祥地，每到節慶，伊達邵的居民都會到這裡祭祖。

這裡是一個狹長的半島，有長約八百公尺的棧道式步道依地形曲折高低通往湖邊，雙層觀景台建在水中。湖面寬廣，霧中如茫茫大海。

觀景台旁邊有一座燈塔，是台灣地勢最高，體積最小的迷你燈塔，因為小巧，也成了來日月潭的遊客搜尋的名勝景點。

Tutingzai

Tutingzai is the place of origin for the Thao indigenous people of Yidashao. The Yidashao villagers would come here to worship their ancestors in every festival. It is an elongated peninsula. There is a winding plank trail about 800 meters long that goes ups and downs leading to the lakeside. A double-deck observation pavilion is built in the water. The lake surface is immense looking like a big ocean in the mist. There is a lighthouse next to the observation pavilion, which is the highest and smallest one in Taiwan. Because of its mini size, it becomes a tourist attraction for visitors of Sun Moon Lake.

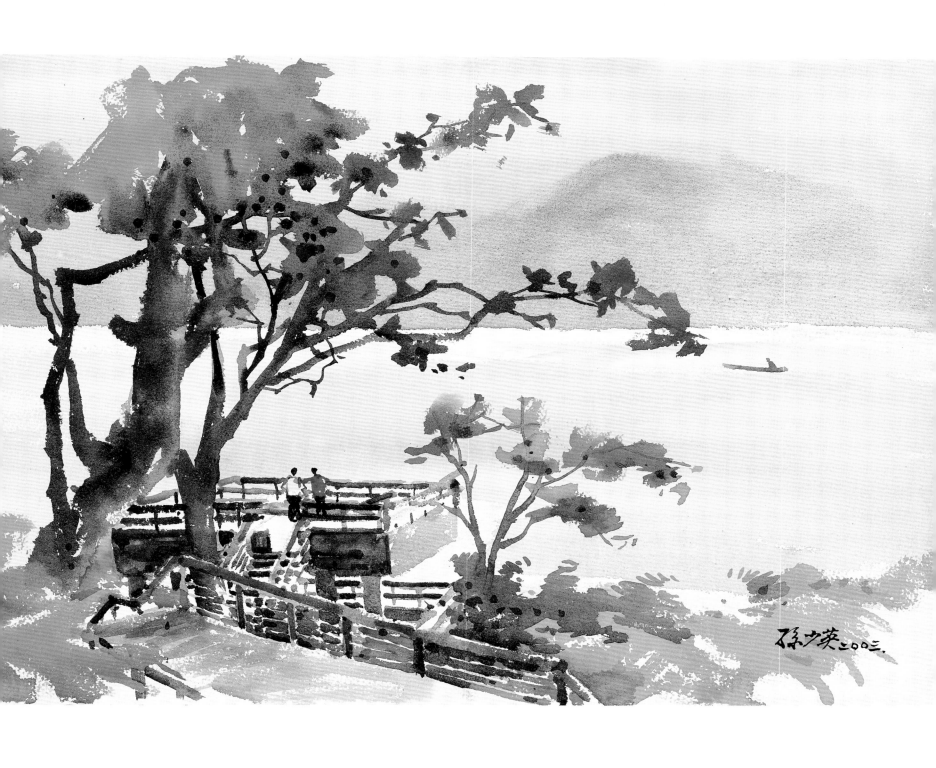

土亭仔觀景台（一）

Tutingzai Observation Pavilion

39×57cm 2003

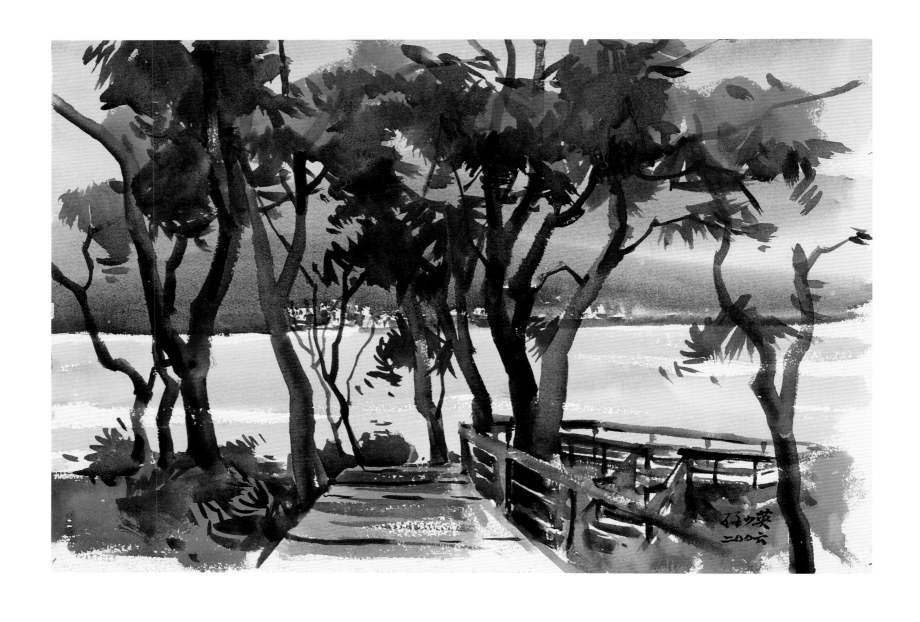

土亭仔湖面

Lake Scenery at Tutingzai

39×57cm 2006

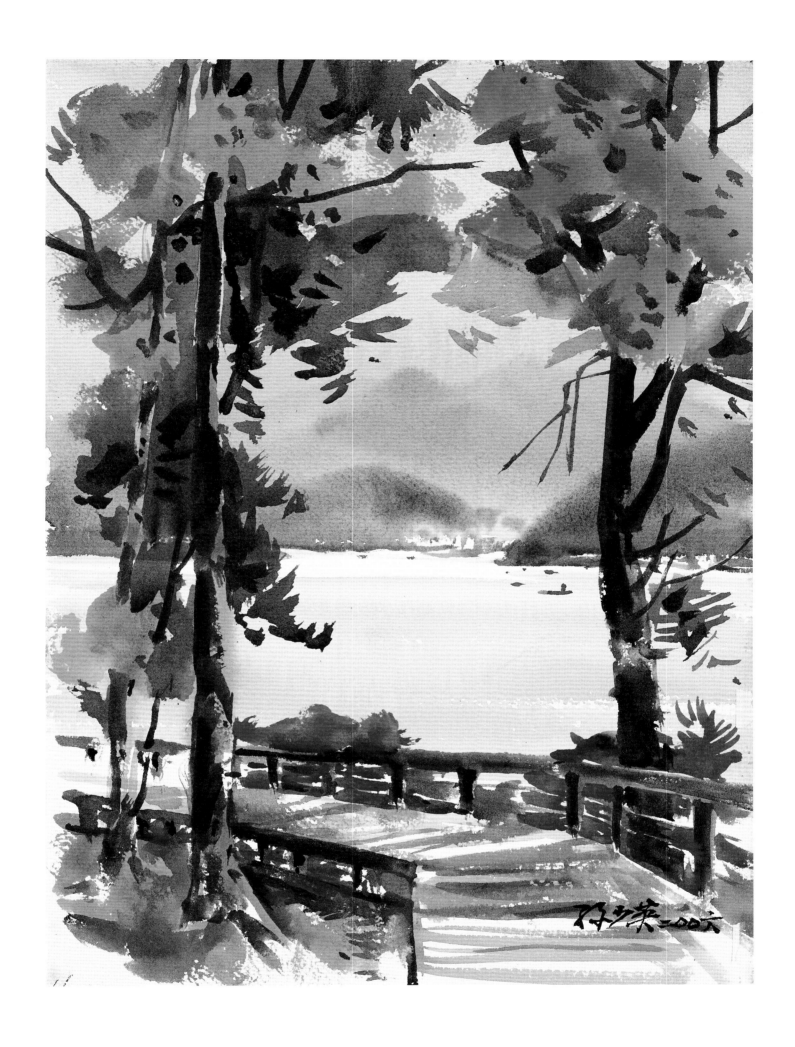

臨湖步道

Lakeside Trail

39×28.5cm 2006

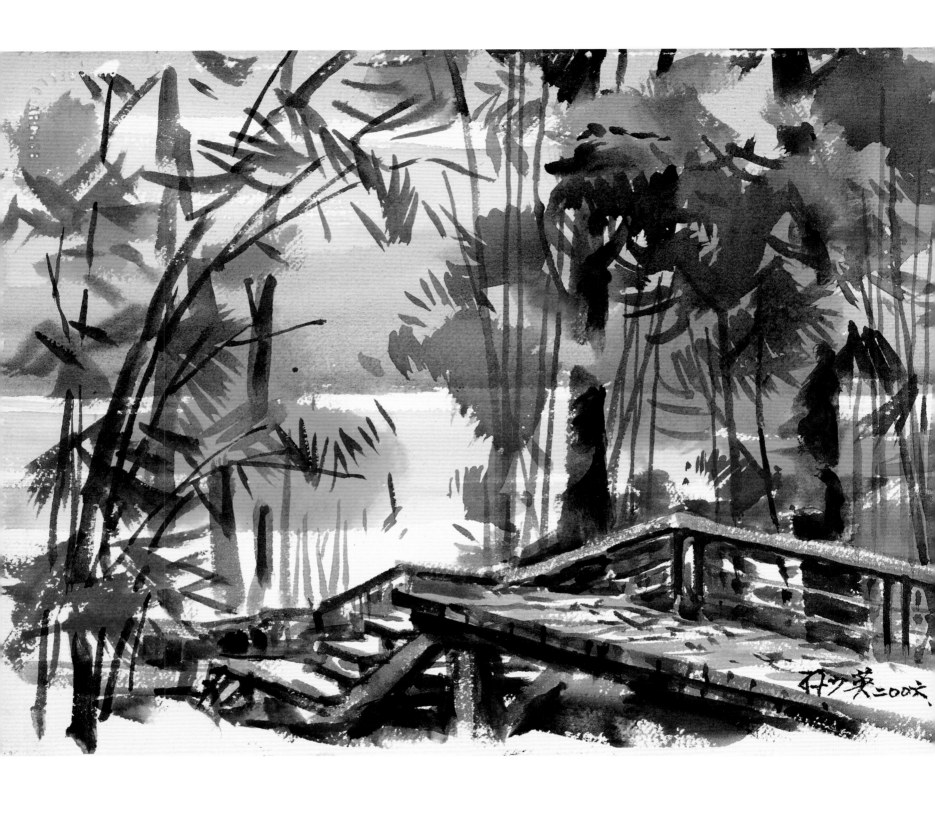

步道另一端

The Other Side of the Hiking Trail

28.5×39cm 2006

土亭仔觀景台（二）

Tutingzai Observation Pavilion

39×57cm 2013

土亭仔步道與涼亭

Tutingzai Hiking Trail and Pavilion

39×57cm 2013

樹間遠眺水社

Shuishe Scenery in a Long Distance

28.5×39cm 2000

遠眺日月村

Sun Moon Village in a Long Distance

28.5×39cm 2000

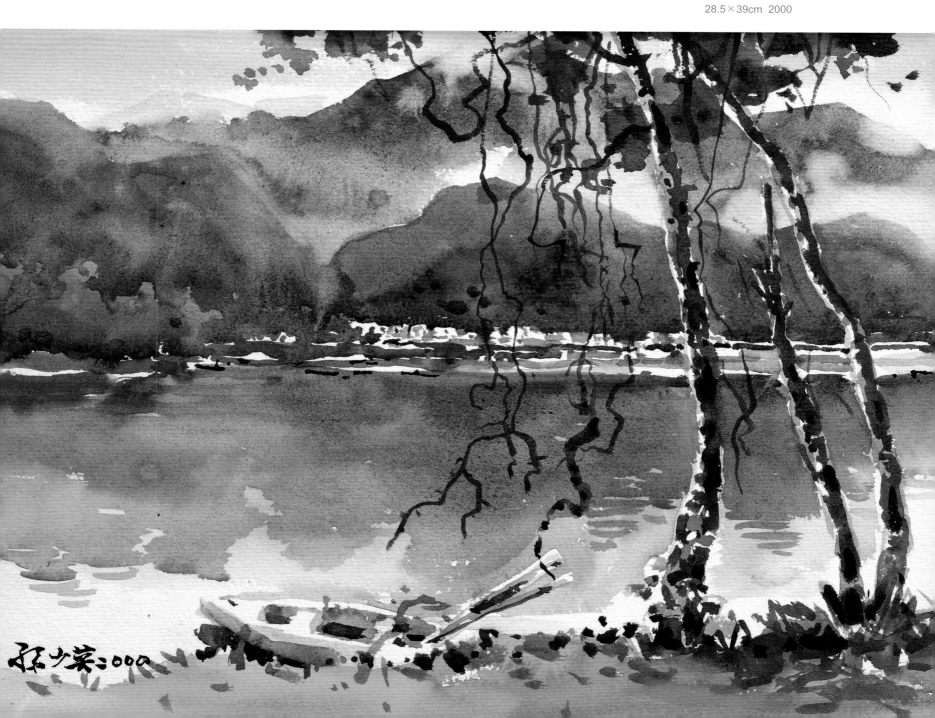

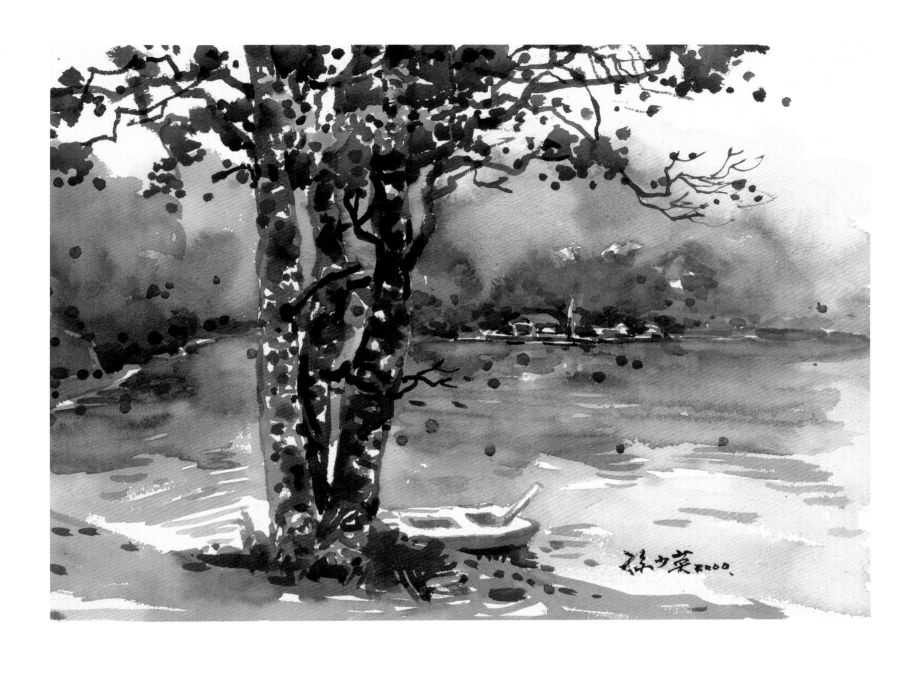

土亭仔一角

A corner at Tutingzai

28.5×39cm 2000

玄光半島

半島上有玄光寺、玄奘寺和慈恩塔。

玄光寺和玄奘寺是為紀念唐僧玄奘大師所建，據說寺內珍藏有玄奘大師的舍利。

慈恩塔塔高九層，塔頂海拔正好一千公尺，是蔣公為紀念母恩所建。塔頂可瞭望日月潭全景，近處如玄光寺、玄奘寺，遠處如水社、向山、朝霧、伊達邵盡在眼底。

Xuanguang Peninsula

There are Xuanguang Temple, Xuanzhuang Temple and Ci'en Pagoda on the peninsula. Xuanguang Temple and Xuanzhuang Temple were built to commemorate the Venerable Xuanzhuang of Tang Dynasty. It is said that the temple houses the relics of Venerable Xuanzhuang. The Ci'en Pagoda has nine levels, whose top is exactly 1000 meters above sea level. It was built by Late President Chiang Kai-shek in memory of his mother. From the top of the pagoda, the entire view of Sun Moon Lake can be overlooked at a glance, including Xuanguang Temple and Xuanzhuang Temple closely and Shuishe, Xiangshan, Chaowu and Yidashao remotely.

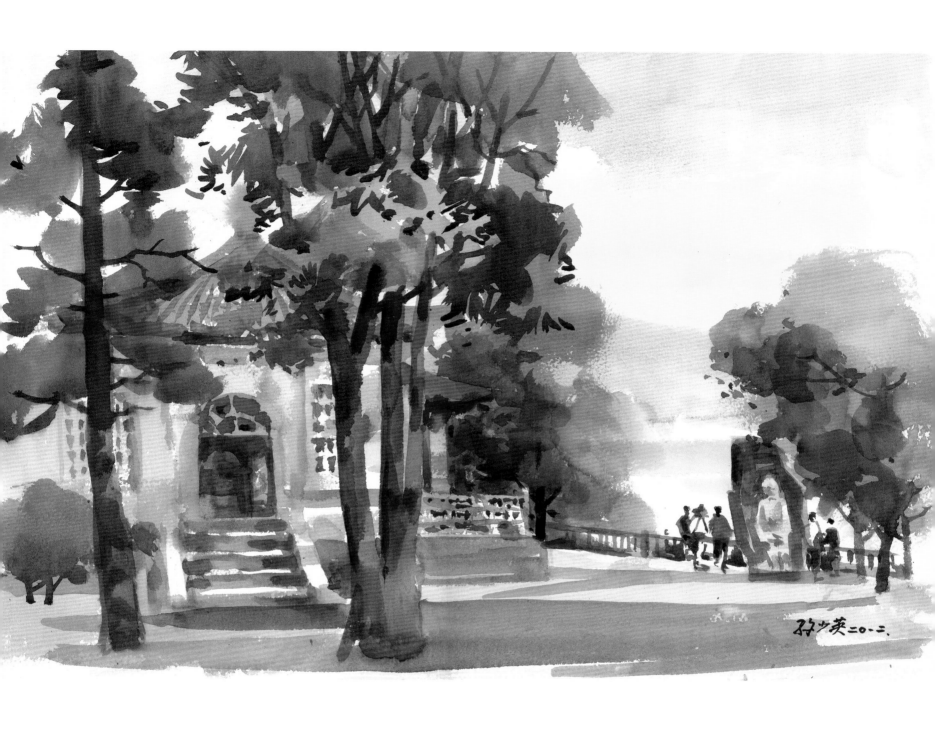

玄光寺（一）

Xuanguang Temple

39×57cm 2012

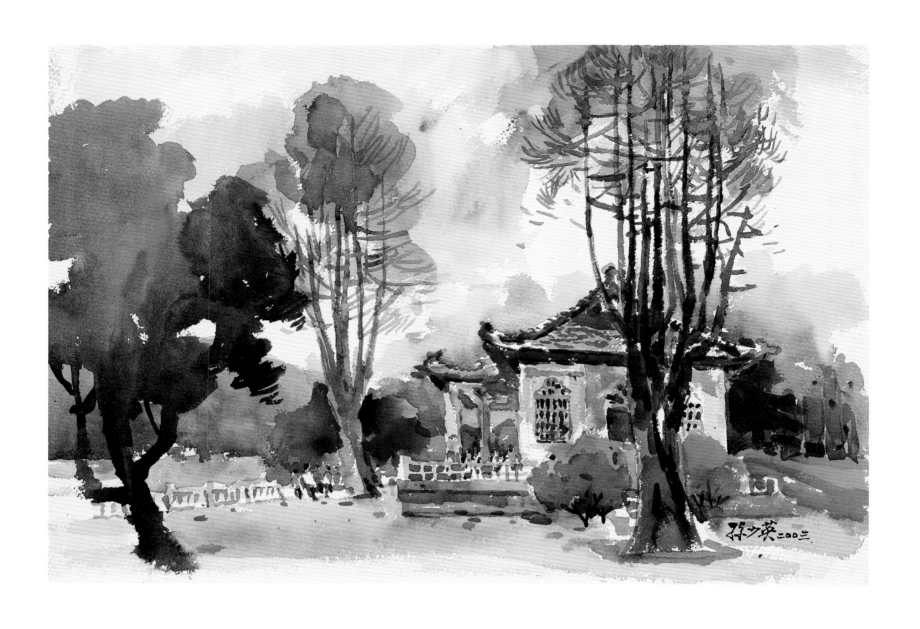

玄光寺（二）

Xuanguang Temple

39×57cm　2003

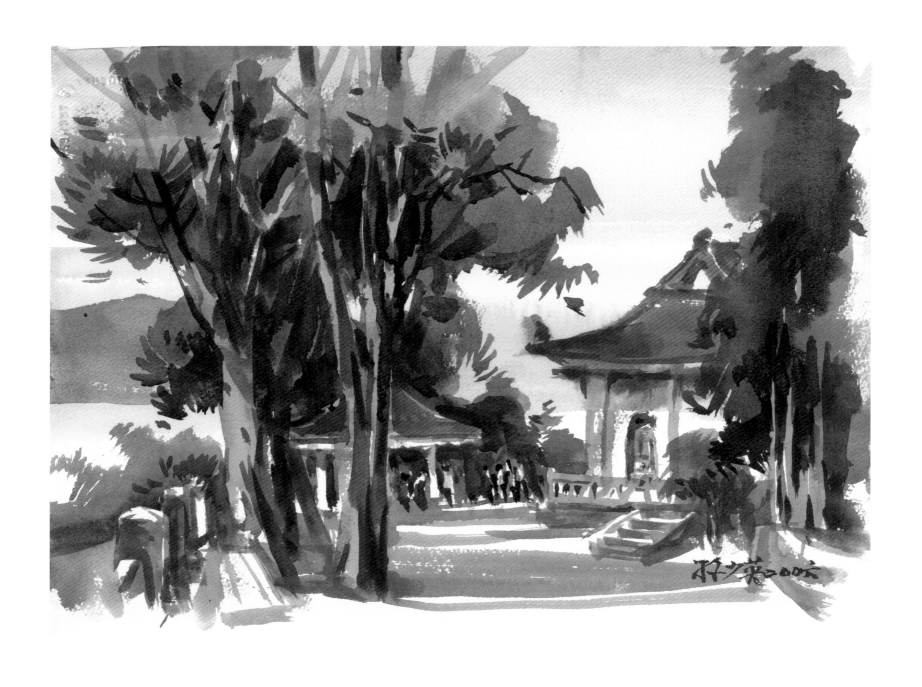

玄光寺（三）

Xuanguang Temple

39×57cm 2006

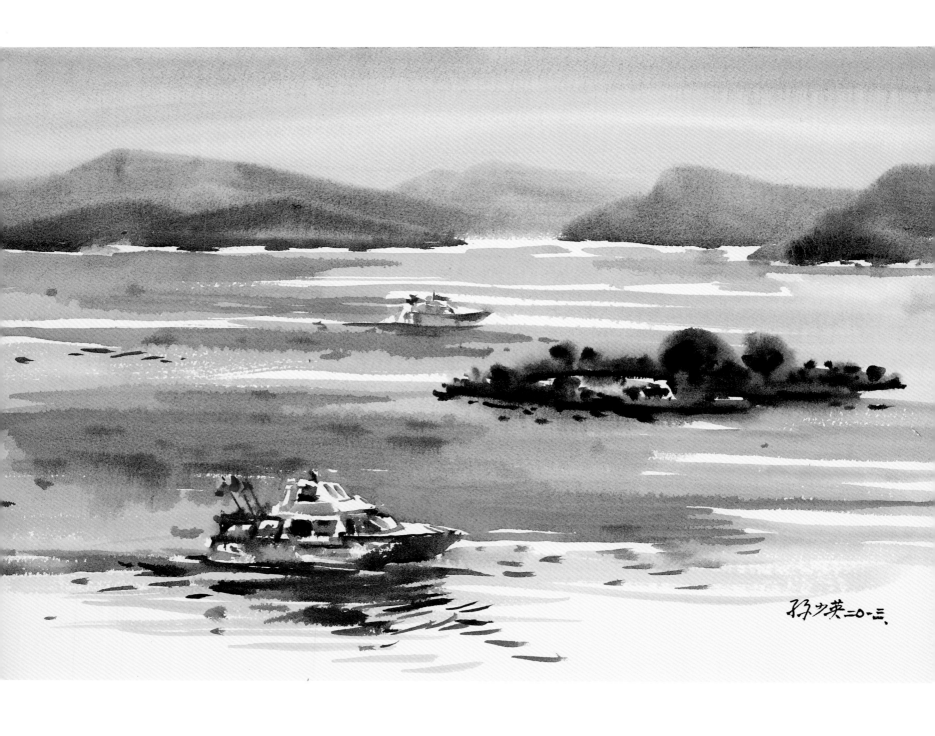

玄光寺湖面

Lake scenery by the Xuanguang Temple

57×78cm 2013

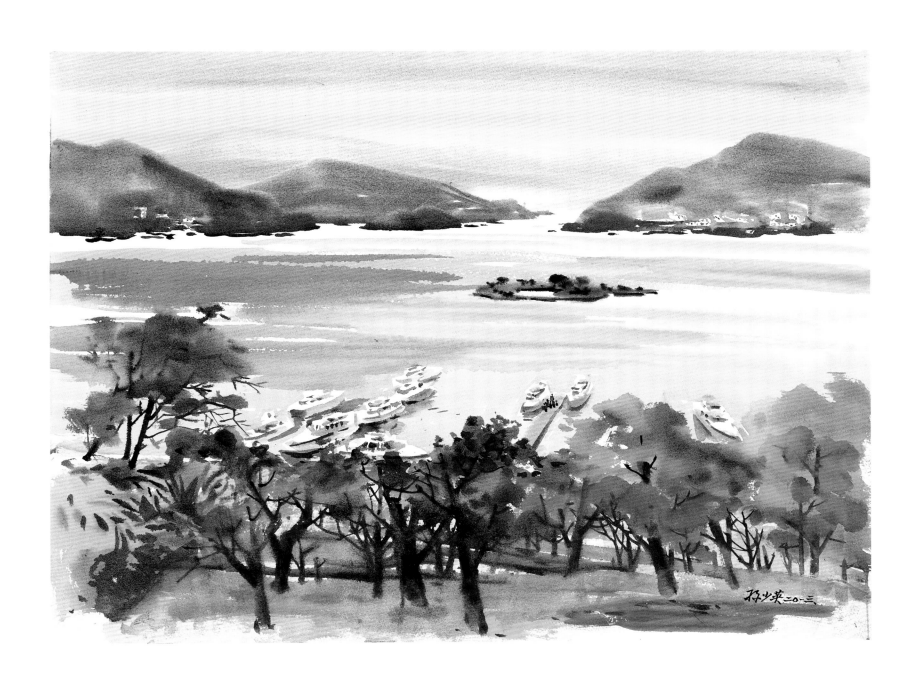

從玄光寺看拉魯島

Lalu Island Scenery from the Xuanguang Temple

39×57cm 2013

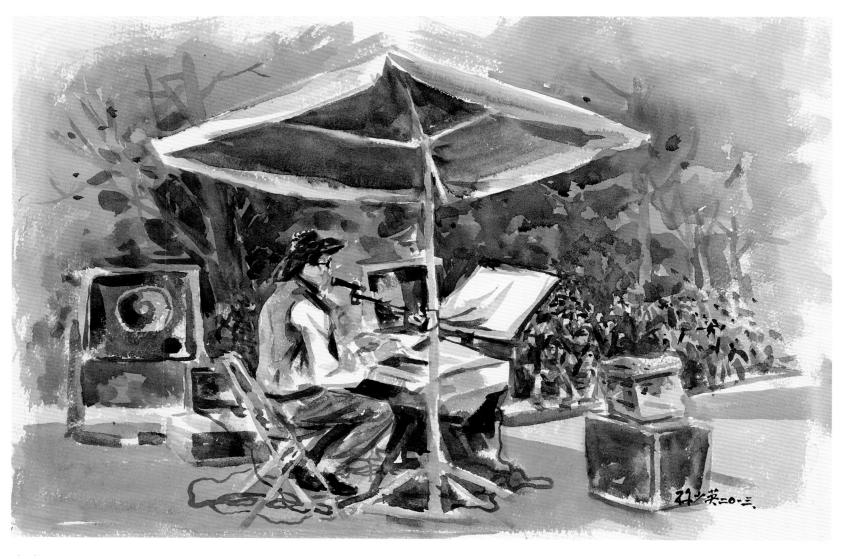

玄光寺街頭藝人孟寬先生

Street Performer Meng Kuan at the Xuanguang Temple

39×57cm　2013

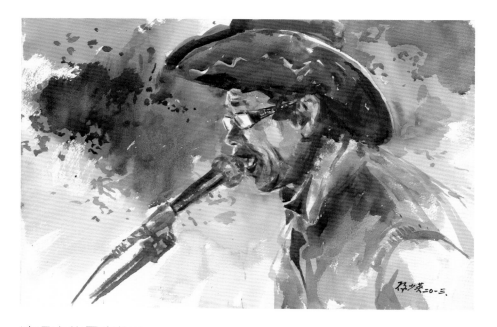

演唱中的孟寬先生

Mr. Meng Kuan's Singing

39×57cm　2013

玄光寺附設小亭專賣金盆阿嬤茶葉蛋

Jinpen Grandma Tea Egg Kiosk at the Xuanguang Temple Pier

39×57cm　2013

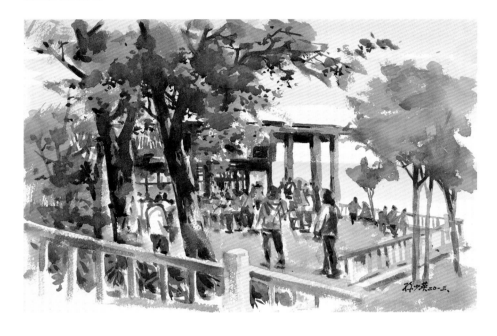

松樹間看玄奘寺

Xuanzhuang Temple Scenery from the Palm Woods

39×57cm　2006

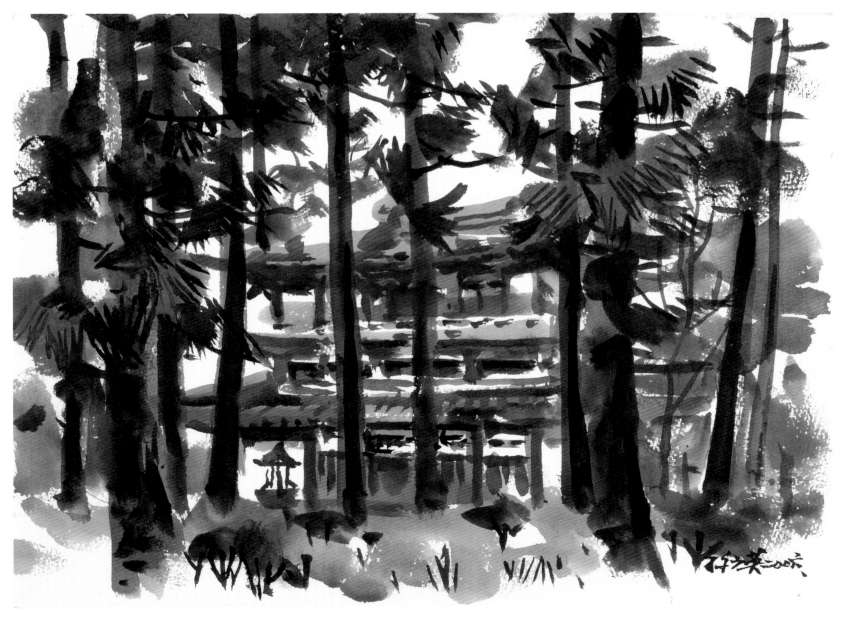

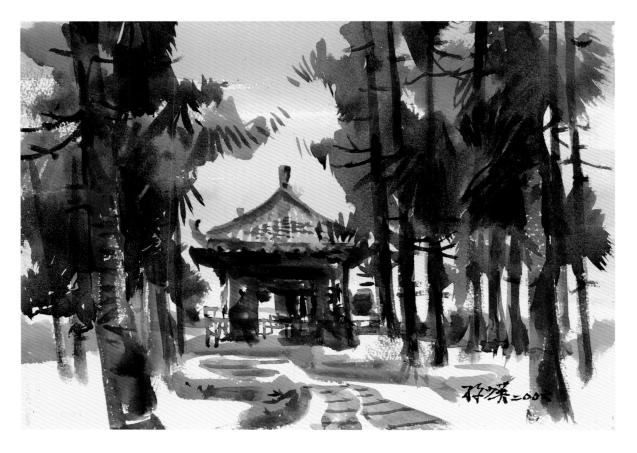

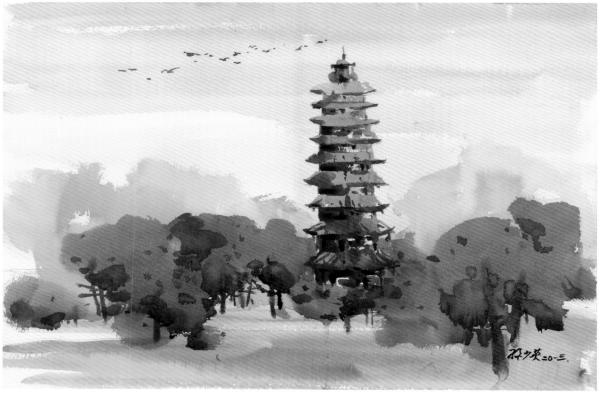

玄奘寺香亭

Xiang Kiosk at the Xuanzhuang Temple

28.5×39cm 2006

慈恩塔

Ci'en Pagoda

39×57cm 2013

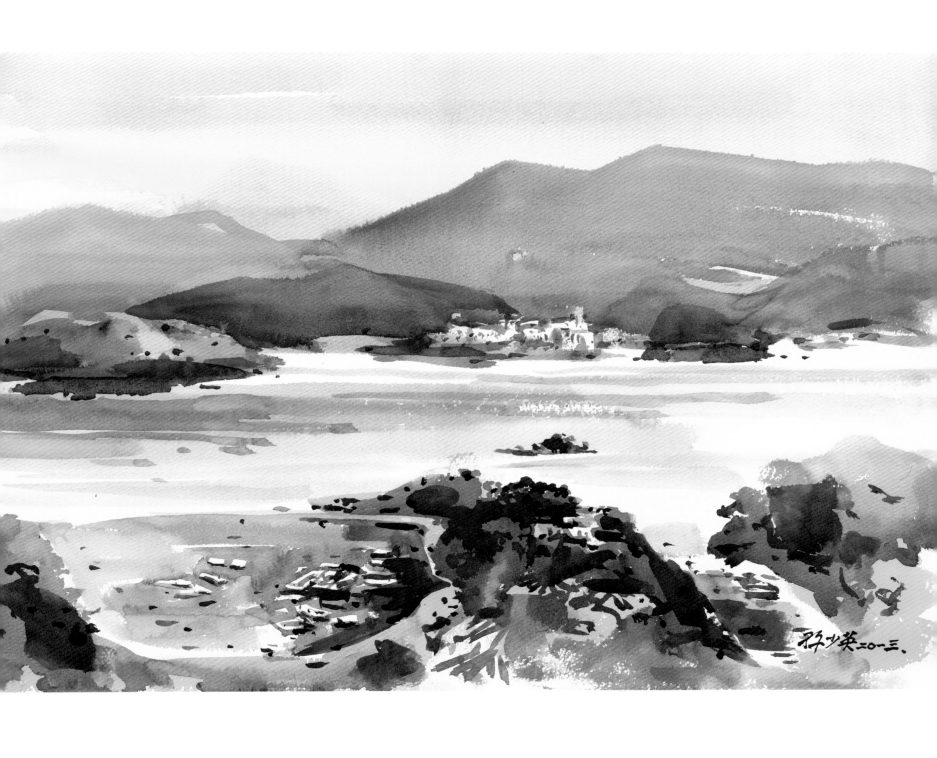

在慈恩塔頂層看日月潭

Sun Moon Lake View from the Top of the Ci'en Pagoda

39×57cm　2013

沙巴囒

沙巴囒山下是一處湖灣，原為日月潭唯一的修船塢，隨著科技進步，木造遊艇漸被淘汰，修船塢的功能也漸形消失。目前傳統的四角網船屋又再度多起來，當地居民，有的以網魚為生，也有的以船屋招攬遊客垂釣。網魚以日月潭原生種奇力魚最多，也有外來種紅魔鬼，魚肉鮮美，很受歡迎。垂釣則以曲腰魚為主，曲腰魚又名總統魚，刺多但味美，也很受青睞。

Shabalan

There is an arm of lake at the foot of Shabalan Mountain, originally the only repair dock of Sun Moon Lake. As the modern technology thrives, the wooden yachts have gradually been eliminated and functions of the repair dock have also slowly disappeared. Nowadays the traditional four-angle-net boathouses are flourishing again. The local inhabitants live on angling or providing netting service on the boathouse for visitors. The target for angling is mainly "kiluat" fish, native to Sun Moon Lake, and red devil fish, an alien species, is also very popular for its delicious meat. The target for netting is mostly skygazer, also called president's fish, which has a lot of fish bones but is also favored.

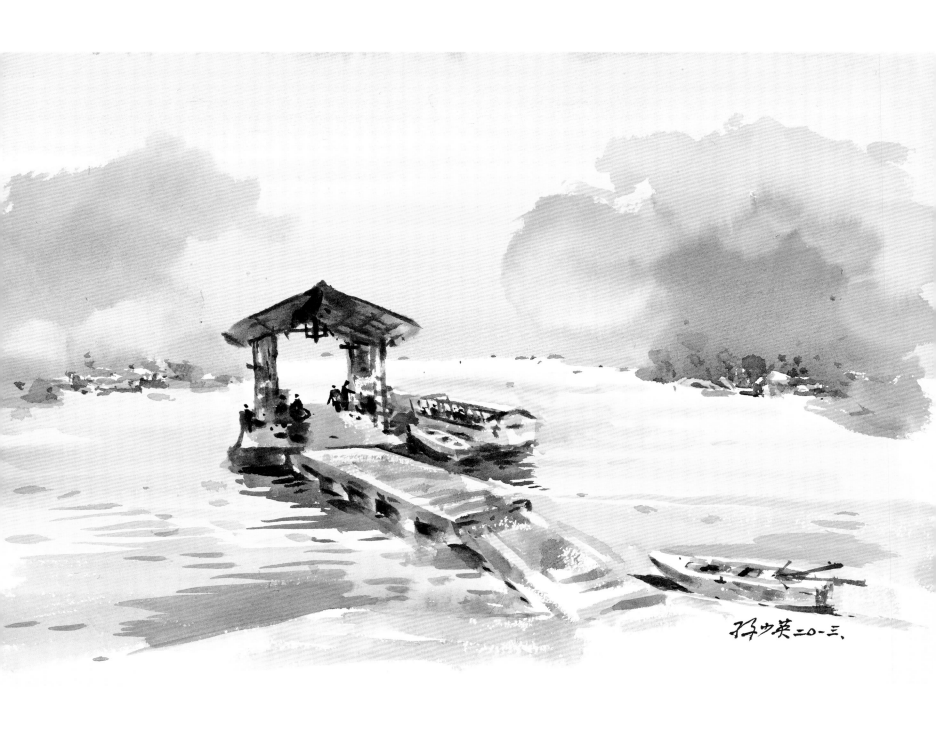

沙巴嘮簡易碼頭

Simple Shabalan Pier

39×57cm 2013

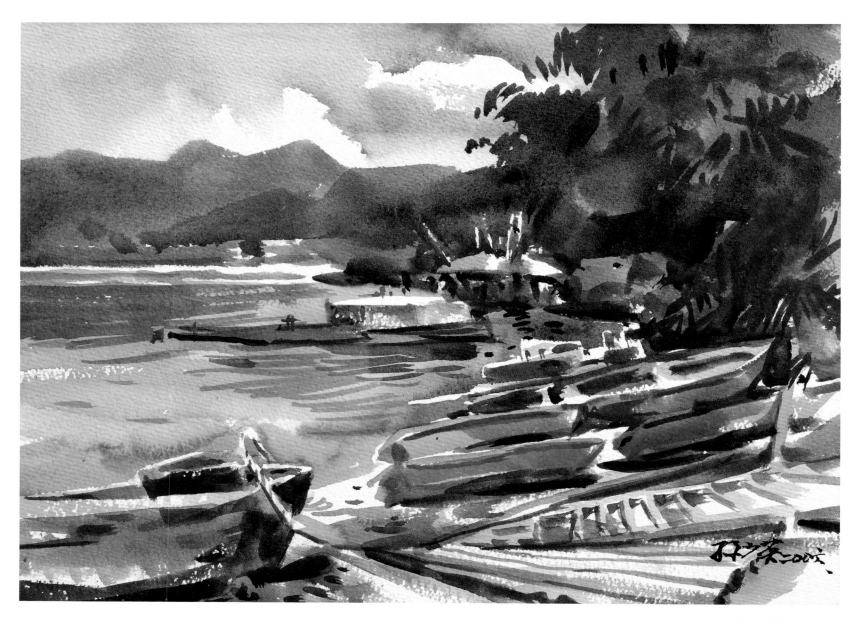

沙巴嘮修船塢

Shabalan Repair Dock

28.5×39cm 2006

沙巴嘮碼頭

Shabalan Pier

28.5×39cm 2000

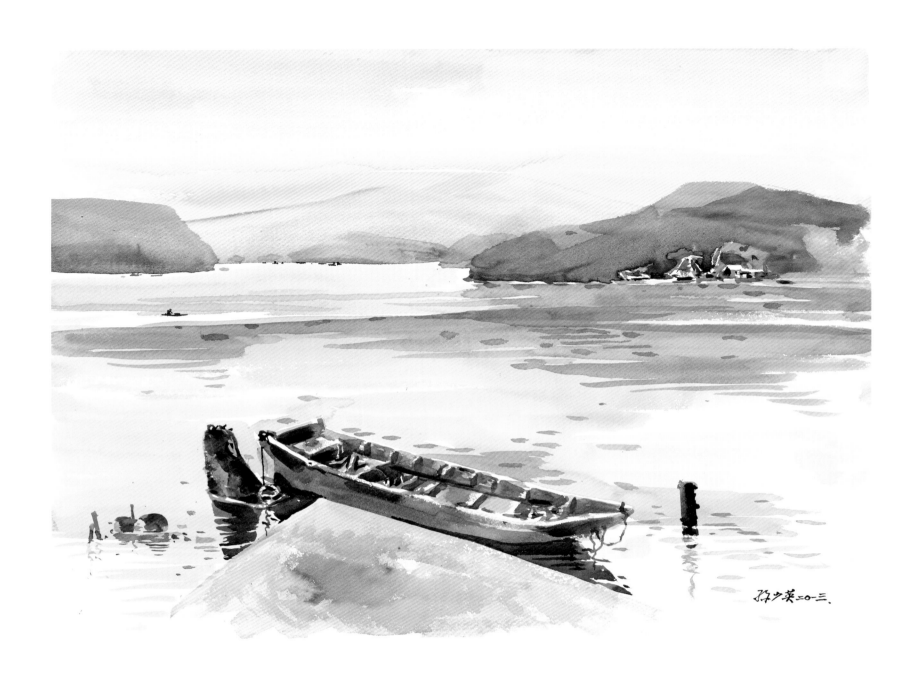

漁舟自橫

Unrestrained Boat

57×78cm 2013

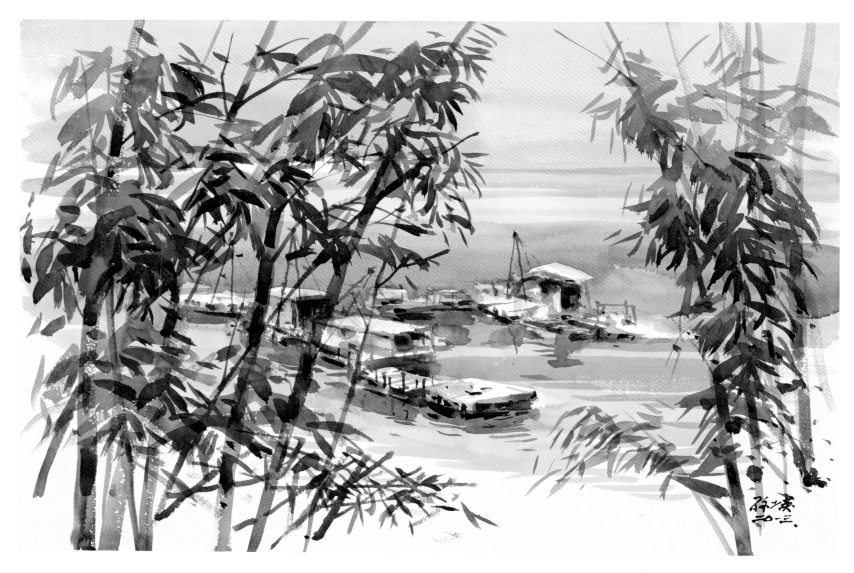

竹林間俯瞰船屋

Bird's-eye Boathouse view from the Bamboos

39×57cm 2013

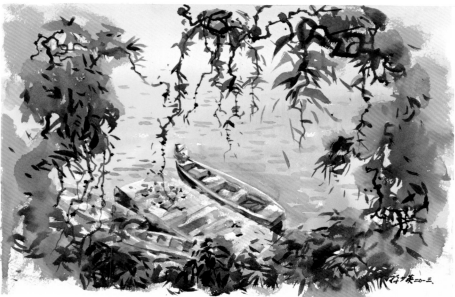

岸邊漁舟

Boats by the Lake Shore

39×57cm 2013

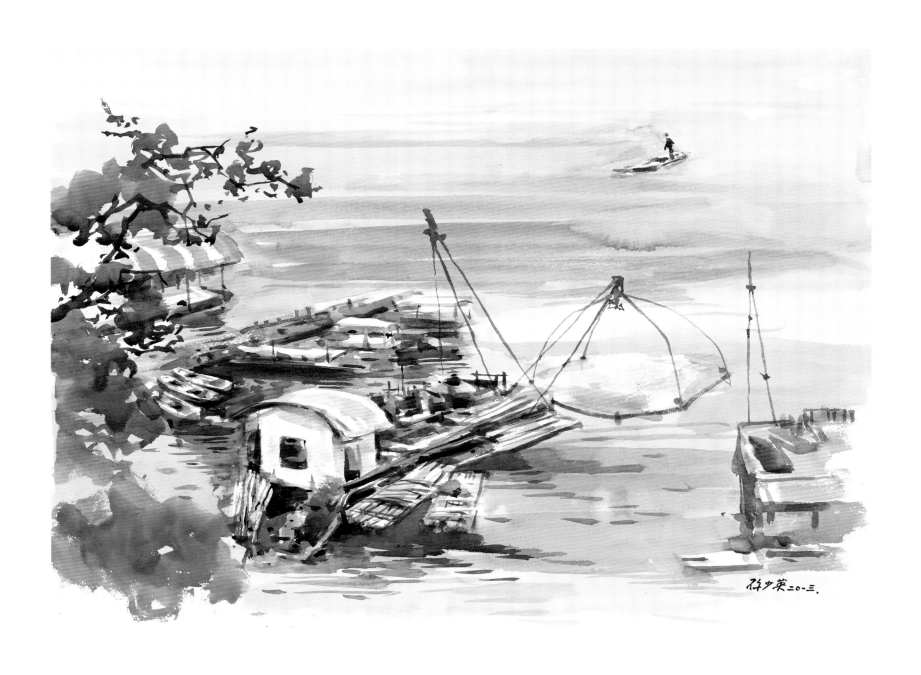

水上漁家

Fishing Households on the Lake

57×78cm 2013

網魚與垂釣

日月潭湖岸多彎曲，形成許多湖灣，漁民多在這些湖灣裡架設浮嶼，以利魚類滋生。浮嶼的做法是以竹林編成底座，上面敷土種草，魚類棲息草下，大量繁殖滋生，漁民則以四角網，晚上放下，早上拉起，天天都有收獲。

原住民還有一種工具叫魚筌，也是用竹子編成，編工很細，以捕蝦為主。

有人喜歡垂釣，會釣到大魚，除食用或賣錢外，也是一種樂趣。

Netting and Angling

The shore of Sun Moon Lake is winding, forming a lot of arms. Fishermen mostly set up small floating islets inside these arms to benefit the living of fish. The making of a small floating islet is by weaving a bottom base with bamboo, under which is covered by soils for planting. The fish can stay under the plants and abundantly flourishing. Fishermen use the four-angle nets, laid down at night and pulled up in the morning, so they harvest every day. There is another tool, called bamboo fish trap and finely woven, for indigenous people to catch shrimp. Some people like angling for big fish, which is a kind of pleasure; and the fish can be eaten or sold.

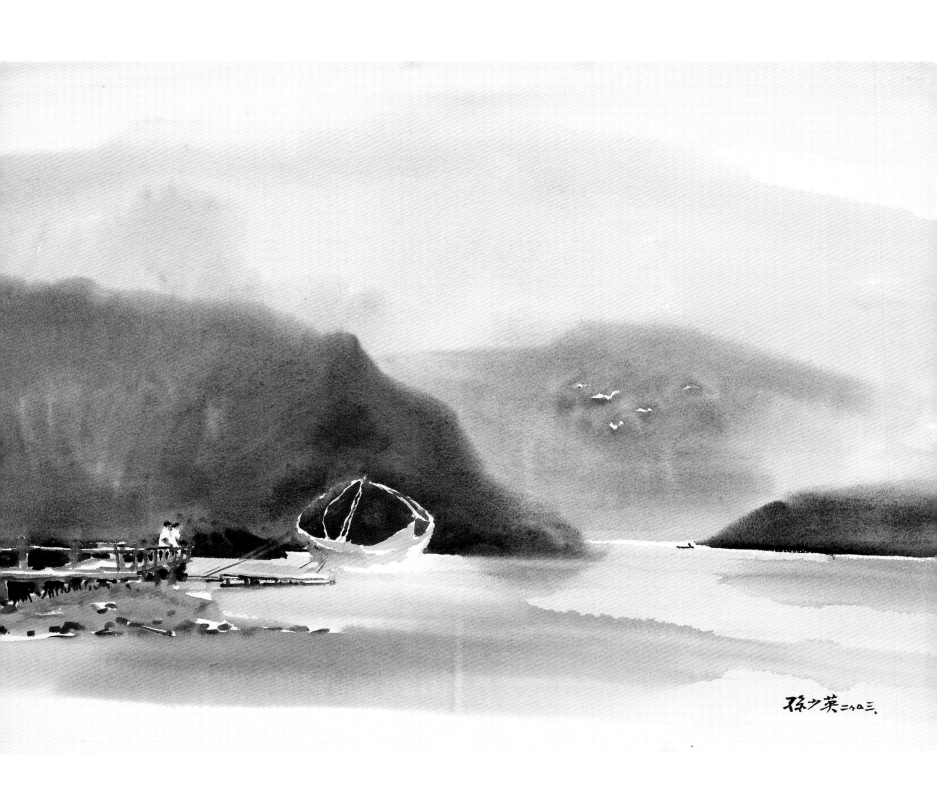

大竹湖四角網

Four-angle Net at Dazhu Lake

57×78cm　2003

魚筌

Bamboo Fish Traps

39×57cm 2013

多種魚類都在浮嶼下滋生

Various Fish Living beneath Small Floating Islets

76×148.5cm 2013

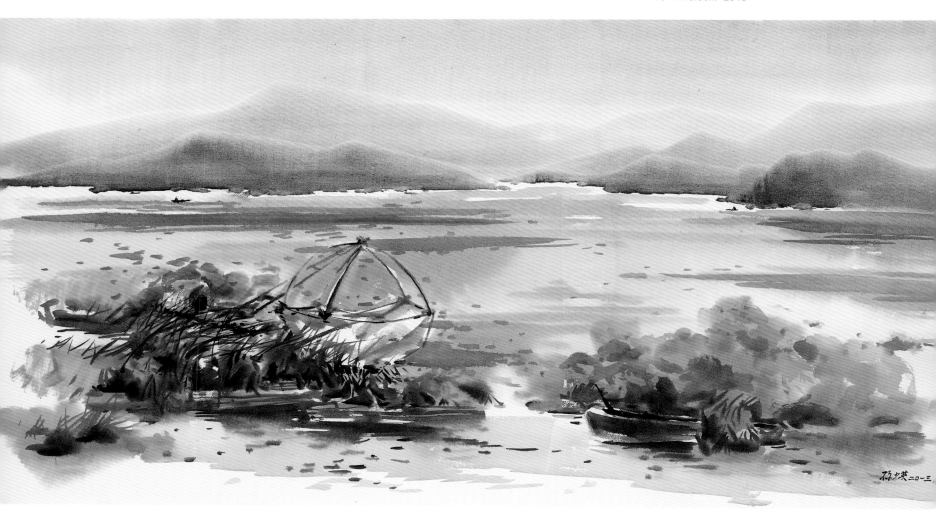

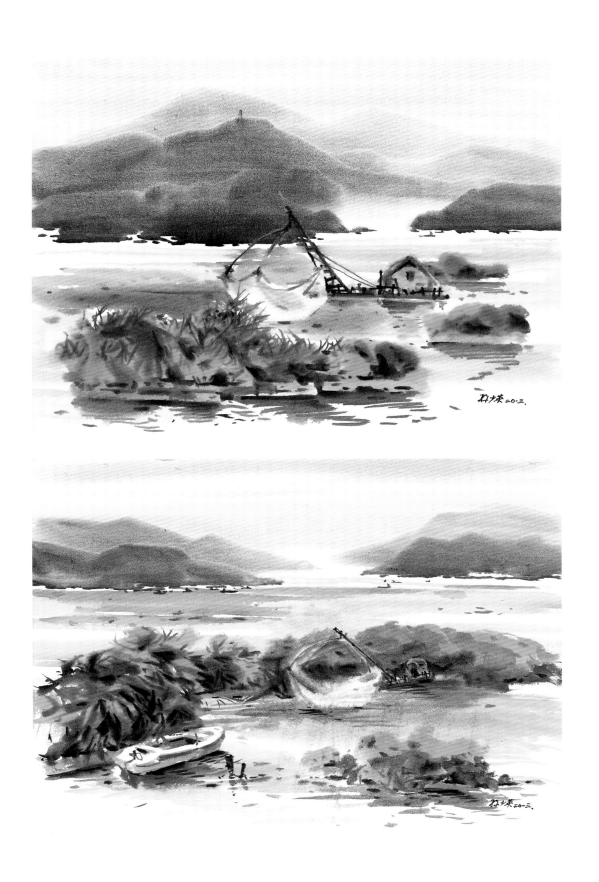

浮嶼間的四角網

Four-angle Net among Small Floating Islets

57×78cm 2013

改良的四角網

Improved Four-angle Net

57×78cm 2013

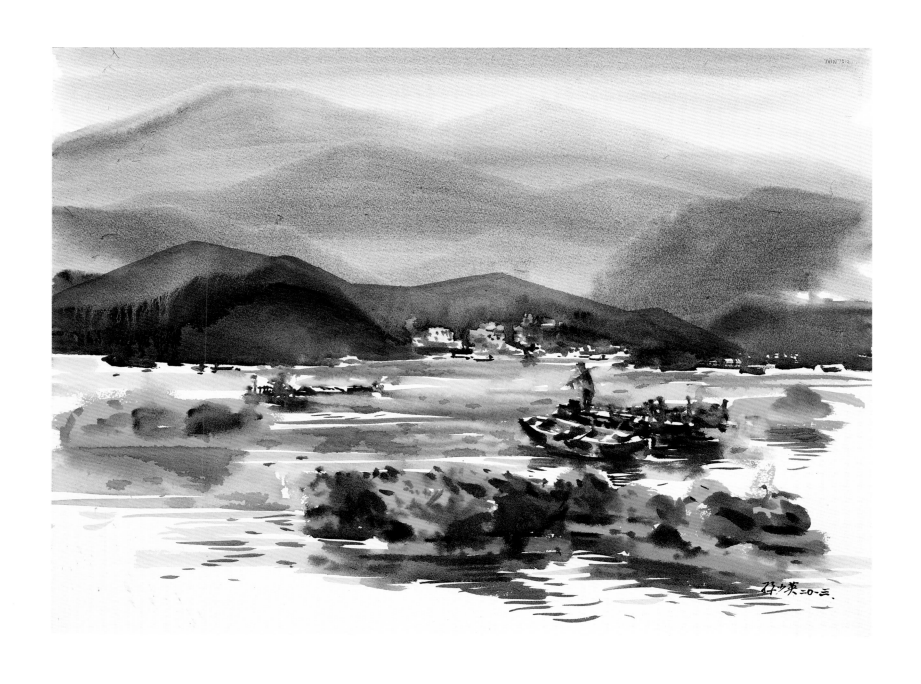

獨釣（一）

Fishing Alone

57×78cm　2013

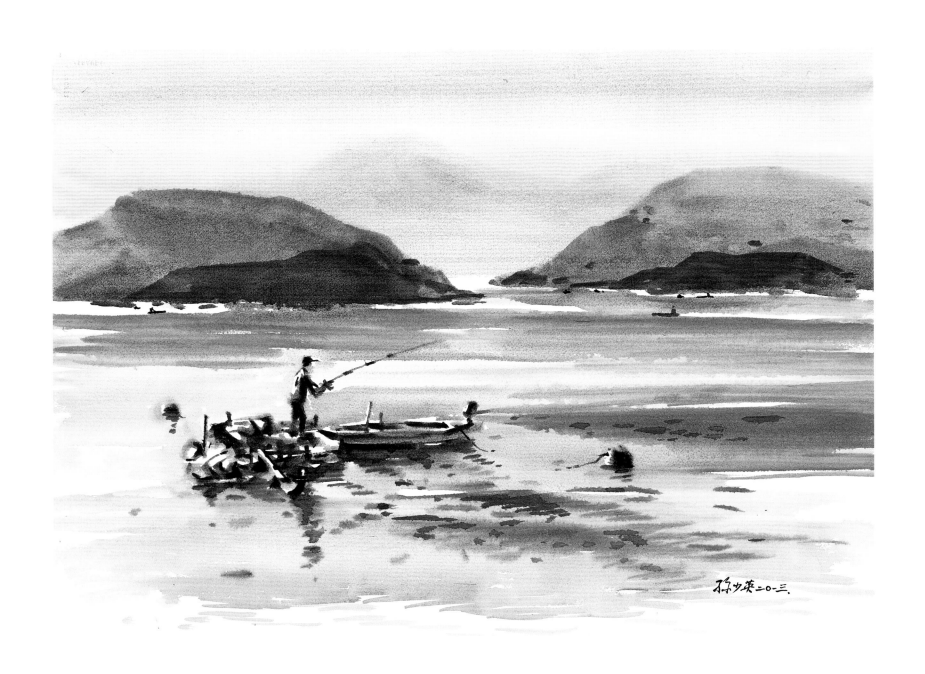

獨釣（二）

Fishing Alone

57×78cm 2013

頭社

頭社早年是一個湖泊，地形較圓，與現在的日月潭合稱為日月潭。後來湖水漸漸乾涸，形成一個盆地，外地居民陸續遷來，種植水稻及菜蔬。年輕居民王順瑜近年試種金針花成功，觀光、食用，一舉兩得。王順瑜又在村內以合作社方式與村民合力推廣農產及加工品，初試順利，現正全力研發經營，利潤逐年增加。

另外頭社有一種原生樹種—頭社柳，樹根有護坡作用，樹花呈金黃色，有觀光價值，本來將要絕種的情形下，王順瑜大量繁殖成功，這可能也是頭社的另一可貴資源。

Toushe

Toushe was a lake in early years, topographically circular, as a part of present-day Sun Moon Lake. Later the lake was drained and a basin was formed. The inhabitants gradually moved in from other places to grow paddy rice and vegetables. The young inhabitant Wang Shun-yu has succeeded in growing orange daylily in recent years, which becomes a tourist attraction and food product. Mr. Wang also founded a cooperative society in the village to promote farm produce and products. His initial trial was successful. They are now sparing no efforts to research and develop, and their profits are increasing annually.

In addition, Toushe has a native species of willow tree. Its roots can protect the slopes and golden flowers possess tourist value. It was originally on the verge of extinction, but now greatly bred by Mr. Wang, which becomes another precious resource for Toushe.

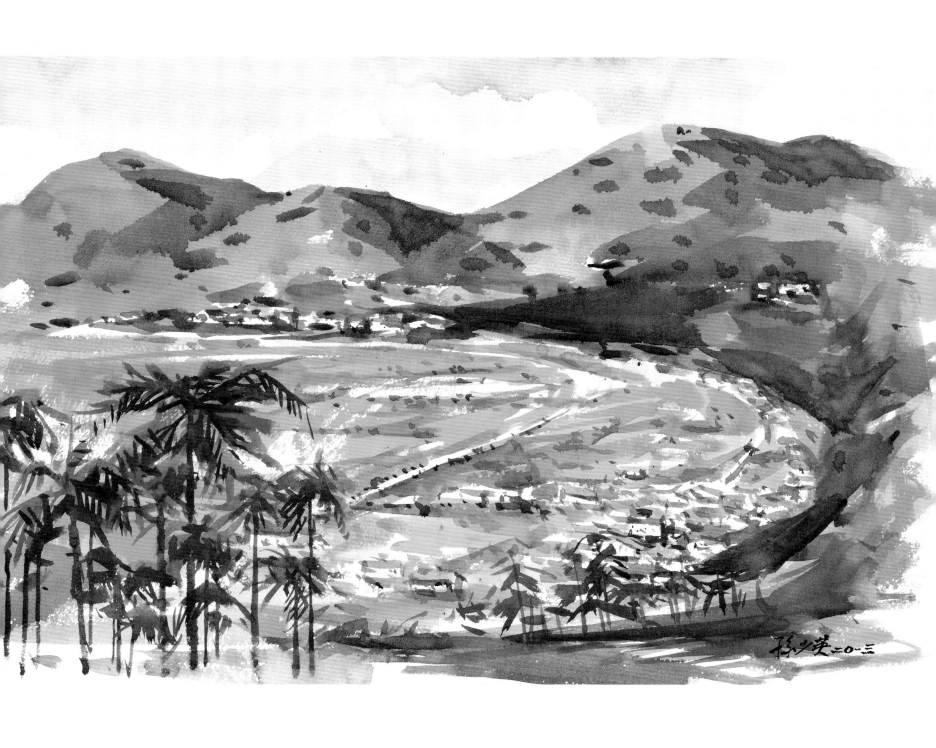

頭社盆地

Toushe Basin

39×57cm 2013

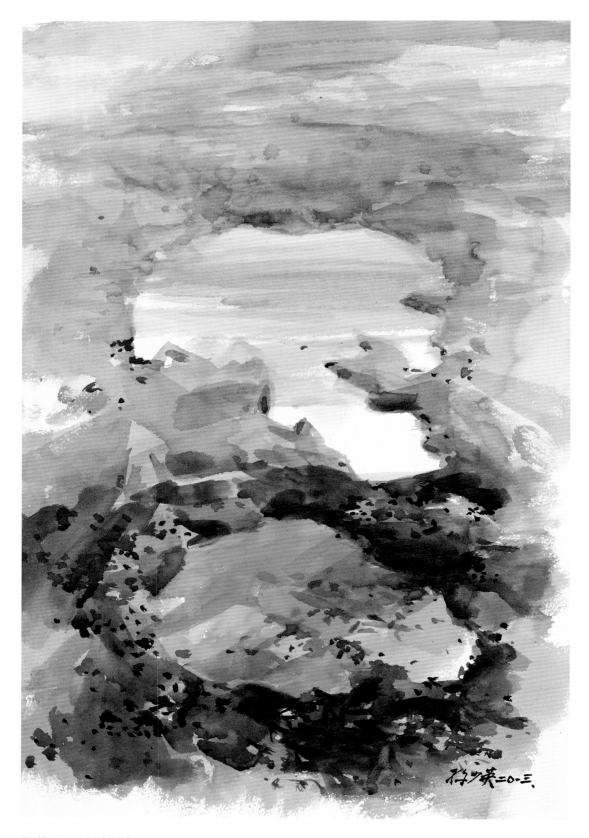

早期日月潭模擬圖

Sun Moon Lake Simulated Picture in Early Years

57×39cm 2013

上方　現在日月潭（原為月潭）
　　　Sun Moon Lake (Former Moon Lake)

下方　現在頭社（原為日月潭）
　　　Toushe (Former Sun Moon Lake)

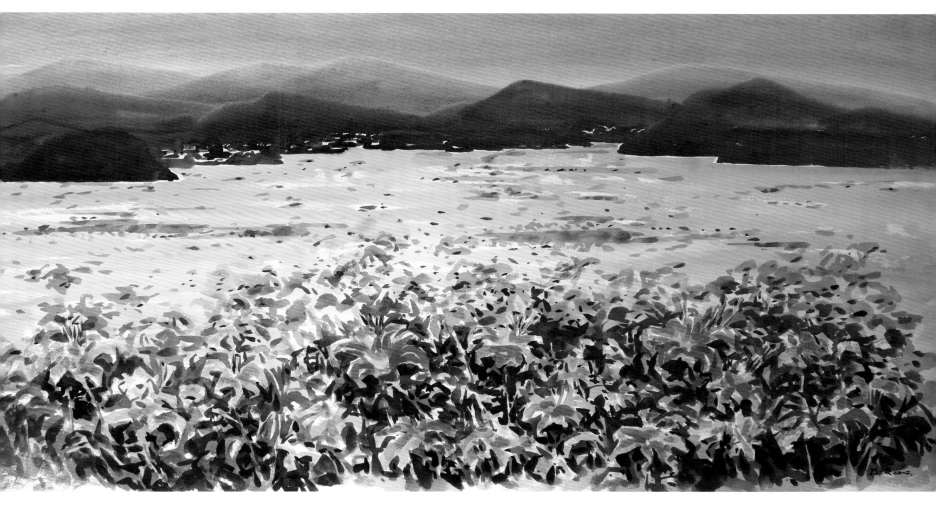

頭社金針花田

Orange Daylily Fields at Toushe

76×148.5cm 2012

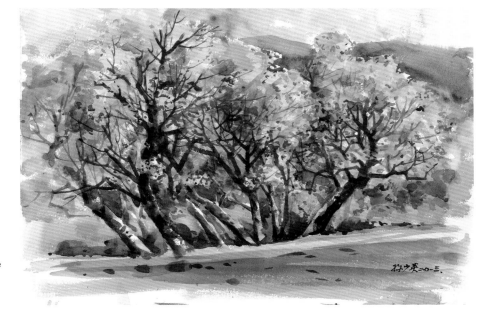

頭社柳

Willow Trees at Toushe

39×57cm 2013

向山

向山在頭社與水社之間，建有日月潭向山遊客中心，遊客中心的建築是由日本建築師團紀彥（Dan Norihiko）所設計，理念是與大自然及當地環境完全結合，不突兀、不誇張。來到現場，看看那種含蓄、純淨、流暢、平衡的畫面，的確令人覺得美好極了。每天遊客那麼多，是有道理的。

向山步道腳踏車道及附近環境也都規劃得非常優美，臨湖的咖啡大廳也寬敞舒適。向山本來是日月潭的偏遠地區，因為遊客中心的規劃成功，使這塊偏遠地方活起來了。

Xiangshan

Xiangshan lies between Toushe and Shuishe, including the building of Xiangshan Visitor Center of Sun Moon Lake. The architecture of Visitor Center was designed by the Japanese architect Dan Norihiko from a concept of complete integration of nature and local environment without prominence or exaggeration. It is really beautiful and wonderful to see a reserved, pure, smooth and balanced picture on the site. No wonder it attracts so many tourists every day.
The bike and pedestrian bridge of Xiangshan and its surroundings are all elegantly planned. The lobby of lakefront café is cozy and spacious. Xiangshan is a remote area of Sun Moon Lake, but because of the successful planning of Visitor Center, it has been revived.

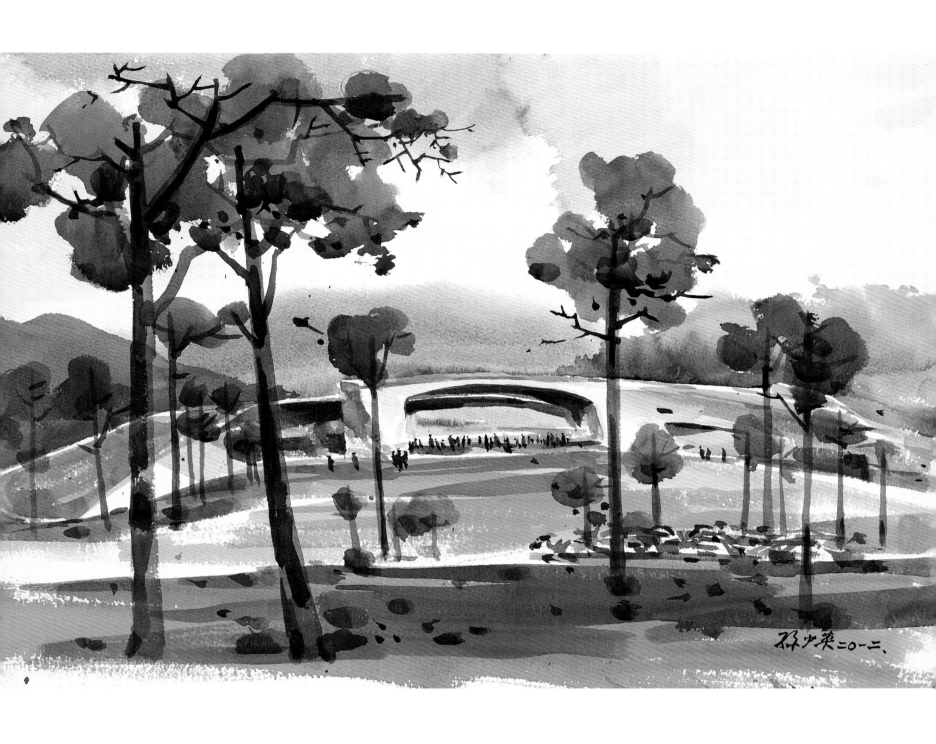

向山遊客中心
Xiangshan Visitor Center
39×57cm 2012

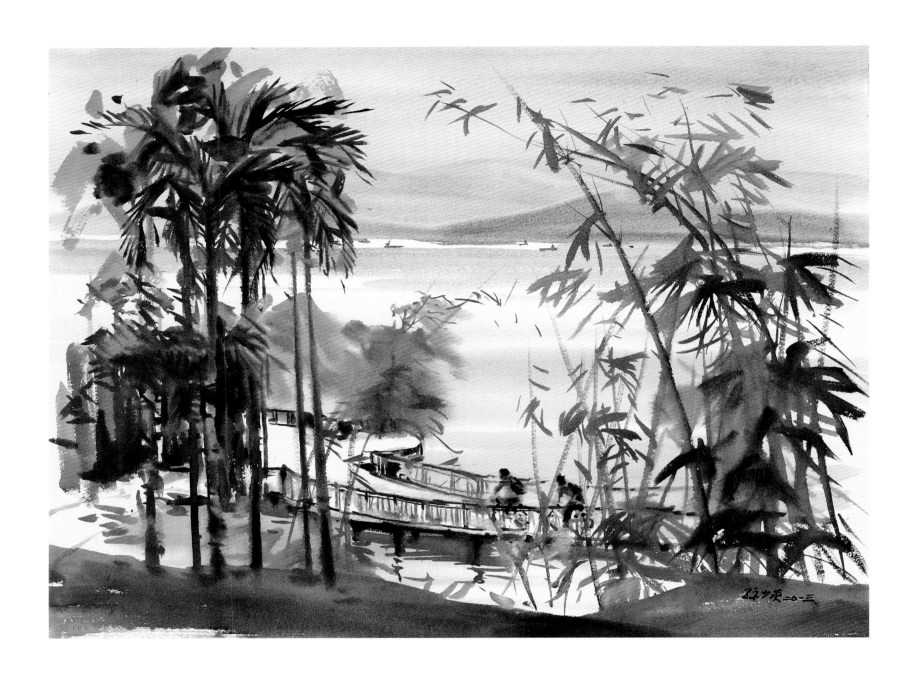

自行車步道（一）

Xiangshan Bike and Pedestrian Bridge

39×57cm 2013

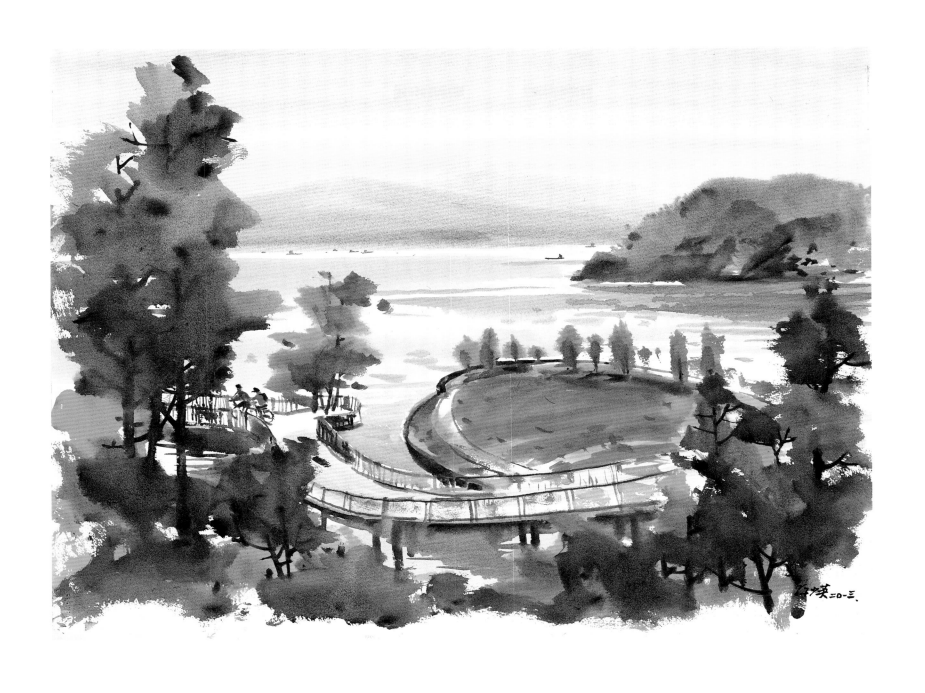

自行車步道（二）

Xiangshan Bike and Pedestrian Bridge

39×57cm 2013

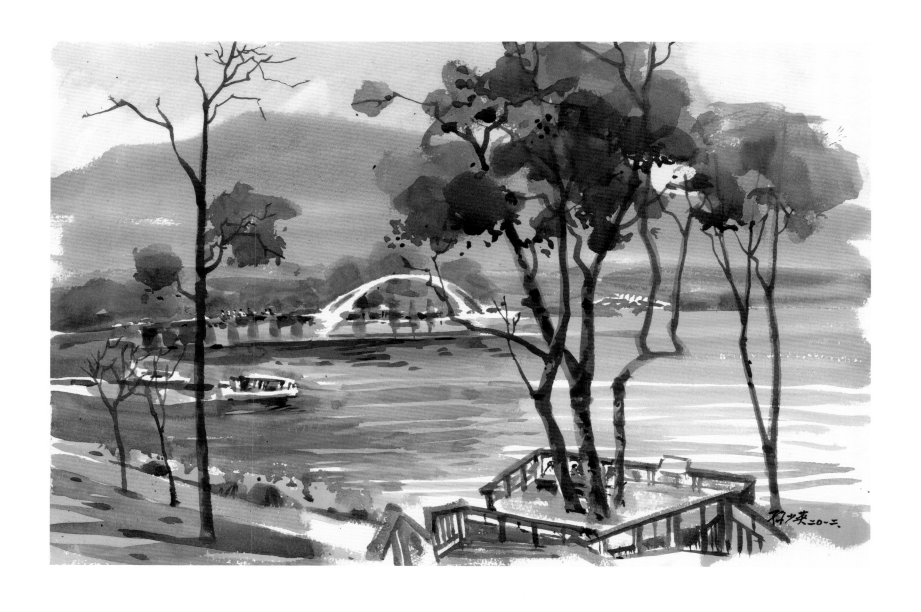

向山湖面

Lake Scenery at Xiangshan

39×57cm 2012

向山附近步道

Trail near Xiangshan

39×57cm 2012

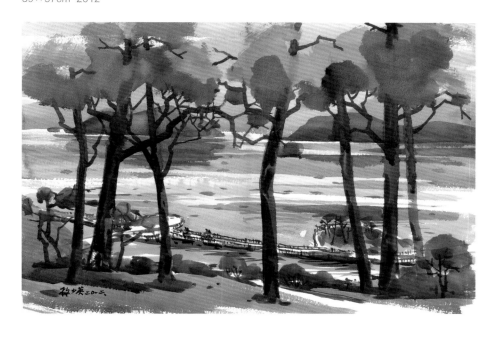

自行車步道另一段

View of the Xiangshan Bike and Pedestrian Bridge

39×57cm 2013

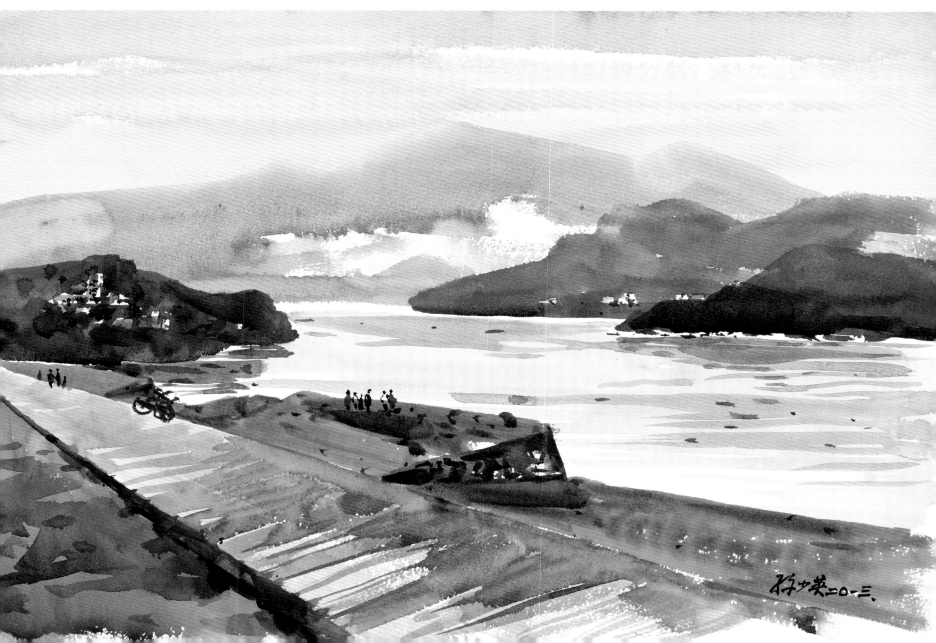

金盆阿嬤

金盆阿嬤賣茶葉蛋已經五十餘年了，除了在自己家門口賣以外，日月潭玄光寺碼頭邊是她主要賣點，生意比家門口好得多。

金盆阿嬤今年八十三歲，但仍守著親手設計的鍋爐，顧著爐子上熱呼呼的茶葉蛋。很多外地遊客慕名湧來，阿嬤常常忙得不可開交；阿嬤雖然年紀大了，身體還算硬朗，應付七嘴八舌的年輕人，也是一件樂事。

吃過阿嬤茶葉蛋的人，都會伸大拇指說聲讚。阿嬤說她的茶葉蛋香料香菇必定要挑選最好的不在乎價錢；而阿薩姆紅茶也得要優等的才行。阿嬤茶葉蛋好吃，人也親切可愛，今後慕名而來的人，鐵定只會多不會少。

Grandma Jinpen's Stand

It has been more than 50 years since Grandma Jinpen began to sell tea-flavored eggs. Besides the stand at the entrance of her home, she mainly sells at the pier of Xuanguang Temple where her business is much better. Grandma Jinpen is 83 years old now, but she still guards the boiler of her own design, tending the piping hot tea-flavored eggs. Many outside visitors are attracted by her fame and crowd in, making Granma extremely busy. Grandma may be old but rather healthy. It is fun for her to deal with the noisy young people.

All the people who have eaten Grandma's tea-flavored eggs would give the thumbs-up and praise it. Grandma said she must choose the best spices and dried mushroom for her tea-flavored eggs regardless of price and the Assam black tea also needs to be excellent. The tea-flavored eggs of Grandma are delicious, and she is also sweet and adorable. From now on, there should be more and more visitors attracted by her reputation.

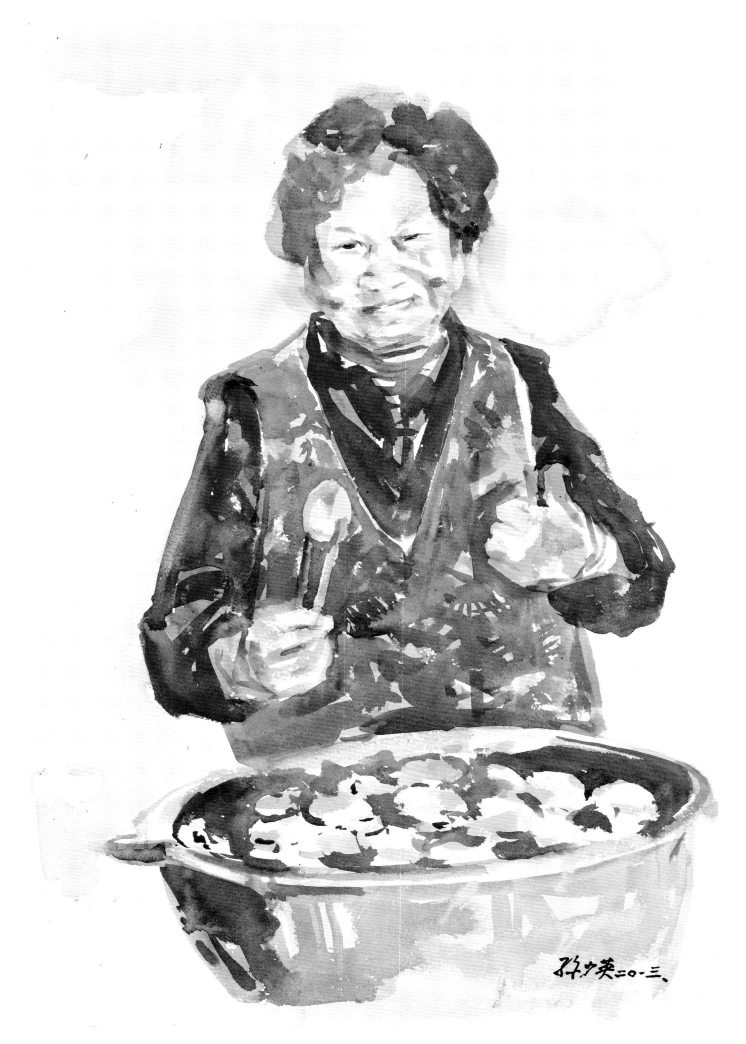

阿嬤茶葉蛋熱賣

Hot-selling Grandma Jinpen's Tea-flavored Egg

57×39cm 2013

忙碌中的阿嬤

Grandma Jinpen Is Busy at Work

28.5×39cm×4 2013

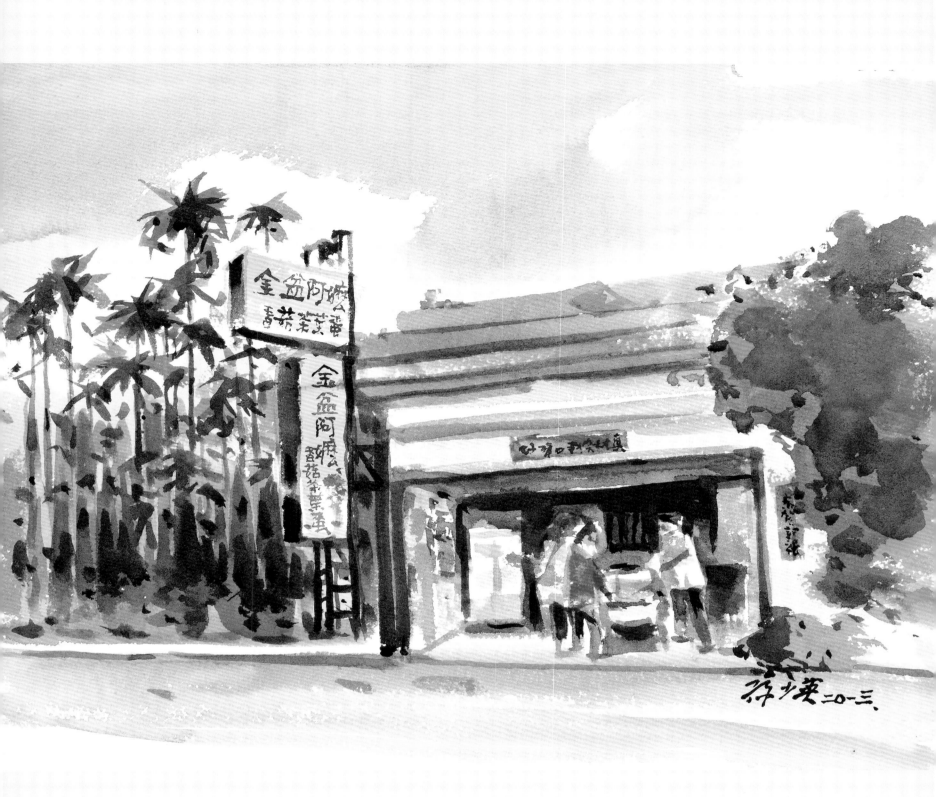

阿嬤的家

Grandma Jinpen's Home

28.5×39cm 2013

貓囒山

著名的台灣紅茶改良廠設在貓囒山上，對台灣紅茶品質的提昇及拓展有莫大的貢獻。

改良廠四周都是茶園，在綠油油的茶園中遙望日月潭的美景自有一種清涼透心的舒暢感覺。

風管處在山上建有步道及涼亭，供遊客漫步休憩。每天日出前常有攝影家在這裡獵取日月潭清晨寧靜多彩的風貌。

Mt. Maolan

The famous Taiwan Black Tea Factory is located on the Mt. Maolan, which has enormously contributed to the quality improvement and promotion of Taiwan black tea. The factory is surrounded by tea fields. To look into the distance over Sun Moon Lake from the green tea fields generates a cool and refreshing feeling that soothes the heart.

湖畔茶園

Tea Field by Lakeside

28.5×39cm 2006

日月潭周邊

目前日月潭周邊的鄉鎮如魚池、埔里、水里、集集、車埕都已納入了日月潭觀光體系，共謀發展，以擴大觀光資源和效果。

這些鄉鎮都各有特色，如魚池的九族文化村，埔里的美人腿茭白筍，水里的蛇窯，集集的火車站，車埕的木業遺產等等，都是日月潭套裝旅遊的上選資源。

Around the Sun Moon Lake

Presently the surrounding townships like Yuchi, Puli, Shuili, Jiji and Checheng of Sun Moon Lake are all included in the Sun Moon Lake tourism system to cooperatively develop in order to expand the tourist resources and effects.

Each of these townships has its own features, such as Yuchi's Formosan Aboriginal Culture Village, Puli's "beauty's leg" water bamboo shoots, Shuili's Snake Kiln, Jiji Station and Checheng's wood industry heritage. All are the top-priority resources for Sun Moon Lake package tours.

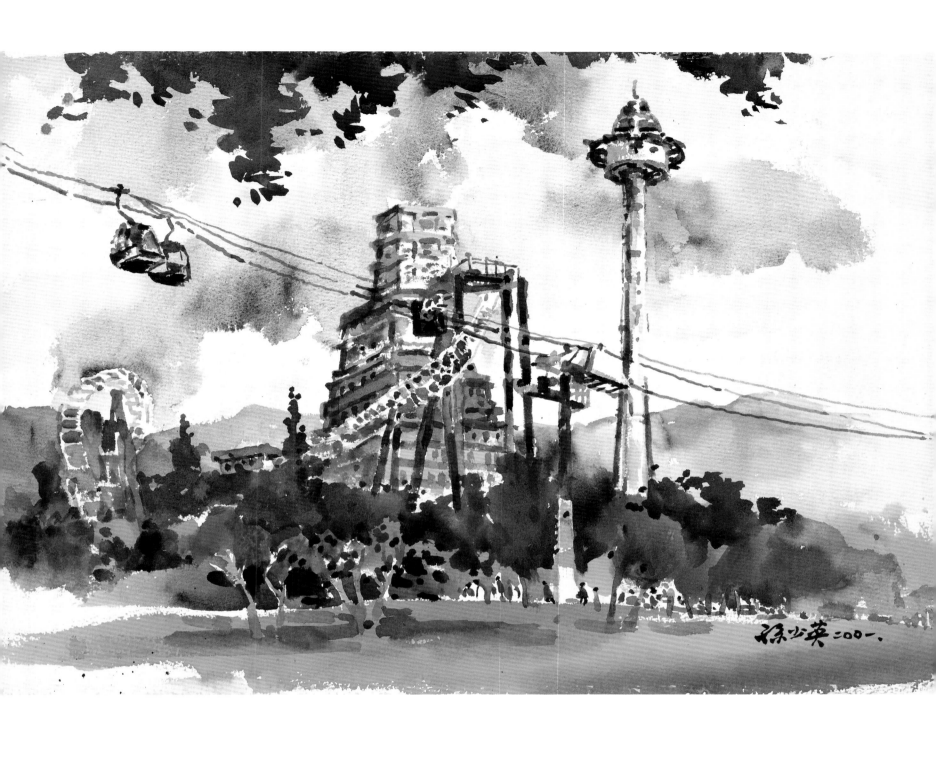

遊樂設施

Entertainment Facilities at the Formosan Aboriginal Culture Village

39×57cm　2001

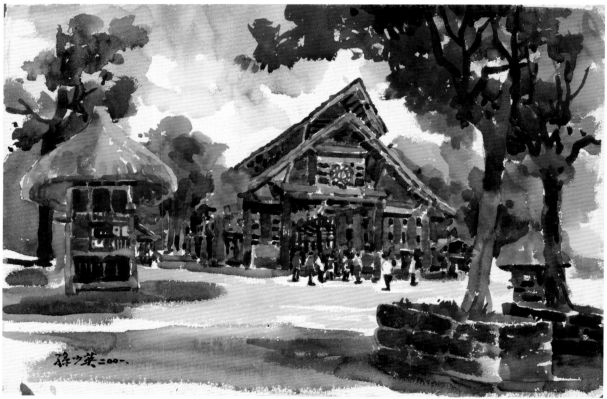

九族文化村遊客中心

Formosan Aboriginal Culture Village Visitor Center

28.5×39cm 2013

九族文化村大門

Entrance Gate of the Formosan Aboriginal Culture Village

39×57cm 2001

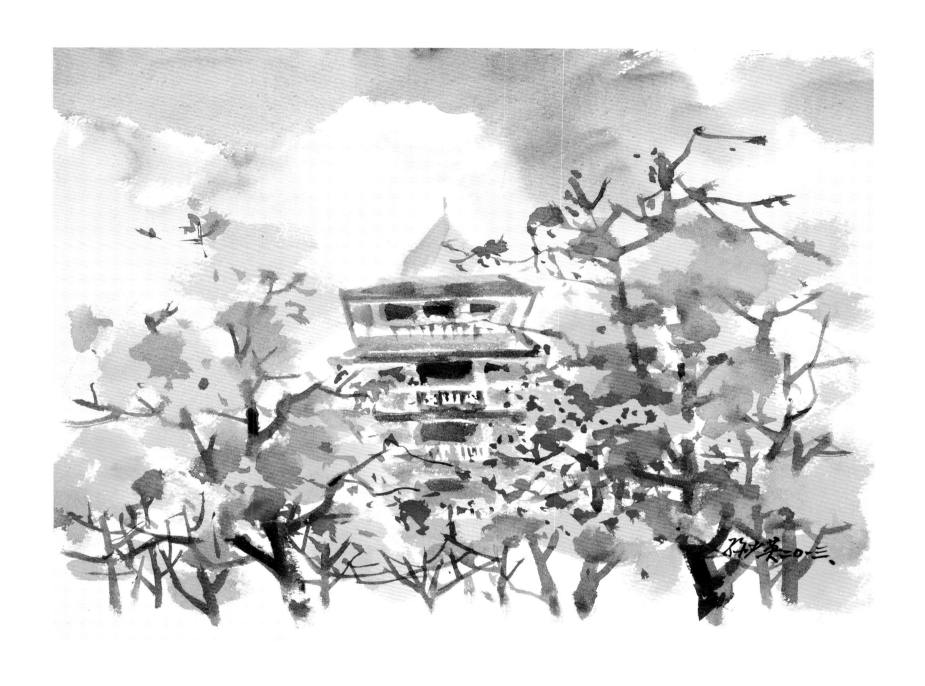

觀景樓

Observation Pavilion

28.5×39cm 2013

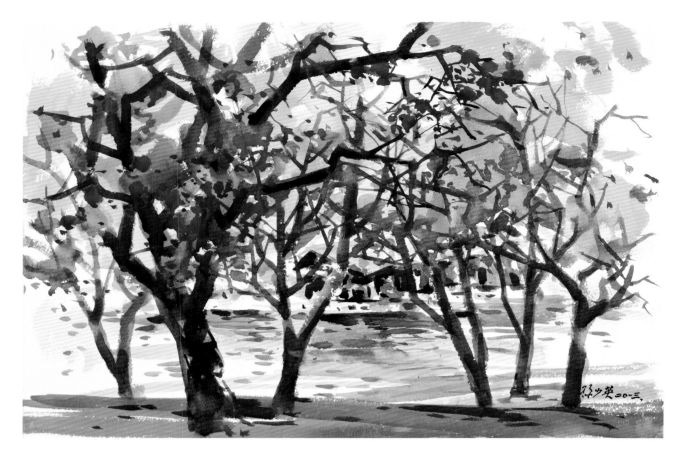

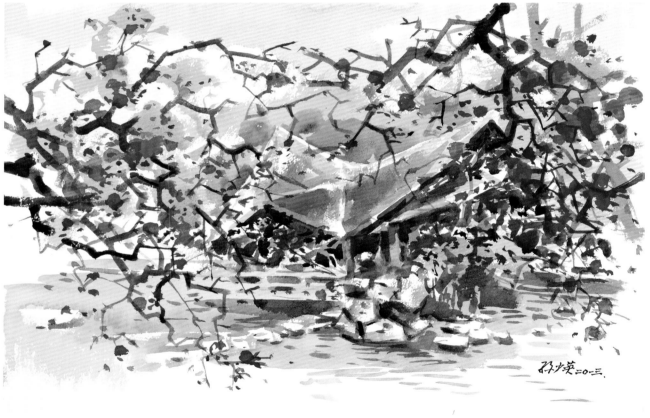

櫻花盛開（一）

Cherry Blossoms

39×57cm 2013

櫻花盛開（二）

Cherry Blossoms

39×57cm 2013

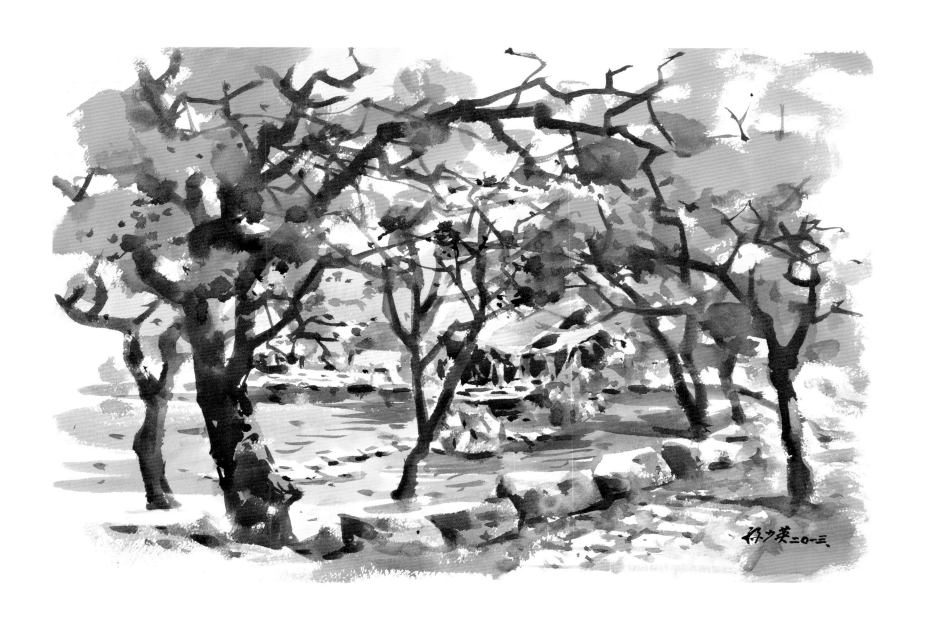

櫻花謝　綠葉生

Cherry Blossoms Fall, Green Leaves Sprout

39×57cm　2013

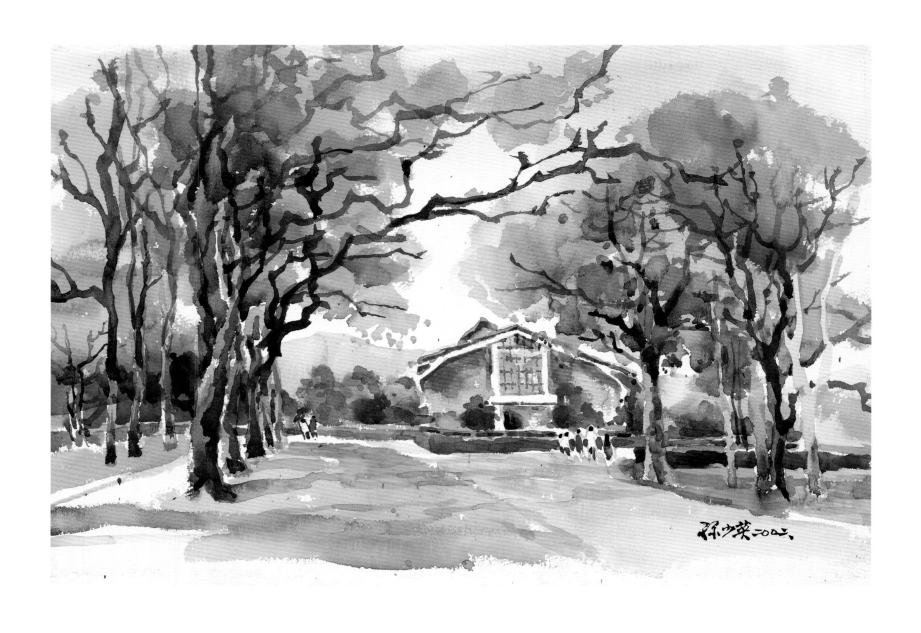

魚池鄉的三育學院

Taiwan Adventist College at Yuchih Town

39×57cm 2002

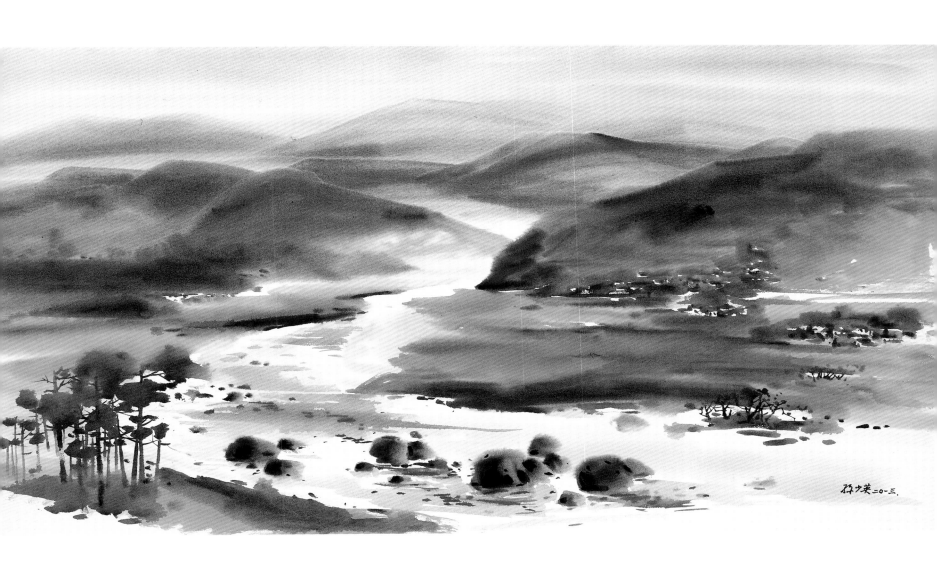

埔里眉溪

Mei Stream at Puli

76×148.5cm 2013

埔里茭白筍田

Water Bamboo Fields at Puli

76×148.5cm　2011

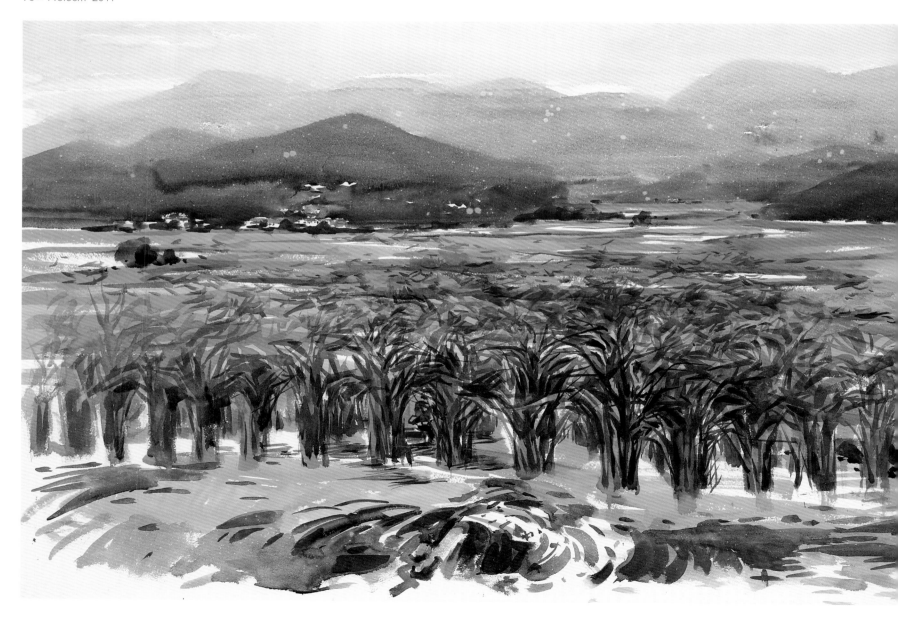

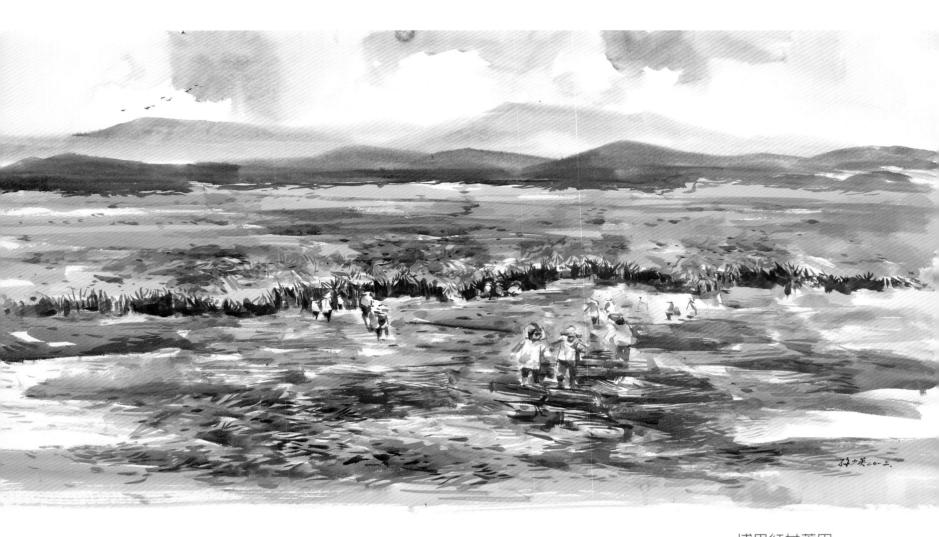

埔里紅甘蔗田

Red Sugar Cane Field at Puli

76×148.5cm　2013

新故鄉文教基金會紙教堂

Paper Dome of the New Homeland Foundation

39×57cm 2009

紙教堂夜景

Night View at Paper Dome

28.5×39cm 2011

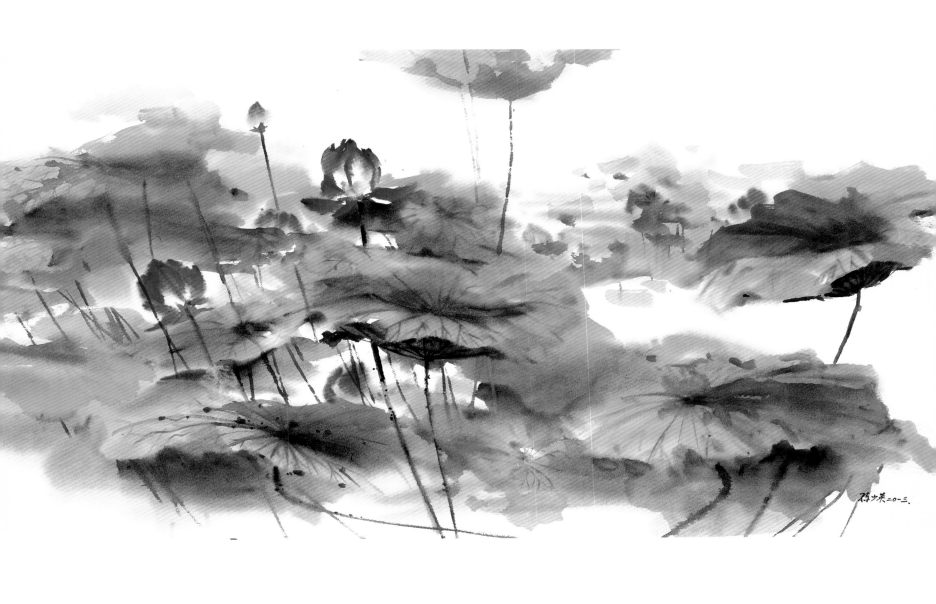

紙教堂的荷花

Lotuses at Paper Dome

76×148.5cm 2013

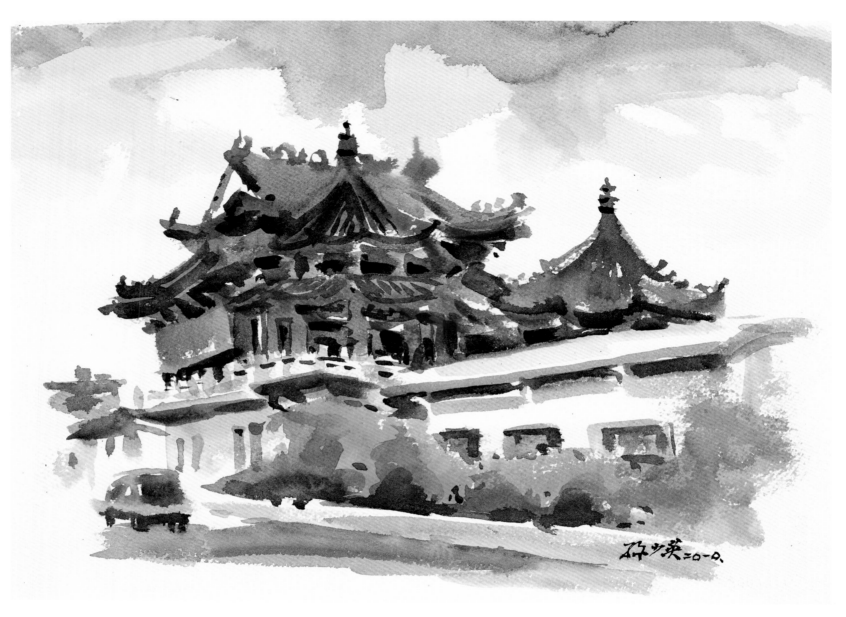

陳綢阿嬤的良顯堂

Grandma Chen, Chou's Liangxian Hall

28.5×39cm 2010

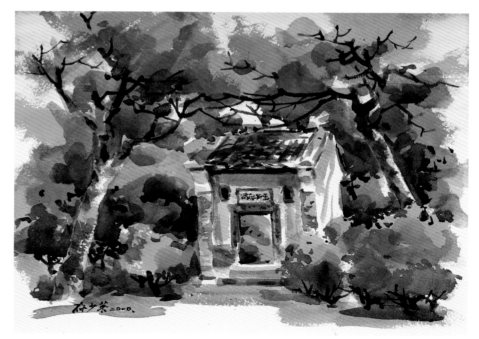

黃家百年門樓

Century Gate of the Huang Family

28.5×39cm 2010

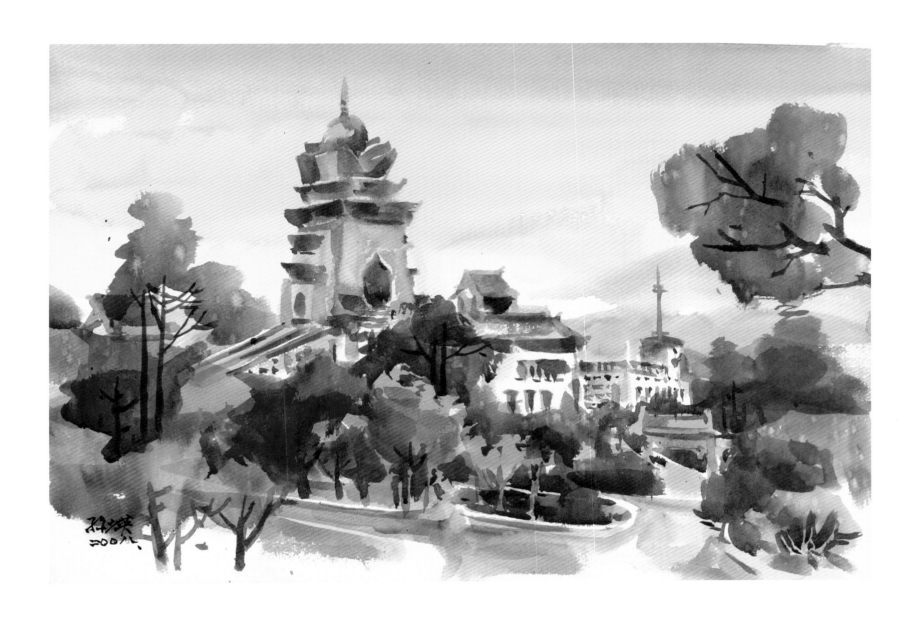

中台禪寺

Chung Tai Chan Monastery

39×57cm 2008

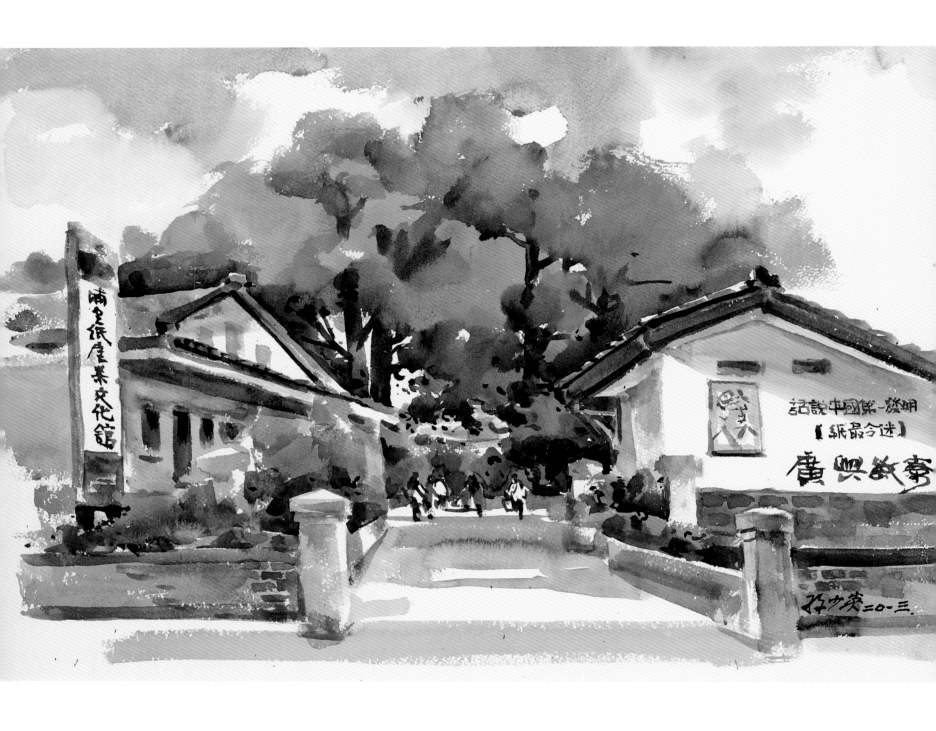

廣興紙寮

Guangxing Paper Plant

39×57cm 2013

林家別墅

Lin Family Villa

39×57cm　2013

埔里土角厝

Soil Block House at Puli

28.5×39cm　2009

埔里鎮圖書館

Library at Puli

28.5×39cm 2009

暨大校園

Campus of the National Chi Nan University

39×57cm 2002

半月燒
Half-moon Cake

胡家臭豆腐
Sticky Soybean Curd

三元捲餅
Sanyuan Roll

埔里美味小吃

Puli Specialty Products
28.5×39cm×3 2010

埔里蝴蝶蘭

Puli Phalaenopsis

39×28.5cm 2012

台灣阿嬤蘭

Taiwan Grandma Phalaenopsis

39×28.5cm 2012

埔里新型社區

Puli New-style Community

28.5×39cm 2006

埔里桃米里福同宮

Futong Temple at Taomi, Puli

28.5×39cm 2001

集集車站

Jiji Station

39×57cm 2004

車埕老屋

Checcheng Old Lodge

28.5×39cm 2003

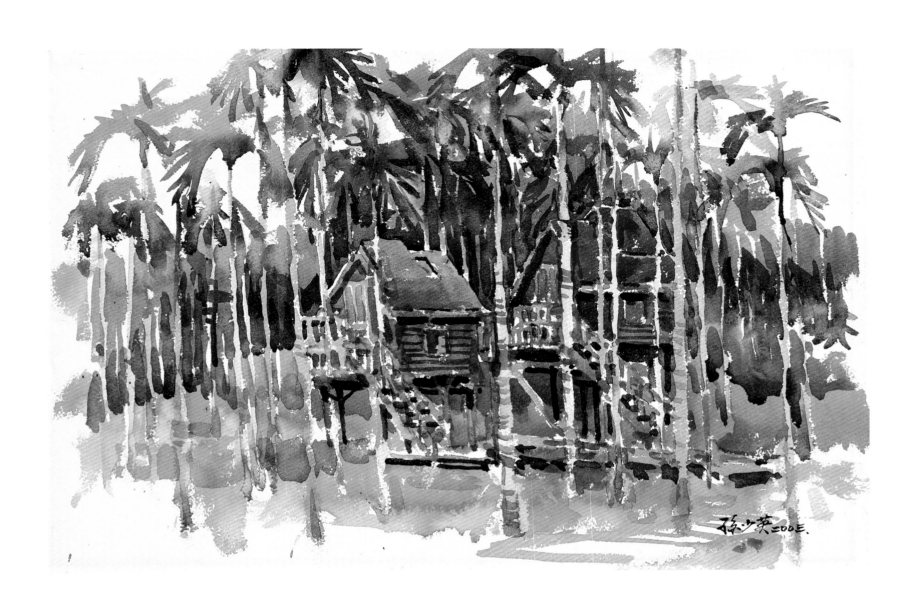

水里蛇窯附設樹屋民宿

Tree House Guesthouse Attached to the Shuili Snake Kiln

39×57cm 2003

附錄

孫少英素描作品

我喜歡畫素描,從年輕到現在畫的素描已無計其數。素描本來是繪畫的練習,但成熟的素描也是很好的作品。我一直喜歡素描的方便、流暢、含蓄、隨興的感覺。

我的素描方式通常有幾種:
一、炭精筆:深黑有力,適合畫大面。
二、6B鉛筆:比炭精筆滑順,黑度不及炭精筆,灰階層次
　　　　　比較好。
三、油性簽字筆:相當於從前的鋼筆或針筆,比針筆方便,
　　　　　好的簽字筆也不會褪色。
四、鉛筆、簽字筆淡彩:有素描和水彩的雙層效果。
五、素描重點著色:這是一種偷懶的作法,但有強調主題的
　　　　　效果。

Addendum

Sun Shao-Ying's Sketch

I like to sketch. I have created numerous sketches since my youth till now. Sketching is essentially a practice for painting, but mature sketches could also be good works. I always like the feelings of convenience, fluidity, modesty and spontaneity of sketching.
Usually there are several kinds of sketching methods for me:

1. Carbon stick: deep black and forceful, suitable for large scale.

2. 6B pencil: smoother than carbon sticks, but less black, doing better in gray levels.

3. Oil-based felt-tip pen: comparable to fountain pens or needle-in-tube pens, and the good ones produce works that resist fading.

4. Pencil or felt-tip pen with light colors: producing double effects of sketching and watercolor.

5. Felt-tip pen with highlight-Colors: this is a lazy way but effective in accentuating the subject matter.

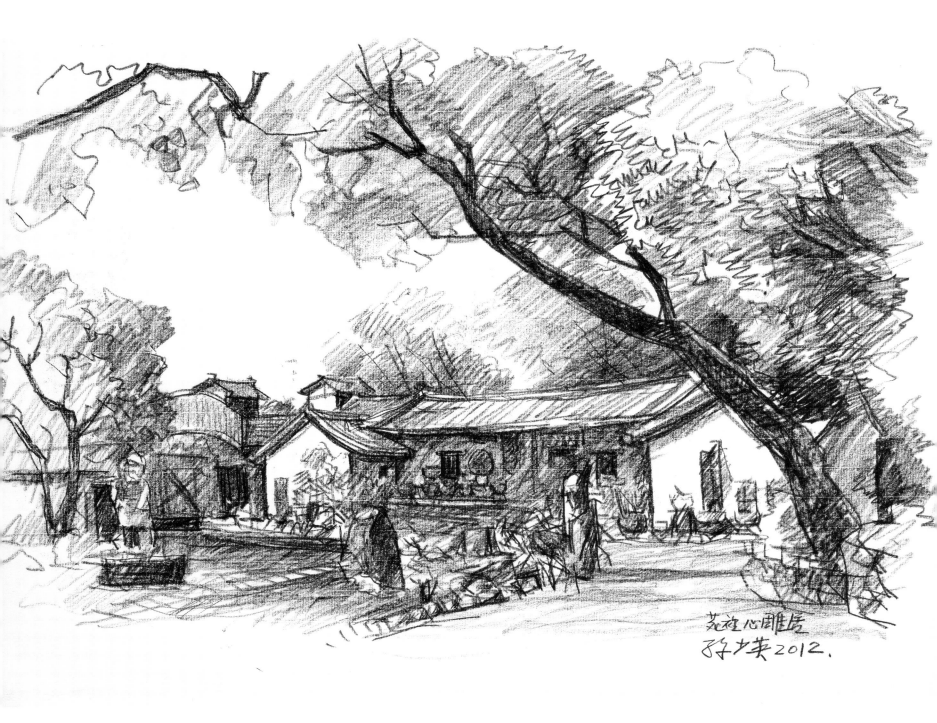

苑裡心雕居

The Artist Chen's Garden, Yuanli

炭精筆　57×78cm　2012

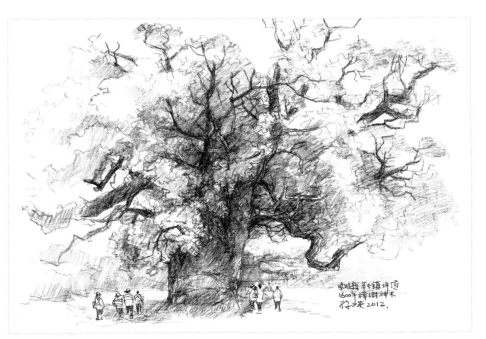

草屯千年樟樹

Millennium Old Camphor Tree at Caotun

炭精筆　57×78cm　2012

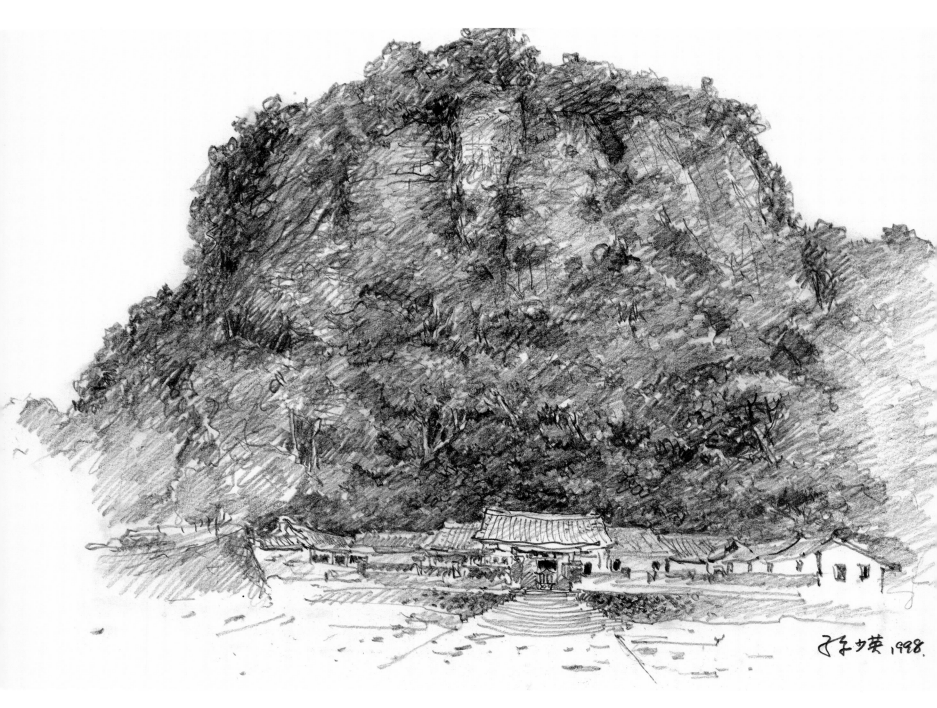

埔里嵌斗山下佛寺

Buddhist Temple at the foothill of the Kandou Mountain, Puli

炭精筆 39×57cm 1998

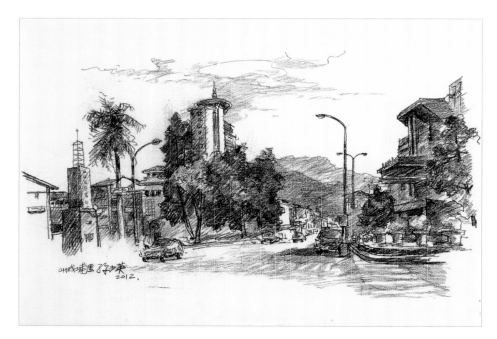

埔里中山路

Zhongshan Road at Puli

炭精筆 57×78cm 2012

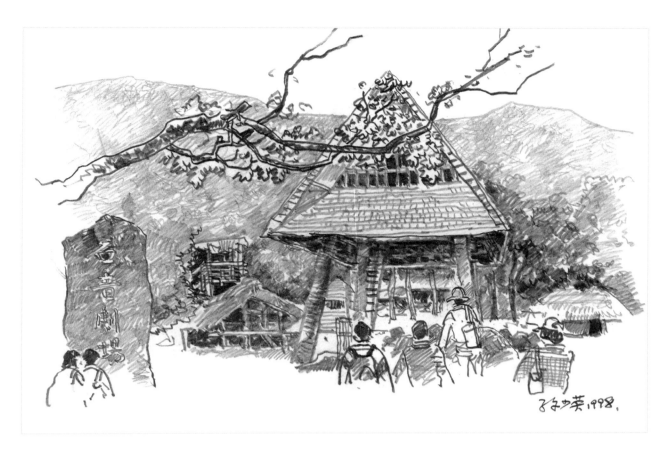

九族文化村

Formosan Aboriginal Culture Village

鉛筆 28.5×39cm 1998

埔里林園市集

Linyuan Market at Puli

鉛筆 28.5×39cm 2001

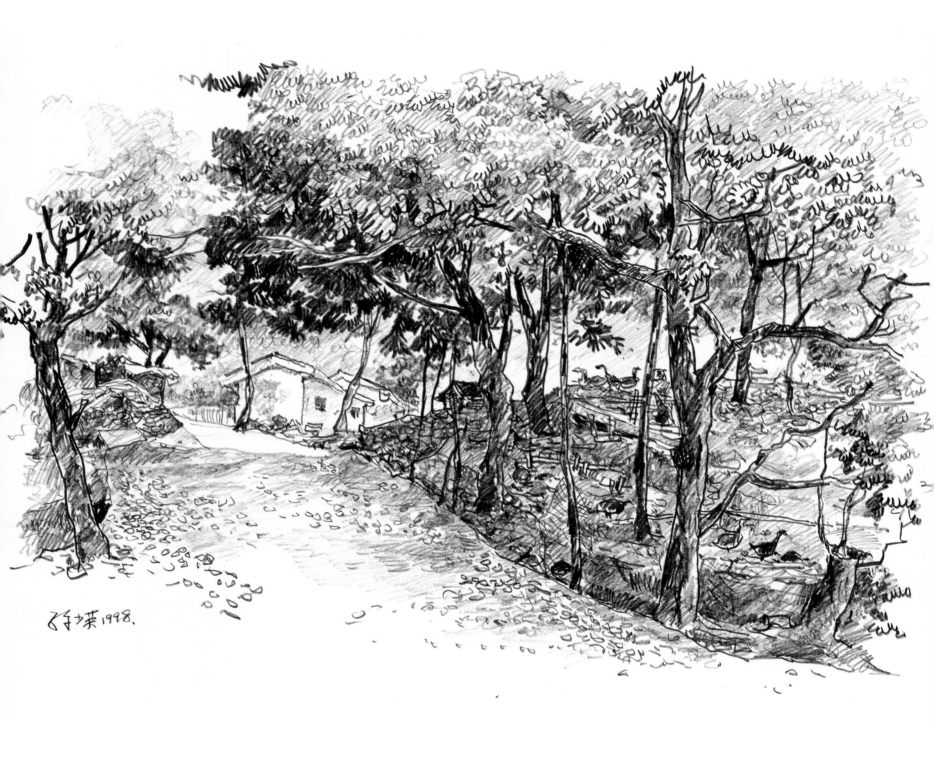

埔里農家

Farmhouses at Puli

鉛筆 39×57cm 1998

荷花速寫

Sketches of Lotuses

鉛筆 28.5×39cm×3 2013 / 2013 / 2010

埔里觀音吊橋

Guanyin Suspension Bridge at Puli

鉛筆　39×57cm　1998

攤香

Spreading the incenses Out

鉛筆　28.5×39cm　2012

長笛合奏

Flute Performance

鉛筆 57×39cm 2010

許先生

Mr. Xu

鉛筆 57×39cm 2010

埔里農家女

Farming Women at Puli

鉛筆 57×39cm 2000

藺草編織達人陳紅柿阿嬤

Juncaceae- weaving Expert, Grandma Chen, Hongshi

鉛筆 39×28.5cm 2012

作家王灝老師書房

Study Room of Writer Wang, Hao

簽字筆淡彩 39×57cm 2004

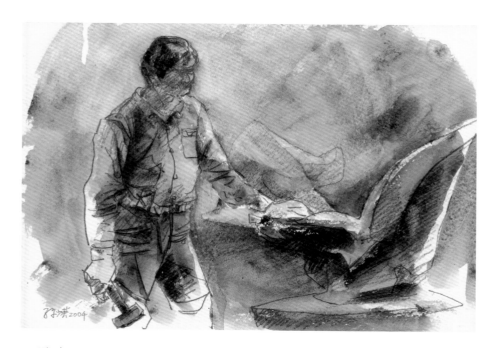

石雕家鄧老師

Stone Carving Expert-Teacher Deng

鉛筆淡彩 39×57cm 2004

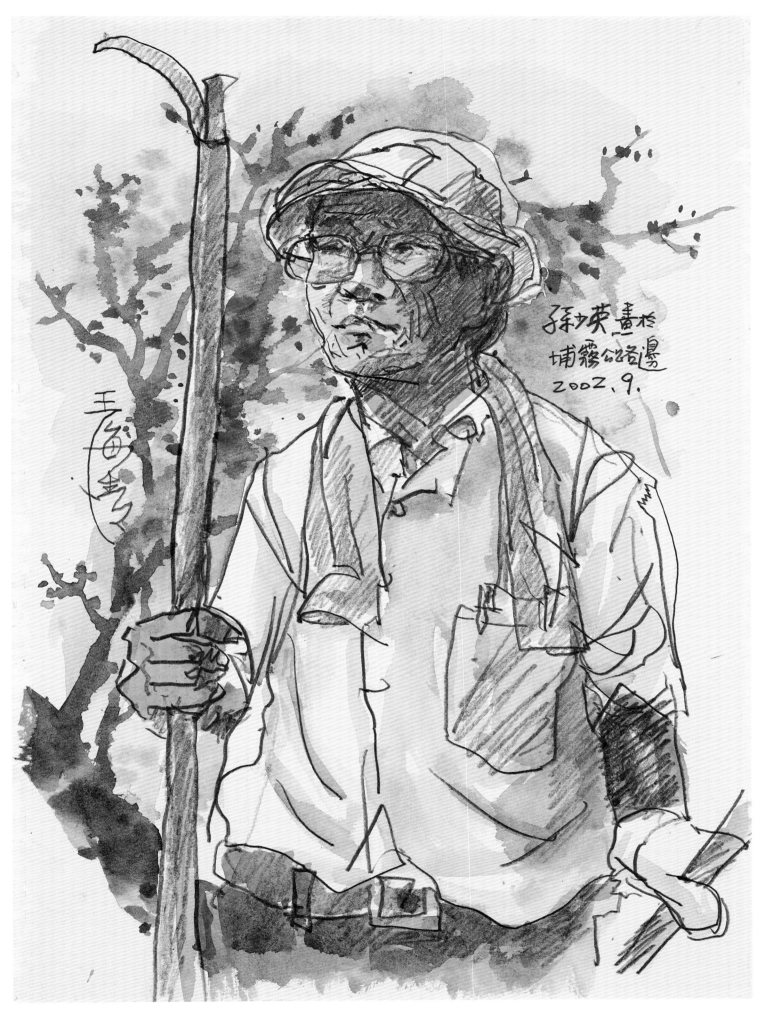

孫少英 畫於
埔霧公路邊
2002. 9.

埔里櫻花老人

Puli Cherry Old-man

鉛筆淡彩 57×39cm 2002

從埔里到霧社沿途櫻花都是他個人種植及維護。
He plants and preserves all the cheery trees
along the road from Puli to Wushe.

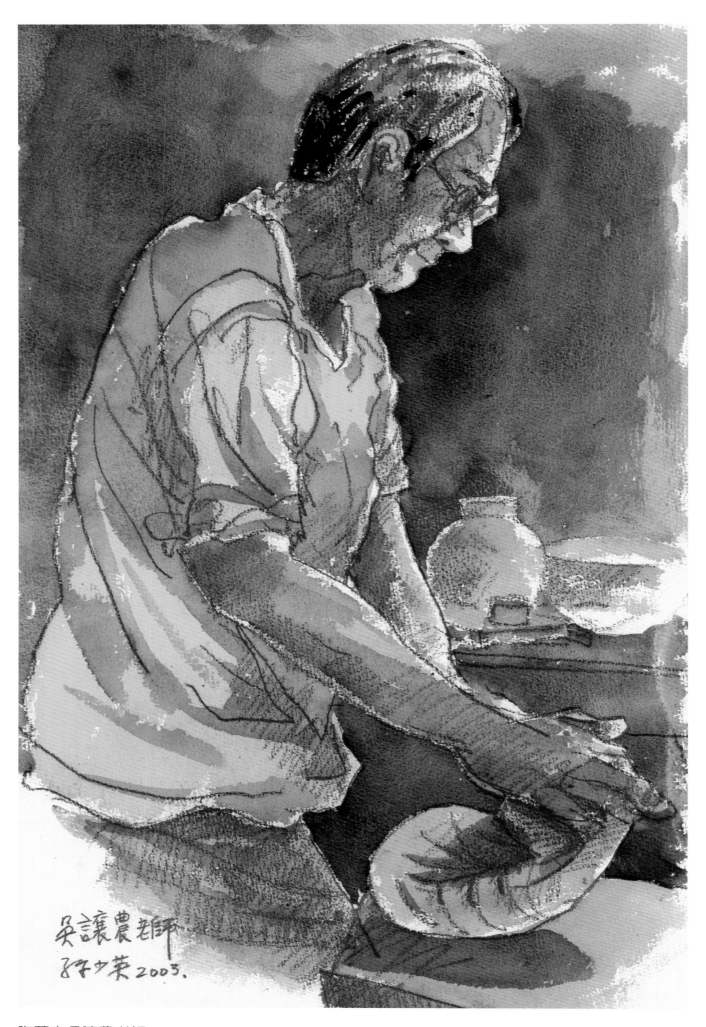

陶藝家吳讓農老師

Ceramic Artist Wu, Rangnong

鉛筆淡彩　57×39cm　2003

埔里泉水洗衣

Washing Clothes with Puli Spring Water

簽字筆　28.5×39cm　2010

藺草插秧

Transplanting Juncaceae shoots

簽字筆　28.5×39cm　2012

埔里文淵工作室

Wenyuan Workshop, Puli

簽字筆　28.5×39cm　2011

小朋友寫生

Kids, Sketching from Nature

簽字筆　28.5×39cm　2011

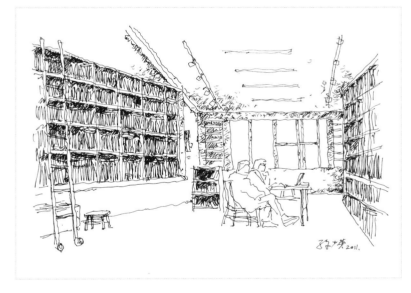

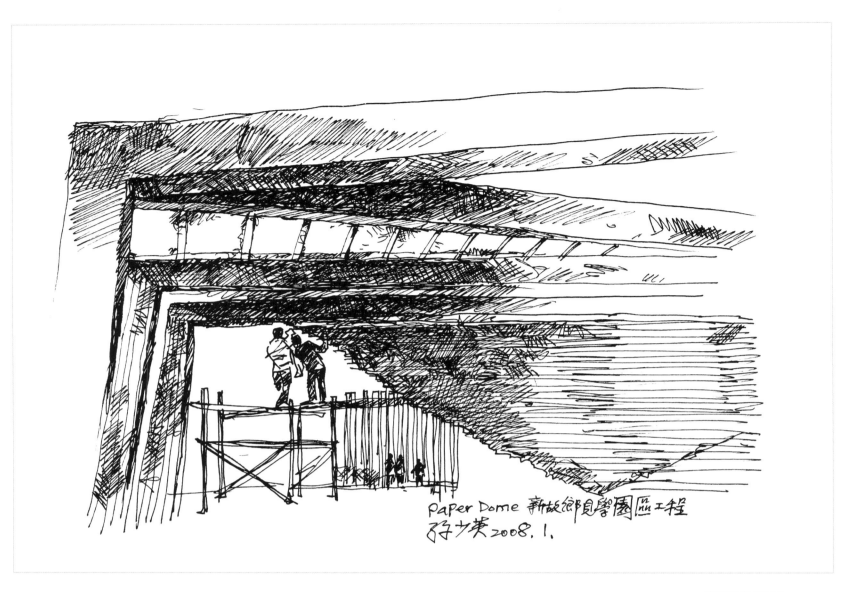

紙教堂施工

Paper Dome, been building

簽字筆 28.5×39cm 2008

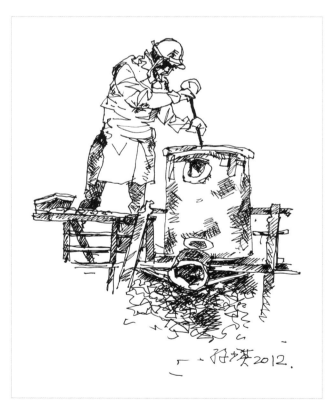

鑄銅－攪拌銅水

Copper Casting－Stirring the Copper Liquid

簽字筆 39×28.5cm 2012

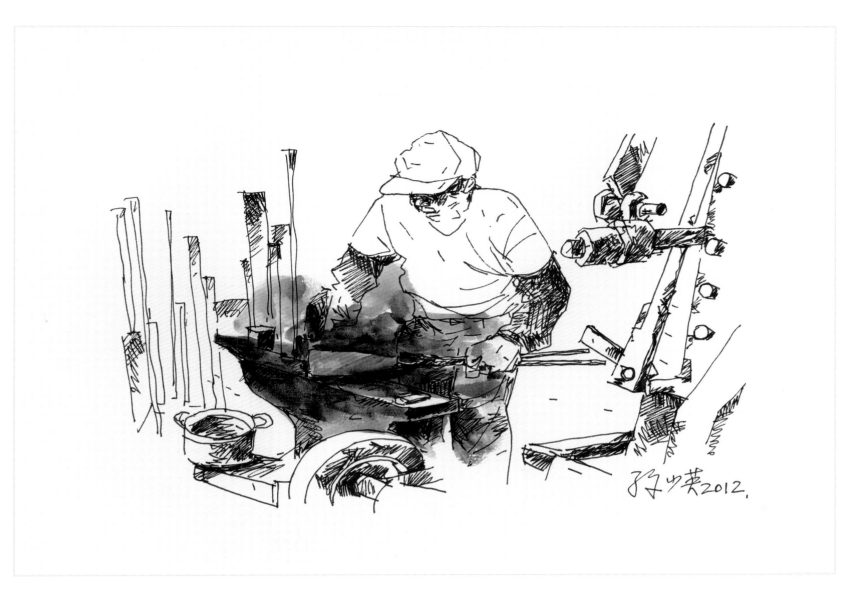

打鐵

Forging ironware

簽字筆重點著色 28.5×39cm 2012

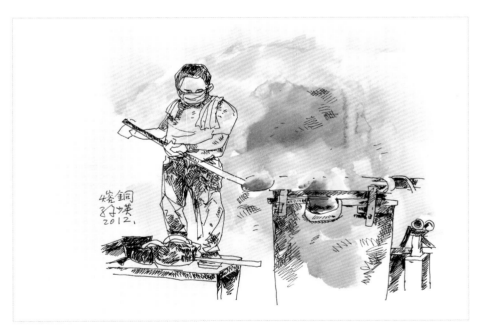

銅水正紅

Red Copper Liquid

簽字筆重點著色 28.5×39cm 2012

後記

孫少英

　　在編輯《水之湄》期間，在盧安藝術文化公司的藏書中，看到一套九巨冊吳冠中全集，他的畫我早就很注意了，原畫和畫冊也看過一些。這九大本專集還是第一次看到，花了幾天時間，概略看完，我覺得很值得珍藏，就託盧安執行長翠敏幫我代訂一套，價格四萬一千元。

　　看完專集，有些感想：

一、吳冠中在求學階段肯用功，也有智慧，打下了良好基礎。

二、留法時期，他眼光敏銳，吸收了很多好東西。

三、回國後，環境惡劣，他從未放棄他藝術興趣的初衷。

四、從傳統到抽象，他過渡的過程很自然，也很真實。

五、繪畫純粹是形式美，內容不重要，甚至也不需要內容。這真是吳冠中大膽而正確的立論。

六、〈筆墨等於零〉是他很重要，也是惹起爭議的文章，其實他並非否定筆墨，而是對過分泥古而不敢創新的一群老畫家的大聲疾呼。事實上這篇文章也創造了他的知名度和日後的身價。

　　總之，吳冠中在華人社會裡是出類拔萃的人物，應不可否認。

　　我也已畫了數十年，現已老邁，身體尚好，看了吳冠中的巨型專集以後，深感還要再努力一番。假若有機會，有人再為我出版另外一本專集，我會呈現另一種面貌。

Afterword

Sun Shao-Ying

During the editing of *Searching for Beauty*, I saw, among the collection of Luan Art Co. Ltd., a 9-volume set of complete album by Wu Guanzhong. I have long paid attention to his paintings and seen some of his original works and albums. Yet I was aware of this large 9-volume set for the first time. It took me a couple of days to finish reading it roughly. I found it worthy of collecting, so I asked Tsui-Min, the director of Luan Art, to place a purchase order for me at the cost of NTD$ 41,000.

I have some thoughts after reading this album:

1. Wu Guanzhong was very hardworking during his educational period and wise enough to have built a strong foundation.

2. During his study in France, he was insightful and keen to absorb a lot of good stuffs.

3. After he returned to his country, even in bad situations, he had never given up his original intention of artistic passion.

4. From the traditional style to abstraction, he had transformed in a very natural and realistic process.

5. Painting is purely formal beauty, so the content is not important or even there is no need for content. This is indeed a bold and correct statement by Wu Guanzhong.

6. "Pen and ink are equal to zero." This is a very important essay of him which was very controversial. Actually, he didn't mean the denial of pen and ink, but rather appealed stridently to a group of old painters who were overly conservative without the guts of innovation. In fact, this essay has made him famous and promoted his status afterwards.

In any case, Wu Guanzhong is an outstanding figure in the Chinese society undeniably.

I have already painted for several decades. I am now old but still healthy. After reading the giant album of Wu Guanzhong, I deeply felt that I should make more efforts. If there is another opportunity that someone would publish another album for me, I shall present a different appearance.

孫少英 簡歷

一、學・經歷

1931 出生於中國山東省諸城縣。

1943 諸城縣瑞華小學畢業。

1946 膠縣瑞華中學肄業。（因戰亂輟學）

1949 青島市立李村師範學校肄業。

1949 隨兄長任職之部隊撤退到海南島。

1950 來到台灣。

1952 考取政工幹校藝術系。

1955 政工幹校畢業。

1961 自軍中退伍。

1961 服務於日月潭教師會館。
　　 對日月潭的湖光山色留下深刻印象，從此埋下了用水彩表
　　 現日月潭之美的願望。

1962 進入光啓社製作部負責電視教學節目製作及電視節目美術
　　 設計。
　　 當時光啓社是台灣唯一的電視節目製作專業機構，初創的
　　 台灣電視公司，許多節目都是由光啓社製作供應播出。

1963 出版了第一本畫冊─《孫少英鉛筆畫集》。

1964 在光啓社由製作部調到動畫部。
　　 動畫部負責人趙澤修在美國修習動畫製作，學成歸國，成
　　 立動畫部，其任內完成數部動畫短片，是台灣動漫藝術的
　　 濫觴。

1965 三年中利用假日到北投復興崗補修學分，取得復興崗大
｜
1968 學學士學位。

1969 考取台灣電視公司美術指導。

1985 升任美術部部長。

1986 到日本NHK及富士電視考察電視美術作業。
　　 同年到韓國KPS電視台訪問。

1987 為台視建立電腦美術作業系統，是當時台灣電視事業的一
　　 大創舉。

1991 自台灣電視公司退休。
　　 同年移居埔里專事繪畫及寫作。
　　 （埔里為妻翁水玉的家鄉）

1992 受邀參加「中華民國畫家訪問團」。
　　 訪問新加坡及馬來西亞，與當地畫家寫生交流。

1994 與畫家好友文霽到歐洲寫生。

1997 出版《從鉛筆到水彩》一書，此書為初學素描及水彩的工
　　 具書，現已印行三版。

1998 出版《埔里情素描集》。

1999 九二一大地震，在災難中完成災況素描百餘幅，發表於各
　　 大報章雜誌。

2000 在誠品書局敦南店發表新書《九二一傷痕》素描集。
　　 這批素描原畫全部由九二一重建基金會收藏，之後捐贈各
　　 予台大圖書館做為紀念九二一大地震之永久典藏。

2001 受邀擔任全國大專院校繪畫比賽評審委員。

2001 出版震後重建圖文集《家園再造》。

2001 到廣西漓江寫生。

2002 佛光山刊物《人間福報》覺世副刊特闢「孫少英圖文」專
　　 欄，每週一篇，已連續三年。

2002 第二次到廣西漓江寫生。

2002 受邀擔任全國公教人員繪畫比賽評審委員。

2003 接受日月潭國家風景區管理處委託，完成《水彩日月潭》
　　 專集，此為風管處贈送貴賓之代表性禮品。七十幅水彩原
　　 畫，部份為風管處收藏。

2003 受聘擔任彰化縣「磺溪」獎評審委員。

2004 受新故鄉文教基金會之邀，完成台灣社區營造水彩畫四十
　　 幅。之後又完成新故鄉見學園區紙教堂施工過程素描二十
　　 幅。

2005 受上旗出版社之邀，完成《畫家筆下的鄉居品味》一書。

2005 在誠品書局天母店舉辦新書《畫家筆下的鄉居品味》發表
　　 會。

2005 受聘為埔里鎮圖書館第一屆駐館藝術家。

2005 接受天仁集團日月潭大淶閣飯店委託，繪製〈大淶閣景觀
　　 〉巨幅水彩畫。

2005 豐年社《鄉間小路》月刊闢「孫少英畫我家園」專欄，至
　　 今已連載八年。

2005 到日本上高地賞楓寫生。

2006 發起創立埔里小鎮寫生隊，每年於埔里鎮田園藝廊舉辦聯
　　 展，對地方藝文推展很有貢獻。

2006 擬定「台灣系列」寫生計劃，預訂每年一書一展。
　　 同年台灣系列（一）《日月潭環湖遊記》出版，是一本兼
　　 具旅遊導覽的畫冊。

2007 到蘇州和杭州西湖寫生。

2008 台灣系列（二）《阿里山遊記》出版。歷時一年，走遍阿
　　 里山遊樂區及四個鄉，往返十次才完成。

2009 台灣系列（三）《台灣小鎮》出版，選擇淡水、北埔、美
　　 濃等具有特色的十五個鄉鎮，全部實地寫生完成。

2009 到日本秋田縣賞櫻寫生。

2009 受邀擔任南投縣玉山獎評審委員。

2010 到美國加州和亞利桑那州寫生。

2010 台灣系列（四）《台灣離島》出版，台灣共有六個離島，
　　 還有許多附屬小島。搭機、坐船、爬山、涉水，在寫生過
　　 程中，相當費力勞神。

2011 台灣系列（五）《山水埔里》出版，充分展現家鄉之美。

2012 集美國、日本、中國大陸寫生畫作一百二十幅，出版《寫
　　 生散記》。

2013 台灣系列（六）《台灣傳統手藝》出版，藉以對台灣民間
　　 身懷絕技的老師傅們表達至誠敬意。

2013 受天福集團委託完成120cm×420cm巨幅水彩畫〈台灣日
　　 月潭覽勝〉，現典藏於中國北京。

2013 受盧安藝術文化有限公司委託，繪製《水之湄─日月潭水
　　 彩畫記》。

二、畫歷

（一）個人展覽

1976　台北市美國新聞處林肯中心素描個展。

1978　台北市龍門畫廊水彩個展。

1980　台灣省立博物館水彩個展。

1982　台北來來藝廊水彩個展。

1989　台北黎明藝文中心水彩個展。

1990　台北黎明藝文中心水彩個展。

1992　雲林縣立文化中心水彩個展。

1993　台南市省立社教館水彩個展。

1993　台南市國策藝術中心水彩個展。

1996　埔里鎮牛耳藝術公園藝廊水彩個展。

1997　台中縣絲寶展示廳水彩個展。

1997　埔里鎮藝文中心田園藝廊水彩個展每年舉辦一次
｜
2012　連續六年。

1998　埔里鎮牛耳藝站素描個展。

1998　埔里基督教醫院藝廊水彩個展。

1999　台南市省立社教館邀請展。

2000　埔里鎮金鶯山藝文天地水彩個展。

2001　埔里鎮金鶯山藝文天地水彩個展。

2005　台中市文化中心水彩個展。

2006　彰化縣文化中心水彩個展。

2007　新竹市文化中心水彩個展。

2007　高雄市文化中心水彩個展。

2011　埔里鎮鴨子咖啡藝廊水彩個展。

2012　埔里鎮鴨子咖啡藝廊素描個展。

2013　南投縣縣政府文化局邀請玉山畫廊水彩個展。

2013　台中市咸亨堂畫廊水彩畫個展。

（二）重要聯展

歷屆全國美展邀請展

亞洲水彩畫家聯盟展

台北市立美術館開館邀請聯展

台灣省立美術館開館邀請聯展

台南市舉辦千人美展

高雄市舉辦當代美術大展

國立歷史館邀請聯展

國立藝術館四季美展

中國美術協會歷年聯展

中華民國藝術訪問團東南亞巡迴展

中國水彩畫會各縣市文化中心巡迴展

海峽兩岸水彩聯展

台南市社教館舉辦當代畫家百人展

台南市社教館舉辦全國名家水彩聯展

彰化縣磺溪獎評審邀請展

台中市及文化中心舉辦全國水彩畫展

台南市社教館舉辦全國書畫大展

國立台灣藝術教育館舉辦兔年特展

中興大學主辦水彩名家聯展

台灣國際水彩畫會歷年聯展

南投市歷年玉山獎邀請展

（三）參加藝文社團

中國美術協會

中國文藝協會

中國水彩畫會

台灣國際水彩畫協會

南投美術協會

中國當代藝術協會

投緣水彩畫會

藝池畫會

埔里小鎮寫生隊

埔里鎮立圖書館第一屆駐館藝術家

（四）獎項

台北市金橋獎座設計首獎

台灣文藝協會水彩畫首獎

三、著作

《孫少英鉛筆畫集》

《從鉛筆到水彩》

《埔里情素描集》

《九二一傷痕素描集》

《家園再造寫生集》

《水彩日月潭》

《畫家筆下的鄉居品味》

《日月潭環湖遊記》

《阿里山遊記》

《台灣小鎮》

《台灣離島》

《山水埔里》

《寫生散記》

《台灣傳統手藝》

《水之湄—日月潭水彩畫記》

Resume of Sun Shao-Ying

Resume of Author

1931 Born in Zhucheng County, Shandong Province, China.

1943 Graduated from Ruihua Elementary School of Zhucheng County.

1946 Incomplete study from Ruihua Middle School of Jiao County (in the turmoil of war).

1949 Incomplete study from Qindao Municipal Licun Normal School.

1949 Retreated to Hainan Island with the troop his elder brother served.

1950 Arrived in Taiwan.

1952 Admitted to Department of Arts, Political Staff School.

1955 Graduated from Political Staff School.

1961 Retired from military service.

1961 Employed by Sun Moon Lake Teacher's Hostel.Highly impressed by the lake and mountain scenery of Sun Moon Lake, imprinting a wish to express the beauty of Sun Moon Lake by watercolor on his mind ever since.

1962 Employed by Production Department of Guangchi Program Service to be in charge of producing TV teaching programs and artistic design. At that time, Guangchi Program Service was the only specialized TV production institute in Taiwan, producing many programs to supply the newly founded Taiwan Television Company.

1963 Published the first album- *Pencil Drawings of Sun Shao-Ying*.

1964 Transferred from Production Department to Animation Department at Guangchi Program Service.
The head of Animation Dept. Chao Tse-hsui founded the Animation Department after fishing his study of animation production in the U.S. and returned to Taiwan. During his tenure, he completed several animations which were deemed the start of animation art in Taiwan.

1965 | 1968 During three years, he spent holidays to get make-up credits at Fuxingang, Beitou and received the Bachelor's degree of Fuxingang University.

1969 Qualified as Art Director, Taiwan Television.

1985 Promoted to the Head of Art Department.

1986 Inspected TV art direction at NHK and Fuji Television in Japan and visited KPS TV in Korea.

1987 Established the digital art operative system for TTV, which was a pioneering work for TV industry of Taiwan at that time.

1991 Retired from Taiwan Television and moved to Puli solely for painting and writing. (Puli is the hometown of his wife, Weng Shui-yu.)

1992 Invited to join the Delegation of ROC Painters to visit Singapore and Malaysia interacting with local painters by nature drawing.

1994 Visited Europe for nature drawing with a good friend, painter Wen Chi.

1997 Published the album, *From Pencil to Watercolor*, which is a reference book for beginners in sketching and watercolor, and now its third edition is in print.

1998 Published *Sketches of Puli*.

1999 After 921 Earthquake, finished more than a hundred sketches of disaster scenes during the calamity, which were presented on all major newspapers and magazines.

2000 Presented the new album, *The Scars of 921*, at Eslite Bookstore Dunnan Branch. The original sketches were all collected by 921 Earthquake Relief Foundation and then donated to National Taiwan University Library as permanent collection in memory of 921 Earthquake.

2001 Invited to act as Juror for National College Painting Competition.

2001 Published the album for the after-quake reconstruction, *Rebuilding Our Homeland*.

2001 Visited Lijiang, Guangxi for nature drawing.

2002 The publication of Fo Guang Shan, *Merit Times*, opened a special column of "Illustrated Essay of Sun Shao-Ying" in its "Awakening" supplement, presenting one article per week and continuing for three consecutive years.

2002 Visited Lijiang, Guangxi for nature drawing for the second time.

2002 Invited to act as Juror for National Painting Competition for Government Employees and Teachers.

2003 Commissioned by Sun Moon Lake National Scenic Area Administration and completed the album, *Watercolors of Sun Moon Lake*, as a representative gift for honorable guests. There were 70 original watercolors, some of which were collected by Scenic Area Administration.

2003 Invited to act as Juror for Huangxi Award of Changhua County.

2004 Invited by New Homeland Foundation to complete 40 watercolors on Community Building in Taiwan. Later, also finished 20 sketches on the construction process of Paper Dome at New Homeland Resource Park.

2005 Invited by Sun Kids Publishing to complete the book, *Country Life by Painter's Brushwork*.

2005 Held a new book release presentation for *Country Life by Painter's Brushwork* at Eslite Bookstore Tianmu Branch.

2005 Invited to be the first-term artist-in-residence for Puli Township Library.

2005 Commissioned by Sun Moon Lake Del Lago Hotel of Ten Ren Group to paint a large-canvas watercolor, *View of Del Lago*.

2005 *Country Road Monthly* of Harvest Farm Magazine opened a special column of "Sun Shao-Ying Painted My Homeland" which has run for 8 years by now.

2005 Visited Kamikochi in Japan to appreciate maples and draw from nature.

2006 Founded the Puli Painting Group to annually organize joint exhibits at Field Gallery of Puli, greatly contributing to the development of local arts and culture.

2006 Made a plan for nature painting on Taiwan Series, deciding on releasing one book and one exhibition every year. Published the first of Taiwan Series, *Round Trip of Sun Moon Lake*, which is an album and also tour guidebook.

2007 Visited Suzhou and West Lake (Xi Hu) of Hangzhou for nature painting.

2008 Published the second of Taiwan Series, *Scenic Jouney of Alishan*, after spending one year to walk all over Alishan Scenic Area and four townships on 10 round trips.

2009 Published the third of Taiwan Series, *Taiwan Townships*, choosing 15 distinctive townships such as Danshui, Beipu and Meinong to finish nature paintings on the spot.

2009 Visited Akitafan in Japan to appreciate cherry blossoms and draw from nature.

2009 Invited to act as Juror for Yushan Award of Nantou County.

2010 Visited California and Arizona of the U.S. for nature painting.

2010 Published the fourth of Taiwan Series, *Off-shore Islands of Taiwan*, after a taxing and strenuous process of nature painting via flights, boating, mountaineering and wades as Taiwan possesses 6 off-shore islands and many affiliated small islands.

2011 Published the fifth of Taiwan Series, *Landscape of Puli*, fully representing the beauty of homeland.

2012 Compiled 120 works of nature painting done in the U.S., Japan and

Mainland China and published *Notes on Nature Painting*.

2013 Published the sixth of Taiwan series, *Traditional Arts of Taiwan*, in order to pay tribute to the masterfully skilled old craftsmen of Taiwan.

2013 Commissioned by Ten Fu Group to complete a huge canvas of watercolor by 420cmx120cm, *Beautiful Scenic Spots of Taiwan's Sun Moon Lake*, which is now in a collection in Beijing, China.

2013 Commissioned by Luan Art Co. Ltd. to paint for the album, *Searching for Beauty*.

Exhibit Experience

1. Solo Exhibitions

1976 Drawing Solo Exhibition at Lincoln Center of United States Information Service, Taipei City

1978 Watercolor Solo Exhibition at Longman Gallery, Taipei City

1980 Watercolor Solo Exhibition at Taiwan Provincial Museum

1982 Watercolor Solo Exhibition at Lailai Gallery, Taipei

1989 Watercolor Solo Exhibition at Liming Arts and Culture Center, Taipei

1990 Watercolor Solo Exhibition at Liming Arts and Culture Center, Taipei

1992 Watercolor Solo Exhibition at Yunlin County Cultural Center

1993 Watercolor Solo Exhibition at Provincial Social and Education Hall, Tainan

1996 Watercolor Solo Exhibition at New Era Art Park Gallery, Puli Township

1997 Watercolor Solo Exhibition at Sibao Exhibition Hall, Taichung County

1997 | Watercolor Solo Exhibition at Pastoral Gallery, Puli Art Center,
2012 | annually for 6 consecutive years

1998 Drawing Solo Exhibition at New Era Art Station, Puli Township

1998 Watercolor Solo Exhibition at Puli Christian Hospital Gallery

1999 Invitation Exhibition at Provincial Social and Education Hall, Tainan City

2000 Watercolor Solo Exhibition at Jingyingshan Art Center, Puli Township

2001 Watercolor Solo Exhibition at Jingyingshan Art Center, Puli Township

2005 Watercolor Solo Exhibition at Taichung City Cultural Center

2006 Watercolor Solo Exhibition at Changhua County Cultural Center

2007 Watercolor Solo Exhibition at Hsinchu City Cultural Center

2007 Watercolor Solo Exhibition at Kaohsiung City Cultural Center

2011 Watercolor Solo Exhibition at Arts Café Gallery, Puli Township

2012 Drawing Solo Exhibition at Arts Café Gallery, Puli Township

2013 Watercolor Solo Exhibition at Yushan Gallery, invited by Nantou County

2013 Watercolor Solo Exhibition at Xianhengtang Gallery, Taichung City

2. Important Joint Exhibitions

· Invitation Exhibition at National Art Exhibition of the Republic of China, all the sessions
· Asia Watercolor Painting Alliance Exhibition
· Invited Group Exhibition for the Opening of Taipei Fine Arts Museum
· Invited Group Exhibition for the Opening of Provincial Fine Arts Museum of Taiwan
· Thousand-People Art Exhibition, held by Tainan City
· Contemporary Art Exhibition, held by Kaohsiung City
· Invited Group Exhibition at Nation History Museum
· Four Season Art Exhibition at National Center of Arts
· Group Exhibition of China Art Association, through the years
· Southeast Asia Tour Exhibition of R.O.C. Art Delegation
· Tour Exhibition of China Watercolor Association around County/City Cultural Center

· Cross-Strait Joint Exhibition of Watercolor
· Contemporary Hundred-People Painter Exhibition, held by Tainan City Social Education Hall
· Joint Exhibition of Domestic Renowned Watercolor Painters, held by Tainan City Social Education Hall
· Jury Invitation Exhibition of Huangxi Award of Changhua County
· National Watercolor Exhibition, held by Taichung City and Cultural Center
· National Calligraphy and Painting Exhibition, held by Tainan City Social Education Hall
· Year of the Rabbit Special Exhibition, held by National Taiwan Arts Education Center
· Joined Exhibition of Renowned Painters, held by National Chung Hsing University
· Joint Exhibition of International Association of Watercolor Taiwan, through the years
· Invitation Exhibition for Yushan Award of Nantou City, through the years

3. Arts and Culture Association

· China Art Association
· China Literature and Art Association
· China Watercolor Association
· International Association of Watercolor Taiwan
· Nantou Art Association
· China Contemporary Association
· Affinity Watercolor Society
· Art Pool Painting Society
· Puli Painting Group
· First-term Artist-in-Residence of Puli Township Library

4. Awards

· First Place in Design of Golden Bridge Award, Taipei City
· First Place in Watercolor, Taiwan Literature and Art Association

Publication

· *Pencil Drawings of Sun Shao-Ying*
· *From Pencil to Watercolor*
· *Sketches of Puli*
· *The Scars of 921*
· *Rebuilding Our Homeland*
· *Watercolors of Sun Moon Lake*
· *Country Life by Painter's Brushwork*
· *Round Trip of Sun Moon Lake*
· *Scenic Journey of Alishan*
· *Taiwan Townships*
· *Off-shore Islands of Taiwan*
· *Landscape of Puli*
· *Notes on Nature Painting*
· *Traditional Arts of Taiwan*
· *Searching for Beauty*

圖版索引
Painting Catalogue

21 從樹間看水社碼頭

Shuishe Pier Scenery from the Woods
28.5×39cm 2006

22 水社湖面

Lake Scenery at Shuishe
56.5×224cm 2013

23 水社碼頭側面

Flank View of the Shuishe Pier
39×57cm 2013

24 從梅荷園看水社碼頭

View of Shuishe Pier From the Meihe
Park
76×148.5cm 2013

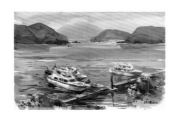

25 水社碼頭一角

A corner at Shuishe
39×57cm 2012

26 大淶閣景觀（一）

View of Hotel Del Lago
39×57cm 2007

27 大淶閣景觀（二）

View of Hotel Del Lago
57×78cm 2012

28 萬人泳渡（一）

Ten-Thounsand Swimmers Crossing
Sun Moon Lake
79×110cm 2013

29 萬人泳渡（二）

Ten-Thounsand Swimmers Crossing
Sun Moon Lake
79×110cm 2013

30 日月潭覽勝

Beautiful Scenic Spot of Sun Moon Lake
120×420cm 2013 現收藏於北京

32 鴻濱景觀（一）

View of Apollo Resort Hotel
39×57cm 2013

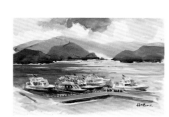

33 鴻濱景觀（二）

View of Apollo Resort Hotel
39×57cm 2013

34 鴻濱景觀（三）

View of Apollo Resort Hotel
39×57cm 2013

35 梅荷園

Meihe Park
28.5×39cm 2005

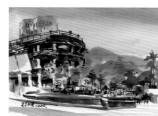

36 水社遊客中心

Shuishe Visitor Center
28.5×39cm 2006

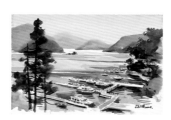

37 水社碼頭俯瞰

Bird's-eye View of the Shuishe Pier
39×57cm 2007

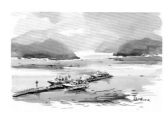

38 碼頭分支

A Branch of the Shuishe Pier
39×57cm 2013

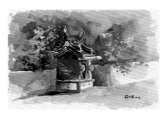

39 岸上土地公廟

Earth God Temple on shore
39×57cm 2013

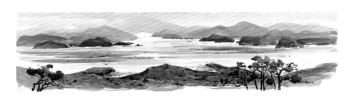

40 水社俯瞰
Bird's-eye View of Shuishe
38×148.5cm 2013

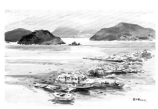

41 SPA Home景觀
View of the SPA Home
39×57cm 2013

42 水社名勝巷
Sightseeing Lane at Shuishe
57×39cm 2006

43 紅薯餅店
Red Sweet Potato Shop
39×57cm 2013

43 紅薯餅產品
Special Local Product – Red Sweet
Potato
28.5×39cm 2013

44 五星級廁所（現已改建為商店）
Five-star Toilet (a shop Now)
39×57cm 2003

45 街頭藝人洪英沛表演手鼓
Show of Street Performer Yung-pei
Hong
57×39cm 2003

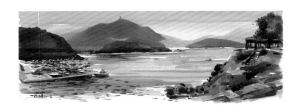

46 梅荷園湖面
Lake Scenery of the Meihe Park
28.5×78cm 2012

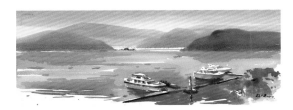

47 水社另一角
Another Corner at Shuishe
28.5×78cm 2012

48 水社清晨
Morning at Shuishe
57×114cm 2009

49 龍鳳廟遠眺
Distant View of the Longfeng Temple
39×57cm 2010

51 涵碧步道
Hanbi Hiking Trail
39×57cm 2013

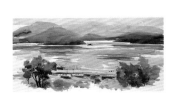

52 涵碧樓景觀
View of the Lalu Hotel
113×222cm 2012

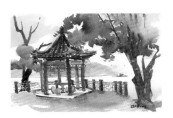

54 蔣公觀景亭
Late President Chiang Kai-shek
Observation Pavilion
39×57cm 2003

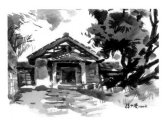

54 蔣公紀念館
Late President Chiang Kai-shek
Memorial Hall
28.5×39cm 2006

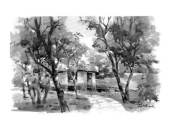

55 杏壇
Teacher's Place
39×57cm 2013

55 教師會館
Teachers' Hostel
39×57cm 2013

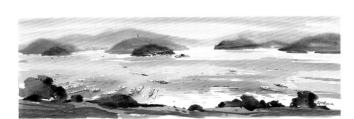

56 日月行館景觀
View of the Wen Wan Resort
37.5×114cm 2013

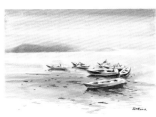

59 小舟群
Boats
57×78cm 2013

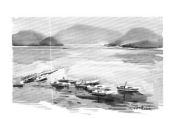

60 小型碼頭
Lovely Pier
39×57cm 2007

61 遊客排隊登船
Travelers in Line for Boarding
39×57cm 2013

62 朝霧步道（一）
Chaowu Hiking Trail
39×57cm 2013

63 朝霧步道（二）
Chaowu Hiking Trail
57×78cm 2013

65 霧中賞竹
Bamboos in the Fog
39×57cm 2006

66 竹間漁舟
Fishing Boat Seen though the Bamboos
39×57cm 2013

67 竹石園內景觀
View in the Bamboo Rock Park
28.5×39cm 2006

69 文武廟俯瞰（一）
Bird's-eye View of the Wunwu Temple
57×78cm 2013

70 文武廟俯瞰（二）
Bird's-eye View of the Wunwu Temple
39×57cm 2013

70 守門火獅
Gate-keeper Fire Lions
39×57cm 2003

71 文武廟景觀（一）
View from the Wunwu Temple
39×57cm 2012

72 文武廟景觀（二）
View from the Wunwu Temple
39×57cm 2013

72 文武廟景觀（三）
View from the Wunwu Temple
39×57cm 2012

73 樹間看景聖樓
Jingsheng Building Scenery
from the Woods
39×28.5cm 2006

75 松柏崙步道與涼亭
Songbolun Nature Hiking Trail and
Pavilion
39×57cm 2013

76 松柏崙湖面船臺（一）
Boat Platform at Songbolun
39×57cm 2013

77 松柏崙湖面船臺（二）
Boat Platform at Songbolun
39×57cm 2013

79 大竹湖垂釣
Fishing by Dazhu Lake
57×78cm 2003

80 大竹湖俯瞰
Bird's-eye View of Dazhu Lake
39×57cm 2013

81 大竹湖步道
Dazhu Lake Trail
28.5×39cm 2006

81 大竹湖出水口
Dazhu Lake Outket
28.5×39cm 2013

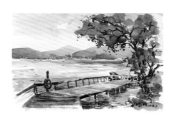

83 水蛙頭步道
Shuiwatou Trail
39×57cm 2013

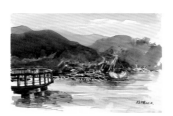

84 水蛙頭另一步道
The Other Trail at Shuiwatou
39×57cm 2013

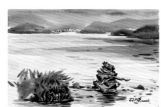

85 九隻青蛙雕塑（一）
Nine Frogs Sculpture
39×57cm 2006

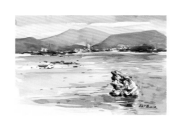

85 九隻青蛙雕塑（二）
Nine Frogs Sculpture
39×57cm 2013

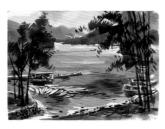

87 營地輕舟及划板
Boats and Canoes at the Holy Love
Campsite
28.5×39cm 2006

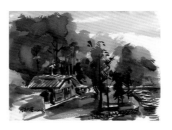

88 營地小屋
Cottage at the Holy Love Campsite
28.5×39cm 2006

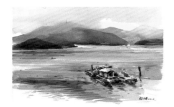

89 營地湖面
Lake Scenery by the Holy Love
Campsite
39×57cm 2012

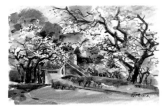

91 梅林與別墅
Plum Trees and a Villa
39×57cm 2013

92 青年活動中心園區
Park of the Youth Activity Center
39×57cm 2006

93 水上步道（一）
Trail above Sun Moon Lake
39×57cm 2012

94 水上步道（二）
Trail above Sun Moon Lake
39×57cm 2010

95 纜車起站
The Start Station of Cable
39×57cm 2013

97 日月村街景
Street View at Sun Moon Village
39×57cm 2013

98 從水岸民宿俯瞰湖面
Bird's-eye Lake View from the Lakeside
Guesthouse
39×57cm 2013

99 從路邊俯瞰湖面船屋
Bird's-eye Boathouse on Lake from
the Path
39×57cm 2003

100 村邊漁舟
Fishing Boats by the Village
39×57cm 2013

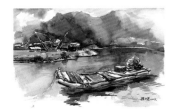

101 四平灣漁筏
Fishing Raft at Siping Bay
39×57cm 2003

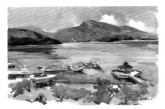

102 湖岸公園
Lakeside Park
39×57cm 2012

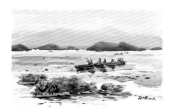

102 獨木舟
Canoes
39×57cm 2013

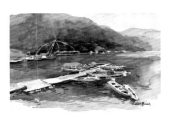

103 四平湖碼頭
Siping Bay Pier
39×57cm 2003

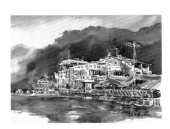

104 從湖面看日月村
Sun Moon Village Scenery from the
Lake
28.5×39cm 2000

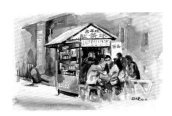

104 路邊茶攤
Tea Stand at the Roadside
39×57cm 2013

105 湖中小舟群
Small Boats in the Lake
39×57cm 2012

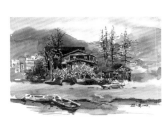

105 富豪群飯店
Full House Resort
39×57cm 2002

106 舞團石小姐
A Dancer
57×39cm 2013

106 袁家公主
Princess Of Shao
57×39cm 2013

106 石磊頭目和采妮公主
Gang Leader Shilei and
Princess Caini
57×39cm 2006

107 袁福田頭目
Gang Leader Of Shao
57×39cm 2003

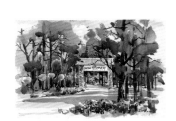

109 伊達邵大門
Yidashao Entrance Gate
39×57cm 2013

109 伊達邵祖靈藍
Yidashao Ancestor Spirit Basket
39×57cm 2013

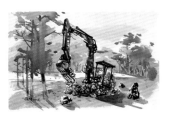

110 伊達邵公共藝術
Yidashao Public Art Installation
39×57cm 2013

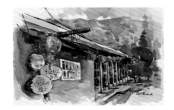

111 伊達邵母語教學牌

Signs of the Yidashao Native Language
Teaching
39×57cm 2013

111 伊達邵靈鳥貓頭鷹雕刻品

Sculptures of the Yidashao God
Bird─Owl
39×57cm 2013

112 伊達邵過年喝酒歡樂

New Year Party at Yidashao
39×57cm 2003

112 伊達邵杵音舞

Yidashao Pestle Sound Dance
57×78cm 2013

113 水社大山登山口

Entrance of Shuishe Mountain
57×78cm 2013

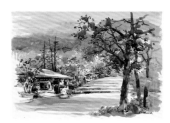

114 陳賢美在登山口的藝品店

Ms. Chen, Wianmei at a Craft Shop
near the Entrance
57×78cm 2013

114 伊達邵先生媽陳賢美女士

Shuishe's Medicine Woman─Ms.
Chen, Wianmei
39×57cm 2013

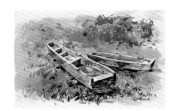

115 丹明元的獨木舟

Mr. Dan, Mingyuan's Canoes
39×57cm 2013

115 獨木舟達人丹明元先生

Canoe Expert Mr. Dan, Mingyuan
39×57cm 2013

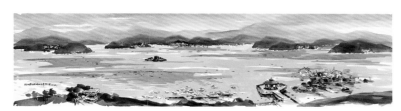

116 伊達邵湖面

Lake View at Yidashao
56.5×224cm 2013

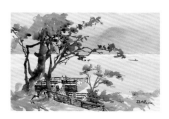

119 土亭仔觀景台（一）

Tutingzai Observation Pavilion
39×57cm 2003

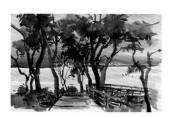

120 土亭仔湖面

Lake Scenery at Tutingzai
39×57cm 2006

121 臨湖步道

Lakeside Trail
39×28.5cm 2006

122 步道另一端

The Other Side of the Hiking Trail
28.5×39cm 2006

123 土亭仔觀景台（二）

Tutingzai Observation Pavilion
39×57cm 2013

123 土亭仔步道與涼亭

Tutingzai Hiking Trail and Pavilion
39×57cm 2013

124 樹間遠眺水社

Shuishe Scenery in a Long Distance
28.5×39cm 2000

124 遠眺日月村

Sun Moon Village in a Long Distance
28.5×39cm 2000

125 土亭仔一角

A corner at Tutingzai
28.5×39cm 2000

127 玄光寺（一）

Xuanguang Temple
39×57cm 2012

128 玄光寺（二）

Xuanguang Temple
39×57cm 2003

129 玄光寺（三）

Xuanguang Temple
39×57cm 2006

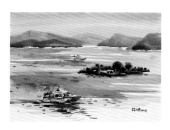

130 玄光寺湖面

Lake scenery by the Xuanguang Temple
57×78cm 2013

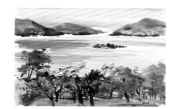

131 從玄光寺看拉魯島
Lalu Island Scenery from the
Xuanguang Temple
39×57cm 2013

132 玄光寺街頭藝人孟寬先生
Street Performer Meng Kuan at the
Xuanguang Temple
39×57cm 2013

132 演唱中的孟寬先生
Mr. Meng Kuan's Singing
39×57cm 2013

133 玄光寺附設小亭專賣
金盆阿嬤茶葉蛋
Jinpen Grandma Tea Egg Kiosk at
the Xuanguang Temple Pier
39×57cm 2013

133 松樹間看玄奘寺
Xuanzhuang Temple Scenery
from the Palm Woods
39×57cm 2006

134 玄奘寺香亭
Xiang Kiosk at the Xuanzhuang Temple
28.5×39cm 2006

134 慈恩塔
Ci'en Pagoda
39×57cm 2013

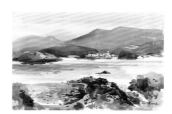

135 在慈恩塔頂層看日月潭
Sun Moon Lake View from the Top
of the Ci'en Pagoda
39×57cm 2013

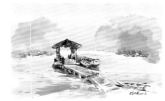

137 沙巴嘮簡易碼頭
Simple Shabalan Pier
39×57cm 2013

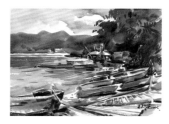

138 沙巴嘮修船塢
Shabalan Repair Dock
28.5×39cm 2006

138 沙巴嘮碼頭
Shabalan Pier
28.5×39cm 2000

139 漁舟自橫
Unrestrained Boat
57×78cm 2013

140 竹林間俯瞰船屋
Bird's-eye Boathouse view
from the Bamboos
39×57cm 2013

140 岸邊漁舟
Boats by the Lake Shore
39×57cm 2013

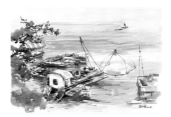

141 水上漁家
Fishing Households on the Lake
57×78cm 2013

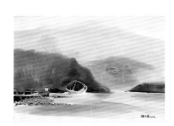

143 大竹湖四角網
Four-angle Net at Dazhu Lake
57×78cm 2003

144 魚筌
Bamboo Fish Traps
39×57cm 2013

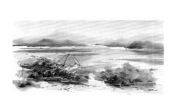

144 多種魚類都在浮嶼下滋生
Various Fish Living beneath Small
Floating Islets
76×148.5cm 2013

145 浮嶼間的四角網
Four-angle Net among Small Floating
Islets
57×78cm 2013

145 改良的四角網
Improved Four-angle Net
57×78cm 2013

146 獨釣（一）
Fishing Alone
57×78cm 2013

147 獨釣（二）
Fishing Alone
57×78cm 2013

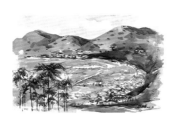

149 頭社盆地
Toushe Basin
39×57cm 2013

150 早期日月潭模擬圖
Sun Moon Lake Simulated
Picture in Early Years
57×39cm 2013

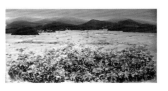

151 頭社金針花田
Orange Daylily Fields at Toushe
76×148.5cm 2012

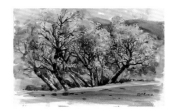

151 頭社柳
Willow Trees at Toushe
39×57cm 2013

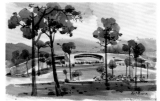

153 向山遊客中心
Xiangshan Visitor Center
39×57cm 2012

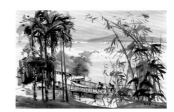

154 自行車步道（一）
Xiangshan Bike and Pedestrian Bridge
39×57cm 2013

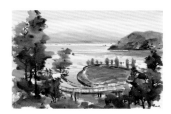

155 自行車步道（二）
Xiangshan Bike and Pedestrian Bridge
39×57cm 2013

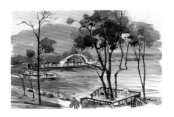

156 向山湖面
Lake Scenery at Xiangshan
39×57cm 2012

157 向山附近步道
Trail near Xiangshan
39×57cm 2012

157 自行車步道另一段
View of the Xiangshan Bike and
Pedestrian Bridge
39×57cm 2013

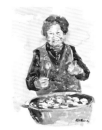

159 阿嬤茶葉蛋熱賣
Hot-selling Grandma Jinpen's
Tea-flavored Eggs
57×39cm 2013

160 忙碌中的阿嬤
Grandma Jinpen Is Busy at Work
28.5×39cm 2013

160 忙碌中的阿嬤
Grandma Jinpen Is Busy at Work
28.5×39cm 2013

160 忙碌中的阿嬤
Grandma Jinpen Is Busy at Work
28.5×39cm 2013

160 忙碌中的阿嬤
Grandma Jinpen Is Busy at Work
28.5×39cm 2013

161 阿嬤的家
Grandma Jinpen's Home
28.5×39cm 2013

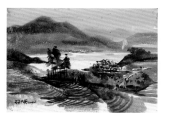

163 湖畔茶園
Tea Field by Lakeside
28.5×39cm 2006

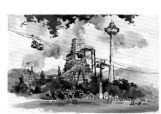

165 遊樂設施
Entertainment Facilities at the
Formosan Aboriginal Culture Village
39×57cm 2001

166 九族文化村遊客中心
Formosan Aboriginal Culture Village
Visitor Center
28.5×39cm 2013

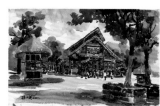

166 九族文化村大門
Entrance Gate of the Formosan
Aboriginal Culture Village
39×57cm 2001

167 觀景樓
Observation Pavilion
28.5×39cm 2013

168 櫻花盛開（一）
Cherry Blossoms
39×57cm 2013

168 櫻花盛開（二）
Cherry Blossoms
39×57cm 2013

169 櫻花謝　綠葉生
Cherry Blossoms Fall, Green Leaves
Sprout
39×57cm 2013

170 魚池鄉的三育學院
Taiwan Adventist College at Yuchih
Town
39×57cm 2002

171 埔里眉溪
Mei Stream at Puli
76×148.5cm 2013

172 埔里茭白筍田
Water Bamboo Fields at Puli
76×148.5cm 2011

173 埔里紅甘蔗田
Red Sugar Cane Field at Puli
76×148.5cm 2013

174 新故鄉文教基金會紙教堂
Paper Dome of the New Homeland Foundation
39×57cm 2009

174 紙教堂夜景
Night View at Paper Dome
28.5×39cm 2011

175 紙教堂的荷花
Lotuses at Paper Dome
76×148.5cm 2013

176 陳綢阿嬤的良顯堂
Grandma Chen, Chou's Liangxian Hall
28.5×39cm 2010

176 黃家百年門樓
Century Gate of the Huang Family
28.5×39cm 2010

177 中台禪寺
Chung Tai Chan Monastery
39×57cm 2008

178 廣興紙寮
Guangxing Paper Plant
39×57cm 2013

179 林家別墅
Lin Family Villa
39×57cm 2013

179 埔里土角厝
Soil Block House at Puli
28.5×39cm 2009

180 埔里鎮圖書館
Library at Puli
28.5×39cm 2009

181 暨大校園
Campus of the National Chi Nan University
39×57cm 2002

182 埔里美味小吃
Puli Specialty Products
28.5×39cm 2010

182 埔里美味小吃
Puli Specialty Products
28.5×39cm 2010

182 埔里美味小吃
Puli Specialty Products
28.5×39cm 2010

183 埔里蝴蝶蘭
Puli Phalaenopsis
39×28.5cm 2012

183 台灣阿嬤蘭
Taiwan Grandma Phalaenopsis
39×28.5cm 2012

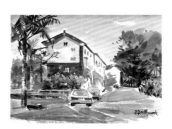

184 埔里新型社區
Puli New-style Community
28.5×39cm 2006

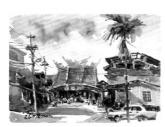

184 埔里桃米里福同宮
Futong Temple at Taomi, Puli
28.5×39cm 2001

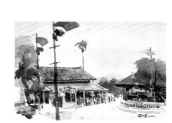

185 集集車站
Jiji Station
39×57cm 2004

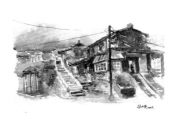

186 車埕老屋
Checheng Old Lodge
28.5×39cm 2003

187 水里蛇窯附設樹屋民宿
Tree House Guesthouse Attached to the Shuili Snake Kiln
39×57cm 2003

196 作家王灝老師書房
Study Room of Writer Wang, Hao
簽字筆淡彩 39×57cm 2004

196 石雕家鄧老師
Stone Carving Expert-Teacher Deng
鉛筆淡彩 39×57cm 2004

197 埔里櫻花老人
Puli Cherry Old-man
鉛筆淡彩 57×39cm 2002

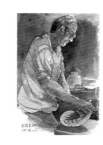

198 陶藝家吳讓農老師
Ceramic Artist Wu, Rangnong
鉛筆淡彩 57×39cm 2003

國家圖書館出版品預行編目資料

水之湄：日月潭水彩畫記 / 孫少英作. -- 初版.
-- 臺中市：盧安藝術文化, 民102.11
　　216面；寬26×高34.5公分
　　ISBN 978-986-89268-1-3（精裝）

　1.水彩畫　　2.畫冊

948.4　　　　　　　　　　　102016662

Searching For Beauty
Sun Moon Lake Watercolor Painting Journal

作　　者：孫少英
發 行 人：盧錫民
顧　　問：廖嘉展・劉龍華・葉秀卿
總 策 劃：康翠敏
英文翻譯：李若薇
英文校對：朱侃如
文字校對：黃晚玲・張雅棠
作者攝影：鄧文淵
出版單位：盧安藝術文化有限公司
郵政劃撥帳號：22764217
地　　址：403台中市西區台灣大道2段375號11樓之2
電　　話：04-23263928
E-mail：luantrueart@gmail.com
官　　網：www.luan.com.tw
設計印刷：立夏文化事業有限公司
地　　址：412台中市大里區三興街1號
電　　話：04-24065020

定價：新台幣 2500元
ISBN：978-986-89268-1-3
中華民國102年11月出版